On Elizabeth Taylor

ALSO BY **MATTHEW KENNEDY**

Marie Dressler: A Biography
Edmund Goulding's Dark Victory: Hollywood's Genius Bad Boy
Joan Blondell: A Life between Takes
Roadshow! The Fall of Film Musicals in the 1960s

On Elizabeth Taylor

An Opinionated Guide

MATTHEW KENNEDY

OXFORD
UNIVERSITY PRESS

OXFORD
UNIVERSITY PRESS

Oxford University Press is a department of the University of Oxford. It furthers
the University's objective of excellence in research, scholarship, and education
by publishing worldwide. Oxford is a registered trade mark of Oxford University
Press in the UK and certain other countries.

Published in the United States of America by Oxford University Press
198 Madison Avenue, New York, NY 10016, United States of America.

Library of Congress Cataloging-in-Publication Data
Names: Kennedy, Matthew, 1957– author.
Title: On Elizabeth Taylor : an opinionated guide / Matthew Kennedy.
Description: New York, NY : Oxford University Press, 2024. |
Includes bibliographical references and index.
Identifiers: LCCN 2023038573 (print) | LCCN 2023038574 (ebook) |
ISBN 9780197664117 (hardback) | ISBN 9780197664131 (epub)
Subjects: LCSH: Taylor, Elizabeth, 1932–2011—Miscellanea | Motion picture
actors and actresses—United States—Biography.
Classification: LCC PN2287.T18 K46 2024 (print) | LCC PN2287.T18 (ebook) |
DDC 791.4302/8092 [B]—dc23/eng/20231124
LC record available at https://lccn.loc.gov/2023038573
LC ebook record available at https://lccn.loc.gov/2023038574

DOI: 10.1093/oso/9780197664117.001.0001

Printed by Sheridan Books, Inc., United States of America

For Mark, who speaks his own language of film

Beauty is rarely soft or consolatory. Quite the contrary. Genuine beauty is always quite alarming.

—Donna Tartt

Everything makes me nervous, except making movies.

—Elizabeth Taylor

Contents

Acknowledgments

I offer thanks and express gratitude to all who played a role in bringing *On Elizabeth Taylor: An Opinionated Guide* to the marketplace.

Visiting the Margaret Herrick Library of the Academy of Motion Picture Arts and Sciences is always a treat—it's simply unbeatable for film history treasures. The ace staff of archivists and librarians, including Louise Hilton, Genevieve Maxwell, and Benjamin Fox, made my visits there fruitful. Likewise, I received excellent assistance from Annemarie van Roessel, Assistant Curator of The Billy Rose Theatre Division at the New York Public Library for the Performing Arts, and Sandra Garcia-Myers of the Cinematic Arts Library at the University of Southern California. Derek Davidson and Todd Ifft at Photofest, and Andrew Howick at mptvimages.com made the process smooth and easy.

Jane Klain of the Paley Center for Media helped guide me to rare Taylor films. Eric Monder, Allan Taylor, and J. D. Payne offered marketing suggestions, friendly support, and collegial mentorship. And James Parish is simply the most generous and thoughtful writing friend and has been for over twenty years.

Raymond Bertuzzi generously offered guidance on photos and on all matters to do with *Cleopatra*. Abundant thanks go to Alyssa Stone, Laura Sheppard, Andy Talajkowski, and Pam Troy at the Mechanics' Institute Library for their steadfast support and shared love of the movies. And to Michael Fox, who patiently listened to me pontificate on this book idea about Elizabeth Taylor over more than one lunch. Jessie Davison continues to maintain my website with a keen eye for design and copy.

I'm blessed with wonderful friends who regularly offer the good idea, unusual perspective, and gentle nudge that can make a huge difference. Thanks go to Kelly Gaynor, Tom Hartnett, David Julian, Paul Reid, Kathy Russell, Eddie Hosey, Stan Godin, Lon Murphy, Charlie Speigel, Jeff Reid, Donna Hill, and Emily and Bill Leider. And to my late friend Jerry Windley, who had plenty to say about Elizabeth Taylor and her films. A special nod is due to Jim Brown, my oldest friend in the world. His opinionated guide to several of Taylor's films found its way into this book.

Kinfolk Sharon Kennedy, Dana Silberstein, and Karl and Gisela Schönbach keep me writing and productive with their thoughtful encouragement and loving support. And sister Anne Peterson is not only a great cheerleader but also a fine editor as well.

My agent Stuart Bernstein applied his customary expertise to this project, and his enthusiasm and guidance were invaluable. I had several nonstarting book ideas over the last few years. Stuart patiently stood by and was smart enough to know this one was going to happen.

Thanks are due to India Gray, Dharuman Bheeman, project manager at Newgen Knowledge Works, and to Zara Cannon-Mohammed, project editor at Oxford University Press, for guiding me through the post-manuscript submission process so well. And I express boundless thanks and gratitude to Norm Hirschy, senior editor at Oxford. *On Elizabeth Taylor: An Opinionated Guide* was his idea. But, to be sure, any errors or shortcomings of the book's content are mine.

Finally, a most special thanks to my sweetie and comrade in life Dylan Miles. He has taught me there are unexpected ways to love Elizabeth Taylor. There's her artistry, her beauty, her generous heart . . . and her love of chipmunks!

Introduction

In the oceans of ink devoted to the monumental movie star businesswoman political activist human being Elizabeth Rosemond Taylor (1932–2011), there are many givens. A dominant one has her beauty and not-so-private life eclipsing her films. Certainly that's true, but hardly inevitable. While it's futile to detach one from the other, it *is* possible to look at her films with the concentration they merit. Her scandalous life was always filtered through the press. Her films, however, are a pure representation of her artistry. We can understand and appreciate her better through her films than through any speculative reporting and pop psychology.

Taylor's big screen credits span over fifty years from her pre-adolescent debut in *There's One Born Every Minute* (1942) to her cameo spot in *The Flintstones* (1994). She worked steadily in everything from a gargantuan epic (*Cleopatra* in 1963) to a daytime TV soap opera (*General Hospital* in 1981). And certainly she knew how to generate publicity, but that's of lesser concern here. In *On Elizabeth Taylor: An Opinionated Guide*, her seven husbands, eight marriages, addictions, tragedies, illnesses, media firestorms, perfume empire, Krupp Diamond, love of fried chicken, and AIDS activism and consciousness-raising take a back seat to *Elizabeth Taylor the actress*.

Taylor won two Oscars and was nominated for five, yet still the notion exists that she wasn't all that good. In 1977, biographer Brenda Maddox asked, "Can she act?," as though Taylor hadn't put that question to rest with *Cat on a Hot Tin Roof* (1958), *Who's Afraid of Virginia Woolf?* (1966) or a dozen other ready examples. Soon after Taylor's death, *The New Yorker* critic Hilton Als summed up

her "idiosyncratic acting style" as "an admixture of a kind of improbable naturalism and fantastic disregard for the discipline of acting." I respectfully disagree. Undisciplined actors don't last half a century. Her first take was often her best. Taylor could be bored or on fire, broad or subtle, but she was never less than a mesmerizing screen presence. She had *it*—that ineffable something known as star power. No one sustained public fascination longer. And no one gave more of herself to the film world.

By all accounts, she was *fun*, and that made a sizable difference in a nerve-rattling business. Any job could be the last, and for movie stars the threat of public ridicule, disdain, or indifference is ever present. Work mates who release anxieties in themselves and others are bound to be popular. Add to that a penchant for democratizing the crew, being considerate and generous to all, and having a "heart like a cathedral" as director Franco Zeffirelli described Taylor, and we are given a notion of what she brought to a set.

Hollywood is filled with gorgeous mugs that turn to ciphers. Once the mask becomes familiar, there's nothing transmitted to the camera and ultimately into our eyes and minds, except perhaps "My, what a pretty face." Taylor always had much more going on than great beauty. The costume designer Irene Sharaff, who clothed Taylor for many films, understood her elusive magic: "The quality that shines through this particular combination of features . . . a quality of femininity that, at its best, is intuition—keen, direct, sympathetic, and absolutely real. Evident at diverse moments, it is, of course, very difficult to put into words. It is there, though, when she is playing with children and animals. There suddenly through the eyes, after the first defensive glance at a stranger. There is that mysterious rapport a star of full stature seems able to communicate through the camera's eye to invisible millions."

Examining her career up close reveals an impressive gallery of strong women fighting against confinement and expectations, though her characters rarely had careers and professional ambitions of their own. If the films weren't always worthy of her,

they often took on rich and complex themes of her choosing. At the height of her career, she thrived in dramas thematically bold and ferocious: gender discrimination (*National Velvet,* 1944); abortion and America's caste system (*A Place in the Sun,* 1951); patriarchy, sexism, and racism (*Giant,* 1956); slavery, mental illness, and miscegenation (*Raintree County,* 1957); homosexuality and repressed memory in *Cat on a Hot Tin Roof* and *Suddenly, Last Summer* (1959); prostitution, female pleasure, and empowerment (*BUtterfield 8,* 1960); sex and politics (*Cleopatra*); the spirit and the flesh (*The Sandpiper,* 1965); marriage and wifely subjugation in *Father of the Bride* (1950), *Who's Afraid of Virginia Woolf?*, *The Taming of the Shrew* (1967), *X Y & Zee* (1972), and *Ash Wednesday* (1973), and a horrifying descent into madness and premeditated death (*The Driver's Seat,* 1974).

Taylor's sixty-five-year career came with oddities. There's a paucity of genre films. Noirs, Westerns, biopics, and romantic comedies are scarce. Her output is largely dramas, many exploring the contours of mental and emotional instability. For someone with limited formal education and no college, her tastes and affinities were remarkably sophisticated. I doubt any movie star ever built a career on a more distinguished roster of literary and theatrical sources. Taylor appeared in films based on various works by Theodore Dreiser, Louisa May Alcott, Stephen Sondheim, Agatha Christie, Graham Greene, Lillian Hellman, Edward Albee, Charlotte Brontë, Christopher Marlowe, Tennessee Williams, F. Scott Fitzgerald, Sir Walter Scott, Noël Coward, Muriel Spark, Carson McCullers, Edna Ferber, Dylan Thomas, and William Shakespeare.

Great actors were in awe of her gifts. Her *Cat on a Hot Tin Roof* costar Paul Newman filmed a Turner Classic Movies tribute, and in it asked, "What can you say about a legend? So much has been written, so much has already been said for so many years about Elizabeth Taylor, is there anything left to say? Well, I think so. But one thing I'm *not* going to talk about is the startling color of her eyes or her amazing beauty. What I *am* going to talk about is what she

brings to the screen, her presence, her volatility, her sense of truth." Richard Burton, her two-time husband and eleven-time costar said, "I think she's one of the world's greatest screen actors. Elizabeth taught me the quieter technique of film acting, not by telling me but simply by doing it." She knew not to try too hard. Burton would watch her on the set and think, "She's not *doing* anything! What is she *doing*?" Watching the rushes was a revelation. "Things are happening behind those eyes," he noted. "You have to try to get that same quality." Best friend and three-time costar Montgomery Clift similarly revered Taylor's screen alchemy. He marveled at how she could capture a mood in an instant without discussion or direction. "I'd rather work with her than any actress in the world," he said. "It's all intuition with her." As she put it, she attempts "the maximum emotional effect with the minimum of visual movement."

In *Sex, Art, and American Culture*, feminist social critic Camille Paglia places Taylor in a context of the mythic female. "At her best, Elizabeth Taylor simply *is*. An electric, erotic charge vibrates the space between her face and the lens. It is an extrasensory, pagan phenomenon." Her work stands as simple yet complex, and emotive while technically assured. Multiple chakras light up when she acts, creating a complex mix of carnality, intellect, and compassion. Her voice was not powerful, but she learned to use it with elastic subtlety. She could be coarsely broad, or delicately nuanced, or somewhere in a wide place in-between. She had a thrilling and uncommon ability to change moods from moment to moment. She can be impenetrable then vulnerable, impulsive then becalmed, sometimes within seconds. She rarely looked away onscreen. And when those lavender-tinted eyes bore into their target, there was the certainty of surrender.

Her well-documented generosity and compassion informed her screen performances. "I think film acting can be an art, and certainly the camera can move in and grab hold of your mind— so the emotion has got to be there behind your eyes, behind your heart," she said. "You can never act superficially and get away with

it. . . . It all has to show in the eye. The slightest movement will speak volumes."

Taylor was not a tutored actor and was never formally trained outside of the guidance from her stage mother and her long-term employer Metro-Goldwyn-Mayer (MGM), the studio that transformed her into a child star. She had a photographic memory and could be ready for the next day's shoot by reading her lines three times the night before. She didn't map out gestures or expressions in her head. When the time came, she let the dialogue or direction inspire her. And by training and temperament she was always a film actress. She was not equipped to endure a long run or play to the upper balcony. Instead, she came alive when the camera approached and the director yelled "Action!"

Certainly she could cut a thick slice of ham. She ad-libs wildly in *Reflections in a Golden Eye* (1967) to compensate for the stingy performance of costar Marlon Brando, whom she nicknamed "Mr. Mumbles." And when going for full-throttle hysteria, she had a habit of clutching the nearest piece of furniture. But she wasn't a gestural actress, preferring instead to leave her hands and arms still, unless they're making use of a cigarette, book, or phone. At her most indulgent and excessive, however, she was still gleefully entertaining. Taylor had a natural magnetism that came from something greater than her beauty or the virtues of any single performance. Her looks and press attention were distractions from her artistry, and she was a harsh judge of herself as well. Now that the exaggerated scandals and self-depreciations are gone, her films are her legacy.

When editor Norman Hirschy approached me to write a book on a film star as part of Oxford University Press' expanding "Opinionated Guide" series, I didn't have a second's hesitation. It had to be Elizabeth Taylor. She has entranced me like no other actress. Growing up during the "Liz 'n' Dick" years of the 1960s, I tore through *Mad Magazine* satires of her films (*The Sinpiper, Who in Heck Is Virginia Woolfe?*), absorbed the constant media noise she generated, and tried to make sense of the adult passions on display.

I first saw her on the big screen in *The Taming of the Shrew*. Seated in the smoky art deco Cascade Theater in downtown Redding, California, that first extreme close-up of a threatening eye peering through the shutters projected onto a fifty-foot-high screen went straight to my long-term memory. The Burtons were everywhere in my youth—in movies, magazines, on TV, and virtually every corner of the known world. "Liz Taylor is 40!" screamed the cover of *Life* magazine in 1972, and I wandered spellbound through the photo layout within.

The earliest opinions I received on Taylor came from my mother, a movie lover going back to first-run Jean Harlow. Elizabeth was such a wonderful child actress, she said, so angelic in *National Velvet*, and now she was just too too. Too many husbands, too much money, too much spotlight glare, and too much eye shadow. But Taylor's humanity always crept into view, and she all but admitted the vulgarity of her excesses. She owned her worst mistakes and was aware of the appearance of chaos and recklessness in her relationships.

Contrition only goes so far with Taylor. She embraced her abnormal life, sought and maintained fame like no other, and honed great survival techniques against unrelenting intrusions. "The public takes an animal delight in putting somebody on the top and then tearing into little bits," she said at the height of her celebrity. "But I have never in my life believed in fighting back to 'cure' my public image. . . . I'm not going to answer for an image created by hundreds of people who do not know what's true or false." Still, she delivered what fans loved: the mercurial fashions, the ostentation, the grab-the-brass-ring attitude to life and husbands essential to the media glare. She rarely played conventional on screen or off, yet she was equally determined to convey the compassion and love of humanity living inside her.

I hold a fascination for her career decline beginning in the 1960s, marveling how she maintained or even enhanced her celebrity against such nonstarters as *The Only Game in Town* (1970) and

Hammersmith Is Out (1972). Virtually all of her later films were deleterious in one unfortunate way or another. But in looking at them again, something else is revealed. The passing years highlight how audacious Taylor became. Films that didn't conform to dramatic expectations such as *Reflections in a Golden Eye, Boom!* (1968), and *The Driver's Seat* were simply discarded as cinematic flotsam in their time. Today they offer a Taylor in the act of pushing herself and her audience to the limit of endurance with new ideas on storytelling and acting. Taylor decided that, as her career ebbed, she would remain a leading lady. She declined playing the mother of the leading actress, or a girlfriend, or some other secondary character. She was a *star*, and she would remain a star long after her film career was over.

I found that delicate balance of art, commerce, and personal ruination absolutely compelling, and I wondered how long it could last. Turns out it lasted a lifetime. The public never wearied of Taylor. She was, among other things, an expert at brand marketing, and renegotiated her public image from punch line to saint. After decades of scandal and derision, Taylor found her greatest cause in the 1980s. She used her fame to give comfort to AIDS patients. She shamed politicians and fellow actors out of their indifference. She embraced hospice patients when no one else would. She raised hundreds of millions of dollars. And she kept at it, still championing the sick and dying as she became a heart patient in a wheelchair. Taylor the actress and media commodity became a supreme philanthropic humanist. As this book is dedicated to her films, I went looking for precursors to her late life strength of character in her earlier work. And I found them.

Taylor appeared in fifty-six theatrically released feature films, ten television movies, two major stage productions, at least twelve guest spots on series television, and innumerable talk shows, award ceremonies, and documentaries. It's noteworthy that so many of her roles were as women attached to men left to destroy or be destroyed by them. Yet she somehow maintained her sense of self if

not her emotional independence. She didn't play shrinking violets, nor did she play corporate executives, nuns, political leaders (with one staggering exception in *Cleopatra*), or compliant wives ready at home for their husbands with a kiss on the cheek and a roast in the oven.

Taylor was always too dynamic and courageous to personify submissive womanhood. Hollywood eats people up, leaving them victimized, vulnerable, lost. "There have been too many of them," said Richard Burton. "Monroe was [one]. Elizabeth in a sense is one, but she always fought back. You could argue that she won; you could argue that she lost. But Hollywood turned her into who she is, and she has survived. At her best she is the most wonderful woman in the world; at worse, she *is* the worst."

Younger readers may know her primarily from her later TV appearances, usually as herself. She was reliably charming, funny, and heartfelt; they were memorable performances in themselves. Still, many today may not appreciate the sheer global fame that once followed Elizabeth Taylor. Her survival mechanisms came from lessons taught by her mother. Taylor always made a clear distinction between who she was and who the world believed her to be. I never had the impression she was addicted to fame, but that it rather came to her as she became a tabloid product. But at the same time, she was never out of public view from age twelve, with her breakthrough role in *National Velvet*, to her death at seventy-nine. Fame was elemental in her life, like air and water. She played the celebrity game shrewdly, throwing decoys at the press while maintaining a life more private than any of us realize. Her lifelong friend Roddy McDowell said, "Planes, trains, everything stops for Elizabeth Taylor, but the public has no conception of who she is."

Press accounts, however damning, never devastated her psyche or corroded her self-image. "If I'm pounced on wearing white fur it's because I like white fur," she said in 1975, adding:

I do what I damned well please. The press is so silly anyway. I can smell them a mile off. When I was in the hospital in London last week, they found out which wing I was in and the nurses were having a giggle opening the windows so I could see. I looked out and there were these silly jerks hiding in a building opposite my room, peeking through the venetian blinds with these cameras. You have to have a sense of humor about it or else you'd go insane. I learned to accept and live with public adulation and invasion of privacy when I was fifteen years old. Now I just go through the back door. My father also taught me how to tune it all out and ignore people who stare at me. If I let it get to me I get claustrophobic and an inner panic sets in—because I am so shy. So I put on blinders. It just clicks into place now.

I can't imagine anyone ever being "the next Elizabeth Taylor." Celebrity and movie stardom have changed. No one will ever have such star machinery behind her. No one will ever command the public's attention for personal acts of love, marriage, and infidelity with such oscillating respect and contempt. Popular culture is now so splintered and transient, our attentions flitting from this podcast to that YouTube video to this streaming miniseries to that TikTok sensation, with hundreds of delivery options and multiple realities to ponder. Films and film stars simply don't have the central place in society they used to.

Extended studies of Taylor the actress are uncommon. Written and filmed accounts often end with her celebrated performance in *Who's Afraid of Virginia Woolf?*, with subsequent films clumped in an undifferentiated mass of critical and financial misfires. Sometimes they're omitted from tributes altogether, as though they never happened. (A close friend and I dream of "The Post–*Virginia Woolf* Elizabeth Taylor Film Festival.") This book includes accounting of her underreported later career. *Boom!*, *X Y & Zee*, and *Night Watch* (1973)—alternatively awash in vague mysticism,

Virginia Woolf derivates, and mystery horror—were ill-suited for an actress so present in the world, as was her Queen of Light-Mother-Witch-Maternal Love in the catastrophic 1976 American-Soviet production of *The Blue Bird*. But not all of her later big-screen efforts were unworthy. *The Taming of the Shrew* has high attributes, and the too hastily derided *The Sandpiper, Night Watch,* and *The Driver's Seat* get reappraisals here.

On Elizabeth Taylor: An Opinionated Guide is composed of two parts, in addition to an introduction, bibliography, notes, and index. Part I is a cradle-to-grave chronology of Taylor's life, noting key professional and personal events, achievements, and milestones. Part II puts the "opinionated" in "an opinionated guide." It comprises the bulk of *On Elizabeth Taylor* and is a work-by-work analysis of her entire career told in chronology. Each film is headlined in bold, with year of release, producing-distributing studio, and director. TV entries include original broadcast date, network, and director. Credits are listed in the order of their filming dates rather than release date, so as to offer an organic progression of Taylor's career. Key aspects of each film are noted—costars, production conditions, firsts and lasts, and critical and popular reaction. There are varying degrees of coverage, with landmark films and performances emphasized and highlighted. And WARNING: the book is rife with spoilers. I did not monitor plot giveaways to protect the newcomers to Taylor's films.

On Elizabeth Taylor serves as a biography of her entire career, but it is also and importantly a reference book with an authorial voice. I speak to the quality of her performances, their contours and shading, and their context to that point in her life and work. Each credit tells a story. If a reader finishes an entry, even one less than laudatory, and says, "I want to see that film," I will be happy.

While *On Elizabeth Taylor* deep dives into her performances, quite often her personal life can't be neatly stowed away. Her profound love of horses illuminates her every moment in *National Velvet*. She and Burton made the TV movie *Divorce His/Divorce*

Hers in 1973, then split one year later. There is a detectable sadness in her eyes throughout the ironically titled *Love Is Better Than Ever* (1952), filmed just as she was leaving Conrad Nicky Hilton, her violent first husband. Though she summoned enormous strength to overcome a multitude of illnesses, a prominent tracheotomy scar appears on her throat in *Cleopatra*, the result of emergency surgery to save her life. Perhaps most memorably, the volcanic performance she gives in *Cat on a Hot Tin Roof* became mourning expressed through art, as the love of her life husband Mike Todd was killed in a plane crash during production.

All that static is gone. The paparazzi and muckrakers have moved on, their visceral impact a dimming memory. The critics who labored to one up each other with withering insults have retired or died. Taylor is no longer an easy target for scorn, envy, and self-righteous judgment. Time has muted the cacophony, and in its place is worshipful revision. I am moved by Taylor's biography as it culminates in this last chapter, where extreme fame and wealth were used for beneficence and kindness. It was then, beginning with her response to the HIV death of friend Rock Hudson in 1985, that Taylor's true nobility of character was realized. Her philanthropy, buttressed by her perfume empire, has brought in an estimated half a billion dollars.

In his excellent book on the making of Taylor's classic *Giant*, Don Graham writes, "Elizabeth Taylor charmed, cajoled, seduced, threatened, schemed, and fought her way to a remarkable career in one of the most chauvinistic enclaves in America—Hollywood. She possessed the beauty of Cleopatra and the bawdy humor and life force of the Wife of Bath. There was never a more likable, funnier, or lovelier Hollywood star." Now *that* gets my absolute agreement. Behold Elizabeth Taylor the artist.

1

Chronology

1932 Elizabeth Rosemond Taylor (ERT) is born on February 27 in Hampstead, London. Father Francis Taylor is an American art dealer living abroad. Mother Sara Viola Warmbrodt is an American stage actress. ERT's brother Howard was born in 1929. Elizabeth is named after both her grandmothers, with Rosemond the birth last name of her paternal grandmother.

1933 ERT and family visit grandparents in the United States.

1933–36 ERT enjoys a privileged childhood, avoiding the deprivations of the worldwide Depression. Dance and singing lessons and horseback riding are favorite activities. ERT gives a dance recital for the Duchess of York, later Queen Elizabeth II, in London. The Taylors acquire the Little Swallows cottage on the estate of family benefactor and Member of Parliament Victor Cazalet.

1937 Cazalet gives ERT a mare. This begins ERT's lifelong adoration of horses. ERT enrolls at the Byron House School, Highgate, London.

1938 ERT continues at Byron House. She, her brother, and parents visit her grandparents in the United States.

1939 On April 3, under the threat of war and at the urging of the American Embassy in London, ERT, her mother, and older brother Howard board the *SS Manhattan* for the United States. ERT arrives in Pasadena, California, on May 1. She enrolls at Willard Elementary School. Sara peruses audition notices, establishes social networks, and hosts dinner parties with the intent

of getting her unusually beautiful daughter into the movies. Meanwhile, ERT is given singing and dancing lessons while taught the ideologies of Christian Science, Sara's religion. Francis rejoins the family in December and opens an art gallery in the Beverly Hills Hotel.

1940 The Taylors move to Beverly Hills, where ERT will live for ten years. She and brother Howard enroll in the nearby Hawthorne Elementary School.

1941 Film columnist Hedda Hopper learns of Elizabeth through a letter of introduction secured by well-connected family friend Victor Cazalet. ERT auditions unsuccessfully at Metro-Goldwyn-Mayer (MGM) studio. On April 21, Sara's efforts pay off when nine-year-old ERT is signed to a six-month contract at Universal Pictures. ERT makes her first film, *There's One Born Every Minute*, in the summer of 1941 at the studio. Universal does not renew her contract.

1942 Without a studio contract, ERT returns to Hawthorne with no strong desire to be in the movies. *There's One Born Every Minute* is released in June.

1943 Sara's continued stage mothering gets ERT her first long-term contract at Hollywood's leading studio, MGM, in January. ERT's starting salary is $100 a week. Her first film at MGM, *Lassie Come Home*, premieres on October 7. ERT begins horseback riding lessons for the leading role in *National Velvet*.

1944 *National Velvet* premieres at Radio City Music Hall on December 14, which makes ERT a movie star at twelve.

1945 As ERT enters adolescence, MGM does not immediately capitalize on her success in *National Velvet*. She is educated at MGM's "little red schoolhouse" with other child actors, while publicists keep her name in entertainment news.

1946 ERT's revised contract at MGM signed on January 8 raises her salary to $750 a week. *Nibbles and Me*, a book about ERT's pet chipmunk, is published. ERT makes *Life with Father* on loan at Warner Bros, and *Cynthia* at home studio MGM. ERT takes part in a radio broadcast fundraising campaign for the March of Dimes in Washington, DC with Franklin D. Roosevelt Jr. and First Lady Bess Truman.

1947 ERT joins a reading of *National Velvet* broadcast February 3 on Lux Radio Theatre. ERT appears on the cover of *Life* magazine for the first time on July 14. *Cynthia* is released on August 29 and includes ERT's first on-screen kiss.

1948 Fan magazines report sixteen-year-old ERT is having her first studio-arranged romance with Army football star Glenn Davis. In October, she returns to England to make *Conspirator*, where she meets British actor and future husband Michael Wilding.

1949 On March 24, ERT makes her first appearance at the Academy Awards ceremony, presenting the first ever costume awards. ERT appears on the cover of *Time* magazine's August 22 issue. ERT has a brief romance and engagement to businessman William Pawley Jr. ERT meets Montgomery Clift and begins production of *A Place in the Sun* in October. ERT meets future husband Conrad Nicholson ("Nicky") Hilton Jr. in November.

1950 ERT films *Father of the Bride* with Spencer Tracy in January. She receives her high school diploma in a ceremony at University High School in Los Angeles, though she attended school on the MGM lot. MGM plans and pays for ERT's marriage to hotel heir Nicky Hilton on May 6 at Church of the Good Shepherd in Beverly Hills before 600 guests. As a movie tie-in to

ERT's real life marriage, *Father of the Bride* premieres on May 18, and is a tremendous box office hit. After a nightmare honeymoon in Europe, ERT films *Father's Little Dividend*, a sequel to *Father of the Bride*, in September. The Hiltons separate on December 17.

1951 ERT is hospitalized with viral infections and nervous collapse. ERT divorces Hilton on January 29. ERT is bestowed the *Harvard Lampoon* "Roscoe" award for "gallantly persisting in her career despite a total inability to act" in February, then is widely acclaimed for her performance in *A Place in the Sun* on its release in August. She reconnects with Michael Wilding while filming *Ivanhoe* in England.

1952 ERT marries Michael Wilding at Caxton Hall in London on February 21. ERT announces her pregnancy on June 21. ERT signs new a MGM contract in July and buys a house on Summitridge Drive in Beverly Hills.

1953 First child, Michael Howard Wilding Jr., is born via cesarean January 6 in London. ERT is loaned to Paramount to make *Elephant Walk*.

1954 ERT has her busiest year as an actress, with four films in release: *Rhapsody, Elephant Walk, Beau Brummell,* and *The Last Time I Saw Paris*. The Wildings move to Beverly Estate Drive in Beverly Hills.

1955 Second child, Christopher Edward Wilding, is born in Los Angeles on February 27, ERT's twenty-third birthday. ERT travels to Marfa, Texas, to film the epic *Giant* for Warner Bros. ERT's *Giant* costar James Dean is killed near Cholame, California, in a high-speed auto accident on September 30.

1956 From April to October, ERT is consumed with filming the big-budgeted *Raintree County* for MGM. On May 12, *Raintree County* costar and ERT close friend

Montgomery Clift suffers serious injuries in a car accident two blocks from ERT's house. A pained and disfigured Clift returns to the *Raintree County* set on July 23. ERT meets film producer and future husband Mike Todd. In July, MGM announces ERT's intent to divorce Wilding. ERT presses her hands in wet cement outside the famed Grauman's Chinese Theater as part of marketing for her smash hit film *Giant* on September 26. ERT files for divorce from Wilding on October 4 as *Raintree County* wraps location filming in Mississippi and Kentucky. Following a series of unchallenging roles in mediocre films at MGM, ERT enjoys renewed acclaim in *Giant*, released in October. She suffers a severe spinal injury leading to surgery in New York in November.

1957 ERT divorces Michael Wilding on January 31 and marries Mike Todd on February 2 in Acapulco, Mexico. ERT receives a Special Achievement Golden Globe Sterling Award for Consistent Performance on February 28. Daughter Elizabeth Frances (Liza) Todd is born prematurely August 6. The Todds move to Schuyer Drive in Beverly Hills. ERT attends the premiere of *Raintree County* at the Brown Theater in Louisville on October 2.

1958 ERT begins rehearsing and filming *Cat on a Hot Tin Roof* in February. ERT is nominated for the Best Actress Academy Award for *Raintree County* on February 18. Mike Todd dies in a plane crash in New Mexico on March 23. ERT is swarmed by a throng of ghoulish fans at Todd's funeral in Chicago on March 25. A grieving ERT resumes filming *Cat on a Hot Tin Roof* in April. Widowed ERT moves to Copa de Oro Road in Bel Air. *Cat on a Hot Tin Roof* opens at the Radio City Music Hall on September 18 and becomes

a huge critical and financial success. ERT ranks second on the annual Quigley Publications poll of top stars at the box office.

1959 ERT earns a second Best Actress Academy Award nomination for *Cat on a Hot Tin Roof* on February 23. After nine months of study, ERT converts from Protestantism to Judaism on March 27 at Temple Israel in Hollywood. She is given the Jewish name Elisheba Rachel. ERT marries singer Eddie Fisher, Mike Todd's good friend, on May 12 in Las Vegas. She films *Suddenly, Last Summer* in England. In September, ERT is approached by Twentieth Century-Fox to star in *Cleopatra*, and she jokingly replies she'll do it for a million dollars. Fox calls her bluff, and in November she becomes the first actress to sign a seven-figure contract. Before beginning production on *Cleopatra*, she stars in *BUtterfield 8*, her last film under her long-term MGM contract. *Suddenly, Last Summer* opens to rave reviews for ERT in December.

1960 ERT is nominated for the Best Actress Academy Award for *Suddenly, Last Summer* on February 22. ERT wins the Golden Globe for Best Actress in a Drama for *Suddenly, Last Summer* on March 10. ERT arrives in London on September 8 to shoot *Cleopatra*. *BUtterfield 8* premieres in New York on November 16. ERT is ill, and production on *Cleopatra* is suspended on November 18. ERT recuperates in Palm Springs, California, then returns to London on December 29 to continue work on *Cleopatra*. ERT ranks fourth on the annual Quigley Publications poll of exhibitors for top stars at the box office.

1961 Rouben Mamoulian resigns as director of *Cleopatra* on January 19 and is replaced by Joseph L. Mankiewicz on January 27. Lloyd's of London, which has insured the

film, wants to replace ERT with Kim Novak, Marilyn Monroe, or Shirley MacLaine. Producer Walter Wanger says, "No Liz—No Cleo" on February 17. ERT is bedridden with double pneumonia and undergoes an emergency tracheotomy on March 4 amidst a global demonstration of concern and prayers. ERT recovers over the next few weeks. ERT wins the Best Actress Academy Award for *BUtterfield 8*, a film she repeatedly called "garbage," on April 17. ERT has her tracheotomy scar removed by cosmetic surgery in Los Angeles on July 19. The future adopted daughter to ERT and Richard Burton is born August 1 in Germany. ERT arrives in Rome to resume work on *Cleopatra* on September 1. Her newly cast costar Burton catches her romantic interest. ERT legally adopts the future Maria Burton on December 21. ERT ranks first on the annual Quigley Publications poll of exhibitors for top stars at the box office.

1962 ERT and Richard Burton play their first scene together in *Cleopatra* on January 22. When director Joseph L. Mankiewicz informs producer Walter Wanger that ERT and Burton are having an affair, the media storm known as *Le Scandale* begins. Fisher throws ERT a champagne party for her thirtieth birthday at a nightclub in Rome. Burton is not invited but gives ERT a diamond-and-emerald brooch from Bulgari. ERT and Fisher announce their intention to divorce on April 2. The Vatican denounces ERT and her open affair with Burton. Filming of *Cleopatra* is completed in July. While *Cleopatra* is in post-production, Taylor is reunited with Burton in London to film *The V.I.P.s*. With no films in release since 1960, ERT still ranks sixth on the annual Quigley Publications poll of exhibitors for top stars at the box office.

1963 *Cleopatra* has its world premiere in New York on June 12 and becomes the number one boxoffice success of the year, despite its four-hour running time and withering reviews for ERT. It is the first of eleven films ERT would make with eventual husband Richard Burton. Taylor and Burton both seek divorces. *The V.I.P.s* opens to robust business. ERT accompanies Burton to Puerto Vallarta, Mexico, for shooting of his film *The Night of the Iguana* in October. ERT ranks sixth on the annual Quigley Publications poll of exhibitors for top stars at the box office.

1964 ERT divorces Eddie Fisher on March 6 and, while Burton is in Toronto rehearsing for *Hamlet* on stage, marries the also freshly divorced Burton on March 15 in Montreal. On April 9, Burton opens in *Hamlet* on Broadway, and newlywed ERT suspends film work to support him in his successful theater venture. The Burtons appeared on the *Freedom Spectacular* TV special held as a fundraiser for civil rights and televised on May 14. On June 16, ERT and Burton, a hemophiliac, establish the Richard Burton Hemophilia Fund, with ERT as founding chair. ERT reads poetry before a live audience on Broadway to a positive reception on June 21. From September to the end of the year, ERT and Burton are in production for *The Sandpiper* in Big Sur, California. Harper & Row publishes *Elizabeth Taylor: An Informal Memoir* by ERT, in which she discusses acting, marriages, divorces, motherhood, her health problems, and her love for Burton.

1965 The Burtons are in negotiations in June to make the film adaptation of the acclaimed stage play *Who's Afraid of Virginia Woolf?* *The Sandpiper* debuts at the Radio City Music Hall on July 15 and breaks the house record of $30,000 for opening ticket sales. The Burtons

film *Who's Afraid of Virginia Woolf?* in September. ERT ranks ninth on the annual Quigley Publications poll of exhibitors for top stars at the box office.

1966 ERT performs live on stage in February as Helen of Troy in *Doctor Faustus* for the Oxford University Dramatic Society, with Burton in the title role. The Burtons are in Rome in March filming *The Taming of the Shrew*. *Who's Afraid of Virginia Woolf?* is released on June 22, with ERT receiving the strongest reviews of her career. In July, the Burtons make a film version of their *Doctor Faustus* production. ERT ranks third on the annual Quigley Publications poll of exhibitors for top stars at the box office.

1967 Avon Books publishes a paperback updated edition of 1964's *Elizabeth Taylor*, adding ERT's excited reflections on making *Who's Afraid of Virginia Woolf?* ERT's only foray into Shakespeare on film, *The Taming of the Shrew*, is released in February and is a critical and financial success. ERT wins her second Best Actress Academy Award for *Who's Afraid of Virginia Woolf?* on April 10. The Burtons buy a Hawker-Siddeley De Havilland 125 twinjet on September 30. ERT ranks sixth on the annual Quigley Publications poll of exhibitors for top stars at the box office.

1968 Burton buys the Krupp diamond at a New York auction for $305,000 on May 17. It is later renamed "The Elizabeth Taylor Diamond." Following Robert Kennedy's assassination in June, ERT buys a $50,000 full-page ad in *The New York Times* urging gun control. ERT's father Francis Taylor dies of complications from a stroke at home in Los Angeles on November 22, aged seventy. ERT ranks tenth on the annual Quigley Publication poll of exhibitors for top stars at the box office. (This is ERT's last appearance on the Quigley poll.)

1969 ERT hopes to end a box-office losing streak that includes *Reflections in a Golden Eye, The Comedians*, and *Secret Ceremony*, with *The Only Game in Town*, costarring Frank Sinatra and reuniting her with *A Place in the Sun* and *Giant* director George Stevens. Burton buys a 69.42-carat diamond for ERT for $1.1 million on October 25.

1970 *The Only Game in Town*, with Warren Beatty replacing Frank Sinatra, opens on March 1 and is a critical and commercial bomb. ERT and Burton make guest appearances on CBS-TV's *Here's Lucy* starring Lucille Ball in May. In October, ERT films *Zee and Co* in London with Michael Caine.

1971 ERT's beloved longtime secretary and friend Richard Hanley dies on January 1. The Burtons film Dylan Thomas's *Under Milk Wood*, a pet project of Richard's, in Wales and London in January. ERT becomes a grandmother at thirty-nine with the birth of Laela Wilding, daughter of her son Michael Wilding Jr.

1972 After a long delay, *Zee and Co*, titled *X Y & Zee* in the United States, opens on January 26 in New York to the best reviews Taylor had since *The Taming of the Shrew*. On February 27, ERT celebrates her fortieth birthday in Budapest with Burton giving her a $1.5 million Cartier diamond and a heart-shaped diamond pendant. The Burtons film *Divorce His/Divorce Hers*, their first TV movie, in Munich in November.

1973 ERT films the fountain of youth drama *Ash Wednesday* with Henry Fonda in February in Northern Italy. ERT goes public with her separation from Richard Burton on July 3 and reconciliation on December 9.

1974 ERT receives the World Film Favorite Golden Globe Award on January 26. After reconciliations and separations, ERT divorces Richard Burton on June 26.

1975	ERT stars in *The Blue Bird*, marketed as the first United States–Russia joint film production, in Russia. ERT and Burton are reunited on August 20. ERT remarries Burton on October 10 in Botswana.
1976	ERT announces her separation from Burton on February 23. The much-anticipated *The Blue Bird* opens to savage reviews and empty seats on May 13 in New York. ERT meets and is quickly attracted to former US Secretary of the Navy John Warner. ERT flies to Austria to make the film version of the stage musical *A Little Night Music*. ERT re-divorces Burton on July 30. After a quick romance, ERT marries John Warner on December 4.
1977	ERT commits to being an ambitious politician's wife with John Warner's candidacy to the US Senate. She speaks at luncheons and charities on the road. ERT is honored as Hasty Pudding Woman of the Year by the Hasty Pudding Theatrical Society at Harvard University on February 15. The Variety Clubs International honors ERT for her philanthropy on behalf of hospitalized children with an *All-Star Tribute* broadcast on CBS on December 1. Guest speakers include Paul Newman, Bob Hope, Henry Fonda, and her *Little Women* costars Janet Leigh, Margaret O'Brien, and June Allyson.
1978	*A Little Night Music* opens in March, with critics mocking Taylor's weak singing voice and fluctuating weight. At a campaign stop for husband and US Senate candidate John Warner in Big Stone Gap, Virginia, in October, ERT nearly asphyxiates on a chicken bone lodged in her throat. Comedian-in-drag John Belushi parodies ERT's eating, weight gain, and chicken bone incident in a skit on *Saturday Night Live* on November 11. Warner is declared winner of the Senate election on November 27 by a razor-thin margin.

1979 Warner is sworn in as US Senator on January 16. Michael Wilding, ERT's second husband and father of her two sons, dies. ERT attends his funeral in England on July 16. ERT attends screening of *Cleopatra* with a reception in her honor at the Cairo Film Festival on September 17. The ban on the film due to ERT's support of Israel had been lifted.

1980 ERT films *The Mirror Crack'd*, an Agatha Christie murder mystery, in England in May. In October, ERT is in talks with theater producers to appear in a New York stage production. ERT receives the Simon Wiesenthal Center for Holocaust Studies first Wiesenthal Humanitarian Laureate in November.

1981 ERT makes her Broadway debut in *The Little Foxes* on May 7 to positive reviews. She performs in New York and on tour in *The Little Foxes* through much of 1981. ERT moves back to California and buys a ranch-style house in Bel Air that she would live in the rest of her life. ERT receives the Damon Runyon/Walter Winchell Humanitarian Award for her charitable giving worldwide on September 3. ERT appears in five episodes of the long-running daytime soap *General Hospital* in November. In December, ERT announces the formation of a theater company with *The Little Foxes* producer Zev Bufman to mount a subscription series of three plays a season on Broadway. ERT announces her separation from John Warner on December 21.

1982 ERT opens in *The Little Foxes* in London on March 11. ERT announces she will appear on stage with Richard Burton in a production of Noël Coward's *Private Lives*. ERT files suit on October 21 to stop ABC from producing a TV docudrama of her life. She loses the case. ERT divorces Warner on November 5. ERT begins dating attorney Victor Gonzalez Luna.

1983 ERT and Burton open on Broadway in the disastrous *Private Lives* on May 8. The Friars Club honors ERT as "Woman of the Year" in a banquet held at the Waldorf-Astoria in New York. Following a family intervention on December 5, ERT is the first celebrity to check into the Betty Ford clinic in Rancho Mirage, California, for alcohol and drug addiction.

1984 ERT breaks off engagement with Victor Luna. Ex-husband Richard Burton dies of a cerebral hemorrhage on August 5 in Celigny, Switzerland. ERT dates business executive Dennis Stein in September.

1985 ERT receives the honorary Cecil B. DeMille Golden Globe Award for "outstanding contributions to the world of entertainment" on January 27. ERT breaks off engagement from Dennis Stein in February. ERT hosts "Commitment to Life," a fundraiser for AIDS Project Los Angeles (APLA) that raises $1.3 million on September 19. ERT co-founds the American Foundation for AIDS Research (amfAR) in September. ERT's friend and former costar Rock Hudson is diagnosed with AIDS. Hudson dies on October 2 in Beverly Hills.

1986 ERT testifies before the US Congress for funding for AIDS care. ERT receives the Film Society of Lincoln Center's Chaplin Award on May 5. The event is attended by nearly 3,000 guests and includes over an hour of film clips. Warm remembrances come from actors Roddy McDowell, Maureen Stapleton, Lillian Gish, Mia Farrow, and from directors Mike Nichols and Joseph L. Mankiewicz, among others.

1987 ERT receives the Legion d'honneur decoration from the French president on May 14. ERT launches her fragrance Passion for Parfums International Ltd. in June. It becomes one of the bestselling fragrances on

the market. ERT testifies before a congressional sub-committee on September 23 for increased funding to combat AIDS/HIV. ERT films *Young Toscanini* in Rome in October.

1988 ERT publishes her memoir/self-help diet book *Elizabeth Takes Off* in January. *Young Toscanini* premieres at the Venice Film Festival. In October, ERT readmits herself to the Betty Ford clinic for addiction to prescription drugs. There she meets construction worker Larry Fortensky.

1989 *America's All-Star Tribute to Elizabeth Taylor* is televised on March 9 on ABC. ERT receives the second annual America's Hope Award, given to an individual who exemplifies the American spirit while honoring her commitment to amfAR, UNICEF, Orphans of War, and the United Way. ERT hosts a birthday party for companion Malcolm Forbes in Tangiers. Rumors of a romance swirl. ERT films *Sweet Bird of Youth*, her fourth Tennessee Williams outing, in July for NBC television.

1990 ERT is critically ill with pneumonia in April.

1991 ERT marries Larry Fortensky on October 6 at Michael Jackson's estate patrolled by a 100-person security force. ERT hosts a dinner in London attended by royalty for AIDS charities on November 4. ERT's White Diamonds perfume is launched. ERT starts The Elizabeth Taylor AIDS Foundation (ETAF), with patient care and education as service priorities.

1992 ERT has a lavish sixtieth birthday at Disneyland, California. White Diamonds wins Women's Fragrance of the Year—Broad Appeal at the FiFi Awards. ERT appears on the November cover of *Vanity Fair* holding a condom in support of AIDS prevention awareness. She voices baby Maggie Simpson on *The Simpsons* in an episode that airs on December 3.

1993 ERT receives the Life Achievement Award from the American Film Institute on March 11. She spends the better part of her acceptance speech giving tribute to "Rock [Hudson], Jimmy [Dean], Monty [Clift], and Richard [Burton], four men who would likely be receiving this award had they lived longer." ERT receives the Jean Hersholt Humanitarian Award by the Academy of Motion Picture Arts and Sciences on March 29 for her support of AIDS research. ERT films *The Flintstones*, her last feature film, in July. On November 9, ERT travels to Mexico to support friend Michael Jackson, who has been charged with child molestation. She accompanies him to London on November 12. NBC announces production of a four-hour miniseries *Liz: An Intimate Biography of Elizabeth Taylor*. Taylor sues to prevent it.

1994 *The Flintstones* is released on May 27 to a huge box office and bad reviews. ERT's mother, Sara Taylor, dies on September 11 in Rancho Mirage, California, age ninety-nine.

1995 New ERT fragrances, including Black Pearls, arrive on the market. The miniseries *Liz: The Elizabeth Taylor Story* premieres on May 21. Based on a book by C. David Heymann, ERT had lost a lawsuit to prevent its production.

1996 ERT is in four CBS sitcoms to promote her new fragrance. She attends Cannes Film Festival for AIDS benefit on May 16 and addresses the General Assembly of the United Nations on AIDS. ERT separates from Larry Fortensky in August. ERT leads the Candlelight March as the AIDS Memorial Quilt returns to the National Mall in Washington, DC on October 12. ERT divorces Fortensky on October 31.

1997 ERT undergoes surgery for a benign brain tumor on February 17.

1998 ERT is presented the Lifetime of Glamour Award on behalf of the Council of Fashion Designers of America in New York on February 8. ERT receives the Screen Actors Guild Life Achievement Award on March 8.

1999 The American Film Institute names Elizabeth Taylor the seventh-greatest female screen star of classic Hollywood. ERT is awarded a British Academy of Film and Television Arts (BAFTA) Fellowship.

2000 ERT is named Dame Commander in the Order of the British Empire by Queen Elizabeth II. ERT is given the Vanguard Award by the Gay and Lesbian Alliance Against Defamation (GLAAD) for promoting gay equality.

2001 President Bill Clinton awards ERT the Presidential Citizens Medal on January 8 for her AIDS activism and fundraising. The TV movie *These Old Broads*, with Taylor, Shirley MacLaine, Debbie Reynolds, and Joan Collins, airs in February. ERT receives France's highest honor, the Commander of Arts and Letters.

2002 ERT's stunning coffee table book *Elizabeth Taylor: My Love Affair with Jewelry* is published by Simon & Schuster. On December 8, ERT receives the Kennedy Center Honors for her film career and commitment to people with AIDS.

2003 ERT announces her retirement from acting in March.

2004 ERT discusses her health problems in the December issue of *W* magazine.

2005 *Variety* names ERT one of the top-100 entertainment icons of the twentieth century. ERT receives the British Academy of Film and Television Arts (BAFTA) Cunard Britannia Award for Artistic Excellence in International Entertainment in Beverly Hills on November 10.

2006 Despite considerable health problems, ERT continues to work on behalf of people with AIDS.

2007	ERT makes her last public acting performance in A. R. Gurney's *Love Letters* at an AIDS benefit at Paramount Studios. On November 13, Andy Warhol's 1963 ERT portrait *Liz* sells at Christie's auction in New York for $23.6 million.
2009	ERT's friend Michael Jackson dies on June 25.
2010	ERT's Violet Eyes fragrance is launched.
2011	ERT is in and out of Cedars-Sinai Hospital with treatment for congestive heart failure. Elizabeth Rosemond Taylor dies of congestive heart failure at 1:28 AM on March 23 in Los Angeles, age seventy-nine, surrounded by her children. She is interred at Forest Lawn Memorial Park in Glendale, California.

She is survived by her brother, four children, ten grandchildren, and four great-grandchildren.

Son Michael Wilding Jr. issued this statement:

> My mother was an extraordinary woman who lived life to the fullest, with great passion, humor, and love. Though her loss is devastating to those of us who held her so close and so dear, we will always be inspired by her enduring contributions to our world. Her remarkable body of work in film, her ongoing success as a businesswoman, and her brave and relentless advocacy in the fight against AIDS/HIV, all make us incredibly proud of what she accomplished. We know, quite simply, that the world is a better place for Mom having lived in it. Her legacy will never fade, her spirit will always be with us, and her love will live forever in our hearts.

2

Films

There's One Born Every Minute (1942, Universal, directed by Harold Young)

Elizabeth Taylor was not a child actor in the way Shirley Temple, Jackie Coogan, or Mickey Rooney were. They were on screen by age six, whereas Taylor didn't have her first bit part until nine. Her earliest years as the privileged daughter of American expats in England were spent blithely unconcerned with a movie camera or any notion of herself as a commodity.

Her first film didn't happen until she and her family settled in Southern California during World War II. Francis Taylor's fine art gallery was advantageously located in the Beverly Hills Hotel. All sorts of movie people ambled past going or coming from deal-making lunches. When the fiancée of Universal Pictures chairman J. Cheever Cowdin dropped in when young Elizabeth happened to be there with her mother, Sara Taylor seized the moment. Soon the Taylors were hosting the engaged couple for afternoon tea. They were ostensibly there to discuss interior decorating and art, but Sara's higher priority was getting her preternaturally lovely daughter into the movies.

Elizabeth gave a decent if not inspired screen test and was assigned a small role in the humble comedy *There's One Born Every Minute*. She played a likeable imp named Gloria Twine. In her first words spoken on screen, she and Carl "Alfalfa" Switzer as her brother Junior Twine announce they're going to sing a campaign song for their politician dad.

Junior: "It's by . . . uh"

Gloria: "By yourself, stupid!"

Two observations emerge from these first moments of Elizabeth Taylor's screen career. One is that she was *acting* from the beginning. She was so well trained that Gloria's impertinence could only happen if she was thinking outside herself. By now, Elizabeth had been strictly taught to be a perfect little lady, curtsy, smile, shake hands, maintain eye contact, and enunciate. The result left her great spirit inhibited but not destroyed. As Elizabeth described herself, she was both hammy and shy. Acting permitted her to break free from shyness by giving her permission to be someone else.

The second observation is that Universal didn't know what to do with her. She worked a total of three days on *There's One Born Every Minute*, her presence barely noted by the surrounding actors, including comedy stalwarts Hugh Herbert and Guy Kibbee. In dropping her contract, casting director Dan Kelly noted she was an old soul with sad eyes who lacked the innocent face of childhood. He was right and wrong at the same time. Taylor herself acknowledged, "There was something inside me that wasn't childlike." But he was wrong and shortsighted to overlook her spirit or to foresee those very qualities translating into a remarkable screen presence.

There's One Born Every Minute is an inconvenient debut. It lives outside a tidy narrative that has a young Elizabeth bound to one studio where she was signed, entrapped, nurtured, pampered, and groomed for major stardom. That would begin at Metro-Goldwyn-Mayer (MGM) with her *second* film. As for her first rejection, she didn't work at Universal again for twenty-six years.

Taylor's debut was disappointing enough to leave her future open. After *There's One Born Every Minute*, she was asked what she dreamed of being someday. "A ballerina . . . a nurse . . . a veterinarian . . . the first female fire engine driver." She could muse on a future of multiple possibilities after her unremarkable film

introduction, but soon such quotes would sound quaint and obsolete as the path to movie stardom became evermore clear.

Lassie Come Home (1943, MGM, directed by Fred M. Wilcox)

Taylor recalled she got the part of sweet and compassionate Priscilla in *Lassie Come Home* almost by accident. Her father was chatting with MGM producer Samuel Marx, who mentioned they needed an English girl on a film already in production. Sara, ambitious stage mother that she was, pursued Marx with the suggestion of casting her daughter. Elizabeth auditioned by pretending a mop was a dog. She impressed onlookers with her sincerity. Marx told the story differently: "Little Elizabeth Taylor walks in and it was like an eclipse," he said. "Everyone else went dark in the light of this little girl. [We] didn't even test her."

Lassie Come Home, more than any film, mirrors the prefame childhood Taylor glorified in memory, growing up on her godfather's estate in Kent. She and her brother Howard explored hundreds of acres and bonded with a menagerie of rabbits, turtles, lambs, and goats. As Priscilla, she's in tailored skirts and jackets, lovingly caretaking her grandfather's kennel in Scotland. Elizabeth was born for the part. Her patrician English accent and deep love of animals are authentic.

Taylor's eighteen-year tenure at MGM begins with *Lassie Come Home*. Starting as a contract player at $100 a week, she was appropriately awe struck at the sprawling movie factory. "It felt like we were the capital of everything," she recalled years later. "The lot was so huge—at that time they were doing maybe thirty films at once and it was teeming with life—people dressed up in Greek clothes, people dressed up as cowboys, people dressed up as apes, and real live movie stars. Of course everybody, even the extras, looked like movie stars to me." Hovering over all was boss Louis B. Mayer,

who Elizabeth soon dreaded. "He looked rather like a gross, thick penguin," she recalled. "He had huge glasses and he had a way of looking at you that made you feel completely squashable."

The stories of star making are filled with "What were they thinking?" moments, and Elizabeth's is no different. The studio initially wanted to dye her hair a lighter color, pluck her eyebrows, change her name to Virginia, and remove a facial mole. Both Sara and Elizabeth refused. Cameraman Len Smith reported a startling anomaly on Elizabeth—a double row of eyelashes. Roddy McDowell, fourteen-year-old star of *Lassie Come Home* and fellow England-to-California war evacuee, knew no tampering was needed with this unpretentious girl. In addressing her, he said, "You were perfect, an exquisite little doll, your features, the coloring, the shape of your face, you were the most perfectly beautiful creature I ever saw and I began laughing because you . . . you were totally unaware."

Lassie, a clever and loyal long-haired she collie, derived from a short story by Yorkshire author Eric Knight, who then published the bestselling novel *Lassie Come Home* in 1940. When MGM bought the rights, no one imagined Lassie would become the most popular canine since Rin Tin Tin. This first Lassie film was fashioned by Mayer and Marx as a B-picture, but a B-picture at MGM resembles an A-picture anywhere else. Filmed in Technicolor, it's abundant with matte paintings, detailed sets, and bucolic vistas that look like storybook drawings come to animated life. Picturesque locales in California doubled for England and Scotland. Lassie (played by a male named Pal) gets most of the screen time, but MGM peopled the film with character heavyweights Nigel Bruce, Donald Crisp, Dame May Whitty, and Elsa Lanchester.

The film is episodic, as Lassie braves both evildoers and the elements in her quest to reunite with her family. As her master, McDowell's emotions were as accessible as Taylor's. The two make a shimmering young pair; their budding off-screen friendship evident in their performances. He had the greater experience in 1942, and there are moments where she hits her mark, but her

concentration wavers when she is without dialogue. Then she walks and stands straight and proud, carrying herself like a well-bred young lady.

Elizabeth was short at ten and could pass for half her age in long shot. But nothing else matters when the camera goes in for her medium shots and close-ups. These are the moments that foreshadow the great star actress. As she enables Lassie's freedom, she bursts with delight at saying, "She's going toward Yorkshire!" It's no surprise in a predictable film, but her investment in the line, as well as her awareness of its importance, opens my heart. She makes Daniele Amfitheatrof's crashing musical accompaniment superfluous. She even commits herself emotively to such dull lines as "Poor Lassie. Poor girl." Already with those simple words she was expressing great and true empathy, which became a hallmark of her acting and lifelong personality. Yet, somehow and already, she was avoiding the cloying over-rehearsed tendencies of most child actors. "I had a great imagination, and I just slid into being an actress," she recalled many years later. "It was a piece of cake. But mostly, when I was first acting, I just liked playing with the dogs and the horses."

Taylor was always modest about her earliest roles, claiming there wasn't much acting going on. Maybe so, but she avoided all self-consciousness when the camera was rolling. And she had a rare confidence that allowed her to live and work in a world contrary to anything akin to a normal childhood. This kid was special. When production executive Dory Schary previewed *Lassie Come Home*, he promptly extended Elizabeth Taylor's contract.

Jane Eyre (1944, Twentieth Century-Fox, directed by Robert Stevenson)

Taylor's path to stardom wasn't straight up. Despite the new contract at MGM, she didn't get any immediate assignments after *Lassie Come Home*. Instead, she was sent to Stage Five at Twentieth

Century-Fox in the summer of 1943 to appear in an uncredited supporting role in a film version of Charlotte Brontë's *Jane Eyre*.

Taylor as Helen appears in an orphanage doubling as a chamber of horrors. Like an angel of mercy, she first appears in long shot, her tiny body descending a dramatically lit staircase to offer the exiled Jane a hunk of bread. Then we see her in close-up, and the effect produces a marked parasympathetic response. That face! She conveys the lifetimes of a wise sage even before speaking lines— ethereal, pure of spirit, kind, and brave. Helen is one of those glowing children of classic American films who seem not of this world. And she wasn't. Helen has a cough, and that's movie short- hand for impending death. She's gone in four scenes. But her spirit with the face of a young goddess hovers over the rest of the film.

The White Cliffs of Dover (1944, MGM, directed by Clarence Brown)

This genteel and proper film, made to the limits of MGM posh in the throes of World War II, is a rampantly sentimental and patri- otic sop. It was a box-office champion, and the right movie at the right time. If heroine Irene Dunne isn't suffering nobly for the cause or speechifying about the glories of America and England, she's competing with "Pomp and Circumstance" or "America (My Country, 'Tis of Thee)" for primacy on the soundtrack. *The White Cliffs of Dover* makes the hit 1942 wartime morale booster *Mrs. Miniver* look downright subversive.

Elizabeth is uncredited as Betsy, a tenant farmer's daughter. She's smitten with young landed gentry Roddy McDowell (*Lassie Come Home*), eyeing him flirtatiously as she swings on a wooden gate. In a plot spanning decades, they fall in love and are later played by Peter Lawford and June Lockhart. Taylor's role is barely more than an audition, but as in *Jane Eyre*, she makes a big impression. She's already demonstrating a complexity rare in child actors, mixing

down home earthiness with ladylike poise and diction. Her impression was so great, in fact, that Taylor would never again live in anonymity. *Dover's* Clarence Brown would soon be directing her to the highest ranks of young stardom.

National Velvet (1944, MGM, directed by Clarence Brown)

Before everything we know to be the tumult and glory of Taylor's life, there was *National Velvet*. This was the last time she acted before the cameras as a little-known person. She and her mother, Sara, were now aligned with the same purpose—to make Elizabeth a star. The degree of success achieved in that effort on *National Velvet* must have shocked them both.

National Velvet began as a 1935 warm-hearted novel by English author Enid Bagnold. Velvet is a Sussex teenager who dreams of entering her horse in the Grand National steeplechase. With the help of a young friend, Velvet and her horse, curiously named The Pie, train and enter the Grand National. But the event is closed to females, so Velvet cross-dresses as a small Russian jockey to gain entry.

Taylor's favorite novel was already *National Velvet*. At the announcement of a film version being produced at MGM, a determination to play Velvet consumed her. She and Sara lobbied producer Pandro S. Berman and director Clarence Brown. Elizabeth was too small, they said. As part of the *National Velvet* legend, she went on an exercise and diet program to gain height and weight. Whether by direct effort or the advancement of puberty, she grew three inches and gained almost ten pounds in a few months.

Once *Velvet* was hers, it seemed to have arrived by divine intent. Taylor became a dedicated and fearless rider, even after an accident left her with permanent back injuries. She trained every day for an hour and a half before reporting to MGM's school for young actors

under contract. The appeal was clear. "Riding a horse gave me a sense of freedom and *abandon*, because I was so controlled by my parents and the studio," she said. "When I was on a horse *we* could do what *we* wanted. Riding a horse was my way of getting away from people telling me what to do and when to do it and how to do it." She was soon attached to King Charles, a volatile thoroughbred selected to play The Pie.

She carried that equine love into production. *National Velvet* gave Taylor her first screen cry, when her horse lies ill with colic. To get in the proper mood, her more experienced young costar Mickey Rooney suggested she think about her father dying and her mother destitute, too poor to buy shoes for her and Howard. "It was like Chekov gone nuts and it was meant to make me start to cry," she recalled. Instead she laughed. Taylor's abilities as an instinctive actress had already outgrown any suggestions from Rooney. When the scene was ready to shoot, "all I thought about was the horse being very sick and that I was the little girl who owned him. And the tears came."

National Velvet was in production on the MGM Culver City backlot over several months in 1944, and Taylor fondly remembered Brown's direction. His manner was leisurely and congenial, contributing to his excellent reputation with children. He realized Taylor's deep affinity for animals translated effortlessly to her performance, and she needed little coaching to prepare for her scenes. With gentle support, he captured her heliotrope eyes and rapturous "Act of God" face in close-up.

National Velvet possesses a rare thing in cinema—an uncomplicatedly loving relationship between mother and daughter. Taylor exceeds the demands of sharing scenes with Anne Revere, a plain-faced actress who nonetheless is perfectly believable as Velvet's mother. When Mrs. Brown gives Velvet money for the Grand National, their love is concentrated in simple words and warm faces. Brown avoids treacle by balancing the two players. Revere, whose Mrs. Brown has a history of risk taking that mirrors

Velvet's, is gracious enough to contain her emotions so that Taylor's can gallop free.

Lurking immediately beneath the surface of this visually rich family entertainment is a startling, even subversive, work of art. Faith is everywhere in this story, as is an unacknowledged God, yet *National Velvet* plants itself firmly in the country dirt of Sussex as rendered on the MGM backlot. The Browns, composed of parents, three daughters, and a son, are superficially warm and loving, if a tad quirky. But Velvet has few restrictions expected of a girl her age. Nothing comes from her father (Donald Crisp), who loves Velvet absolutely but abrogates responsibility. Velvet and her mother have a supernatural bond, and Mrs. Brown is serenely permissive. She's an intriguing mix of the earthly and celestial, uninterested in disrupting Velvet's destiny with anything like caution or alternative thinking. "Everyone should have a chance at a breathtaking piece of folly at least once in his life," says mother to Velvet. "Your dream has come early."

Velvet is free to create a totemic connection to The Pie. When she proclaims him an "enchanted horse with invisible wings" or mimes riding him in bed, she approaches spirit possession. A few moments might have garnered snickers had they not been delivered with the pristine earnestness of twelve-year-old Elizabeth Taylor. Noteworthy, too, is the orthodontic retainer Velvet pops in and out of her mouth. Mother repeatedly implores Velvet to wear it, much as The Pie reluctantly wears his bit. Rising above the consciousness of her beast, Velvet comes to realize that only in discipline and constraint can they achieve their goals.

Velvet upends gender discrimination in entering the Grand National, but she is not an obvious feminist hero. Little is made of shattering glass ceilings and becoming a symbol; she is simply fulfilling a young girl's dream. But that does not lessen Velvet's quiet warrior status. By the end of the film, everyone has yielded to her without challenging her mighty strength. And when her victory is mitigated by disqualification, no tears are shed. Hers is a triumph of following her heart and courage in action.

National Velvet was supposed to be Rooney's movie. He was the headliner and bona fide star at the time of production. He had been a top-ten box-office draw every year since 1938. His character acts as the audience surrogate, with life lesson's filtered through him, but Taylor rode off with the film. She has the tougher assignment. While Rooney makes his character's shady intentions a little too easy to read, Taylor has to juggle innocence and love in every direction. She's the hub of the wheel, sustaining all the film's primary relationships with mother, father, Michael (Rooney), and The Pie.

Taylor took limited credit for her performance, insisting it was an extension of herself. But there are scenes in the film where her modesty rings slightly false. She isn't merely good here. She's aglow every moment she's on, yet never becomes studied or tedious. She embodies the lack of cynicism and irony of the film as helmed by Brown and told by screenwriter Helen Deutsch. *National Velvet* is without judgment or condemnation. Nobody punishes the Browns for letting Velvet risk everything or run off and break the rules by impersonating a male jockey. Everything, even implausibly hands-off parents, are secondary to *National Velvet*'s commitment to youthful empowerment and love of animals.

Something about Taylor's happiness in this movie fills me with unqualified joy. *Her* joy, her innocent obsession, her sorrow, are so complete and clear. "I'm in love with him," says Velvet about The Pie. Who could possibly dispute that or question the wholeheartedness of Taylor's delivery? Her affinity for Velvet isn't derived from her love of horses alone. The role is a worthy vessel for her shining empathy. A case could be made for *National Velvet* as Taylor's best work on screen—or at least her freest of actorly self-awareness.

In addition to being a box-office smash, *National Velvet* scored multiple Oscar nominations. Brown was nominated for his sensitive direction, while it was also cited for Color Cinematography and Art Direction, and it won for Best Editing. Anne Revere, who shared most of her screen time with Taylor, won Best Supporting Actress. Taylor did not get Oscar recognition, but she gained

something more exciting. Her attachment to King Charles was so deep that MGM gave him to her when the film wrapped.

Taylor was ready. With the success of *National Velvet*, she knew how to carry herself with fame, walk into a crowd of gawkers, and give non-answers to invasive questions. Fan mail revealed she was an inspiration to millions of young girls. Sara taught Elizabeth great life lessons. Beauty must originate from within, mother said. Learn to sort the phonies from the loyal and true. Don't be trampled by people who want to use you. And perhaps most important, always distinguish your core identity from images others have of you.

Courage of Lassie (1946, MGM, directed by Fred M. Wilcox)

Courage of Lassie was a step forward and back. This is the first time Taylor received top billing, but she is merely the human with the most screen time. A collie is the star of the show.

Shot in the forests near gorgeous Lake Chelan in Washington State, the film begins with twenty minutes of footage of a fox, beaver, squirrel, porcupine, rabbit, frog, cougar, skunk, bear, owl, and coyote. The action comes at minute twenty-two as Bill the collie is separated from young Kathie, his devoted owner. There aren't any bad guys in *Courage of Lassie*, just bad circumstances. Bill endures one danger after another, from storms and accidents to deprivation and exposure. His great fortitude gets him trained to perform bravely in war. *Courage of Lassie* provides impressive wildlife footage, nail-biting suspense, and a kindly shepherd played by Frank Morgan, who later doubles as Bill's advocate when the dog turns vicious.

Taylor as Kathie exhibits the same transcendent adoration displayed in *Lassie Come Home* and *National Velvet*. She remains the epitome of devotion and love, but the film supporting her this time is weaker. *Courage of Lassie* is a Saturday matinee adventure bereft

of the complex human interrelations that so enriched *National Velvet*. Where the Browns of *Velvet* were conceived, directed, and played with care and precision, here the family is mere window dressing for amazing dog adventures.

Fred M. Wilcox, director of both *Courage of Lassie* and *Lassie Come Home*, found Taylor to be the most cooperative young actor he'd ever encountered. The film is such a blatant cash-in on *Lassie Come Home* and its 1945 sequel *Son of Lassie*, that its very title makes no sense. The canine hero of this film is named Bill. (To further confuse, Bill is also called Duke.)

Courage of Lassie was filmed in 1944, five months after *National Velvet*, but it wouldn't premiere until mid-1946. Taylor meanwhile wrote and illustrated *Nibbles and Me* from an essay assignment at the MGM schoolhouse. Publisher Duell, Sloan and Pearce turned it into a book, becoming Taylor's love story to the chipmunk she found at Lake Chelan and subsequently domesticated. As a marketing tool, it also included production stills from *Blue Sierra*, a working title for *Courage of Lassie*.

Nibbles and Me is a simple accompaniment to Taylor's early films and was received as a charming addition to literature by and for children. The emotional clarity she brought to *Lassie Come Home*, *National Velvet*, and *Courage of Lassie* translates smoothly into print. The effect is compounded with her delicate pencil drawings. There are no profound lessons here, just accounts of Nibbles playing, resting, eating, and snuggling his way into Taylor's heart. She anthropomorphizes the critter until he sounds more like a boyfriend than a chipmunk. And, actually, there were three Nibbles, not one, each with the same name.

Nibbles and Me often reads as the work of any talented thirteen-year-old, but then Taylor will drop a comment about the publicity department, or her *Courage of Lassie* stand-in, or location filming to remind us this author is leading a rarified life. The only intrusion of "reality" is V-J Day, occurring while Taylor (with Nibbles) was in Chicago on a studio junket.

Between the efforts of MGM and "Mummie," Taylor's life was not her own. In the absence of regular schooling and a peer group for Elizabeth, Sara became adviser, best friend, confidante, and business manager. According to Taylor biographer Donald Spoto, Sara guided Elizabeth with "an elaborate series of hand signals. If Elizabeth's voice was too high, Sara put her hand on her stomach. If Elizabeth's reading of a line lacked sufficient feeling, she saw her mother put a hand to her heart. If Elizabeth seemed distracted or was not heeding a director's instruction, Sara touched her head with a forefinger. Directors, cameramen, and producers were at a loss."

In *Courage of Lassie*, we can see how cruel show business can be. Way down at the bottom of the credits, billed as "First Youth," is Carl "Alfalfa" Switzer, Taylor's juvenile partner in pranks from her debut film, *There's One Born Every Minute*. While Alfalfa is descending into oblivion, Taylor is zooming heavenward. *Courage of Lassie* isn't original or creative enough to give Taylor a chance to expand her range, but she distinguishes herself in a formulaic outing. Her imploring of the judge to save Bill's life is fine and resulted in real tears.

For all of Taylor's good-natured kvetching about so many early animal movies, her output was sparse. There was a total of one horse movie and two dog movies. *Courage of Lassie* would be a valedictory of sorts. From now on, she would no longer play support to quadrupedal costars. There would be horses (*Giant*, *Reflections in a Golden Eye*) and dogs (*Boom!*) later, but by then Taylor was the unequivocal star.

Life with Father (1947, Warner Bros., directed by Michael Curtiz)

There are reasons *Life with Father* doesn't get revived. It has a spot in the record books as the longest running play in Broadway

history with 3,224 performances, but it belongs to a bygone era. There are too many points of obsolescence in the Howard Lindsay-Russel Crouse comedy, adapted from an autobiographical novel by Clarence Day. The film is a riot of Technicolor plaid skirts and pink hair ribbons, bustles, pinstripes, and high-starched collars. Even the nostalgia is dated. The travails of a rich 1880s red-headed Upper East Side family, fretting over baptisms and son's upcoming enrollment at Yale, don't amount to much anymore. Though blessed with prestige, a generous budget, and talent galore, *Life with Father* is neither funny nor dramatic enough to be much more than an example of what used to pass for quality family entertainment.

Father Clarence is William Powell; mother Vinnie is Irene Dunne (*The White Cliffs of Dover*). He lords over their brownstone with imperious bluster, complaining about the high cost of living and forever exasperating his wife and kids. The female help is chronically reduced to tears and unemployment. Father is what used to pass for lovably cantankerous, and we're supposed to chuckle when his son mimics him. Today we'd call this abuse and enabling in a dysfunctional family.

On loan to Warner Bros. for the first time, Taylor is third billed as girly-girl Mary, an out-of-town guest who takes an interest in Clarence Junior, played likably enough by Jimmy Lydon. Taylor once again comports herself well. Never for a moment is she intimidated by major stars Powell and Dunne or in scenes with Lydon requiring her to be flirtatious. Her acting always balances theirs, and it gives us something worth watching. She is self-assured by the guiding hand of Michael Curtiz, one of the great directors of classic Hollywood, the man behind *The Adventures of Robin Hood* (1938), *Casablanca* (1942), and *Mildred Pierce* (1945). Her performance is that of a thoughtful young professional, full of poise and studied charm.

If *Life with Father* had a downside, it was in Sara's evermore protective mothering that left her daughter isolated and with a reputation as a nervous hypochondriac. She demanded Elizabeth

be taught by private tutor, not in the studio schoolroom, so as to guard her delicate health. Observers caught on that colds, fevers, and sore throats requiring bed rest were timed to Taylor's menstrual cycle.

Filmed in mid-1946 and released just one month after it closed on Broadway in 1947, *Life with Father* arrived when postwar white America was ready to embrace the myth of an innocent past. *Father* was a sizable hit, though it didn't have much of an effect on Taylor in Hollywood. Her Mary is giggly and quick to smile, dainty and easily impressed with big city fashions and dinner at Delmonico's. Originated by winsome Teresa Wright on stage, Mary is an undemanding role, but Lyndon saw the extraordinary quality that would be better understood and defined in the 1950s. "You can't see it when you're playing a scene with [Elizabeth], but it's there on the screen," he said. "That marvelous technique of hands, eyes, voice, movement. There's an art there."

Warner Bros. was less starry and coddling than MGM, as Taylor soon learned. "Elizabeth was a lovely person, inside and out," said Lyndon:

> We have this cute little scene and she sits on Father's trousers on my lap and I make her get up and everything else and she's heartbroken in the scene. Well, we started to shoot it, "take one," Mike says again, "take two, take three, take four . . ." And it's this triple-stripe Technicolor and these big cameras, and they're very unwieldy. And I can see the bile rising in Mike, you know. "take five, take six, take seven," and Elizabeth isn't getting it, and finally, "take eight." And Mike blows his top. He blows up like crazy and he's hollering at Elizabeth and she starts to cry and she runs off the set. Mike follows her and he's walking up and down in front of Elizabeth's dressing room and all of us can hear him screaming at the top of his lungs, "Elizabeth, damn, don't you cry, you break my heart, you son of a bitch. Don't cry, I'm sorry," and he's screaming at her.

Much like a jockey who's been thrown from a horse, Taylor dried her tears and returned to the set.

Cynthia (1947, MGM, directed by Robert Z. Leonard)

MGM boss Louis B. Mayer bought the screen rights to Vina Delmar's 1945 play *The Rich Full Life*, a dud that closed within a month on Broadway. Its failure didn't concern him. The play embodied Mayer's commitment to clean family entertainment ennobling youth, mothers, and America. Renaming it *Cynthia*, he saw the title character as a showcase for his now fifteen-year-old star of *National Velvet*.

Cynthia Bishop is a fragile girl with one of those unnamed Hollywood conditions that makes her vulnerable to illness. She lives with her overprotective parents in little Napoleon, Ohio, the kind of town where doctors and music teachers make house calls, and everybody knows everybody's business. Deprived of a standard youth and social life, Cynthia must rest and sequester. She's an excellent student with a penchant for Shakespeare, but her spirit is tamped down by so many restrictions. She's a bit of an outcast, and a melancholy surrounds her. She wants nothing more than to idle with friends and go steady with one special boy.

Cynthia is gooey and obvious, with a preordained happy ending. It introduces major dramatic themes of regret and bitterness, only to abandon them in favor of light family comedy. But there is real substance here in a film extolling compassion, self-confidence, and faith. The film reaches its modest peak when Cynthia and her mother (Mary Astor) conspire to get her out of the house to attend the school dance with her dream date. Mother and daughter realize there's a sickness greater than Cynthia's. It's "the sickness of fear" mother exposes in Cynthia's overprotective father. Rather like a hormonal Shirley Temple, Cynthia teaches us how to overcome

life's obstacles through her youthful pluck and honesty. With Taylor alongside an actress as intelligent and resourceful as Astor, this schmaltz-fest comes with a sprig of female solidarity.

Astor found Taylor to be a "well-mannered English girl, with her mother on the set—very unobtrusively. . . . [Elizabeth] was also bright. *Very* bright. Head-of-the-class type of brightness. . . . Elizabeth was cool. . . . There was a look in those violet eyes that was somewhat calculating, as though she knew exactly what she wanted and was quite sure of getting it."

Taylor drew on studio interference in her life to find Cynthia's quiet rebelliousness. She has moments of sarcasm and revels in being the queen of the ball. After her night of enchantment, she bounds down the stairs, crosses the living room set, and exits through the swinging doors to the kitchen as chattering words of joy tumble forth. It's a charming display requiring skilled comedic timing. Cynthia is a "normal" teenager at last, something that could never be said of Elizabeth Taylor.

Cynthia has additional points of interest. Taylor wanted to sing "high—like a bird," and the studio arranged lessons. She tries out for the school musical with a little ditty called "The Melody of Spring." She has a pleasing light soprano, but nothing to justify further musical outings. And it is here, not in *A Date with Judy* (1948) or *A Place in the Sun* as is sometimes reported, that Taylor has her first onscreen kiss. Slender and earnest Jimmy Lydon (*Life with Father*) plants a tender, fleeting, and antiseptic peck on Cynthia's lips. Taylor found the experience terrifying. Both young actors look befuddled in the moment, like they were just following instructions.

The verve Taylor displays in *Cynthia* was no fluke. She was proving to be much more than a worker on Mayer's movie assembly line. He, Taylor, and her mother, Sara, had a meeting in his office soon after *Cynthia* wrapped. He was incensed about something and began screaming at Sara. In a story Taylor often retold, she rose to Sara's defense. She screamed back, "Don't you dare speak to my mother like that! You and your studio can both go to hell!" She

wouldn't apologize, yet she was retained at MGM for years to come. Taylor learned something important that day. She had considerable value and more power than she had realized.

A Date with Judy (1948, MGM, directed by Richard Thorpe)

A Date with Judy was an experiment of sorts. So far Taylor's roles had been spun from sugar—*National Velvet, Life with Father*, and *Cynthia* all capitalized on her twinkly-eyed sweetness. *A Date with Judy* puts her in a prominent supporting role as a young vixen. Sara was displeased at the casting, but Elizabeth was gung-ho for something tart.

A Date with Judy was a teenage musical comedy aimed at square white America; a marshmallow entertainment arriving when going to the local theater was a weekly ritual and movie attendance was at record highs. Noteworthy here is the studio's early sexualizing of Taylor, who was already watchful and calculated in her appearance. "I knew that with lipstick and eye makeup I looked a good eighteen," she recalled. "My evolution from child star to adult star happened overnight. One minute I was kissing a horse and the next I was kissing Bob Stack. And I loved it."

This is a movie about almost nothing. Set in sunny Santa Barbara, perky songbird Jane Powell as Judy Foster is contrasted to dark and sultry Taylor as Carol Pringle. The studio's intentions with Taylor are spelled out early on, as Carol shows her naïve high school chums how to give a song sex appeal, lip-synching an insinuating rendition of "A Most Unusual Day." Carol's precociousness goes further when she pursues Stephen, a soda-jerking med student played by twenty-eight-year-old Robert Stack. Judy is in love with him, but she winds up with Carol's younger brother "Oogie" (Scotty Beckett), who looks to be about twelve. As for Carol, the script plays it safe, pledging her to Stephen once she's legal.

Being a musical, *A Date with Judy* gives Powell's impressive so-
prano five songs. The presence of Xavier Cugat and his orchestra
and "The Brazilian Bombshell" Carmen Miranda all but ensured
Judy would be a moneymaker. Indeed, Miranda supplies more
sparkle than anyone, while cheerfully essaying the film's most chal-
lenging role. By plot requirements, she must show enough ardor for
Wallace Beery, a man with all the sex appeal of road kill, to make an
affair plausible. Then she has to praise his rumba skills absent any
evidence of their existence.

I can't get past a certain creepiness in *A Date with Judy*. Carol is
eroticized while Judy is infantilized. Powell was three years older
than Taylor, yet she's flouncing in a frilly dress bordered with little
pink flowers. Taylor's rouge is so thick it reads in long shots. Both
are man-hungry teenagers, while Carol positions herself as Queen
Bee over Judy. She's more like a domineering mom than a classmate,
telling Judy what to wear, what chores to do, and what songs to sing.
The script explains her as a poor little rich girl with everything but a
loving father. The results are unsettling.

Just as *National Velvet* demonstrated Taylor could carry a movie,
A Date with Judy demonstrates she was capable of looking beyond
adolescence. She's dressed in chic gowns with plenty of décolletage.
This was Taylor's first outing with Helen Rose, a designer who be-
came a trusted friend, who would costume Taylor through her
MGM years. From the beginning of their partnership, Taylor
dressed by Rose had the effect of stopping traffic.

Taylor is already exuding womanliness, even though her life ex-
perience was confining. Still, there's something of Taylor's future
onscreen incubating in *A Date with Judy*. Midway through the film,
Taylor and Powell share a scene. They talk about men, and Taylor
conveys a range of feelings subtly—beguiled, perplexed, accepting,
and resigned. She sounds like a seasoned woman of the world. It's
an extraordinary moment. Taylor is demonstrating an adult know-
ingness far beyond the domain of a fifteen-year-old, particularly
one so publicly displayed and heavily supervised at home and work.

A year later, when George Stevens gave Taylor a challenging role in his drama *A Place in the Sun*, he may well have based his confidence in her on what she does in *A Date with Judy*.

Julia Misbehaves (1948, MGM, directed by Jack Conway)

Julia Misbehaves was supposed to invigorate Greer Garson's career. In the early 1940s, she was MGM reigning Great Lady, playing opposite Walter Pidgeon in a series of prestige dramas. But her brand of noble virtue was growing stale, and postwar audiences were turning away. It was time to lighten the screen image of both her and Pidgeon. *Julia Misbehaves*, based on Margery Sharp's 1937 novel *The Nutmeg Tree* and its stage adaptation *Ladies in Waiting*, was the chosen vehicle.

Garson's Julia treads the boards, gambles, and cheats slow-witted men using flattery and feminine wiles. Taylor plays her daughter Susan, and the role offered no challenges. Long separated from her disreputable mother, Susan is a society girl on the brink of marriage to a stuffy respectable sort, but the artist in residence at her father's mansion is in love with her. This being a frivolous comedy, we know she belongs with the artist. The only uncertainty is how they attach. She fights him off for a time but eventually gives in.

This is not one of Taylor's stronger juvenile performances, though she avoids trying too hard to be funny, which cannot be said of Garson and Pidgeon. Gone is the radiant innocence of *National Velvet*, but her Susan in *Julia Misbehaves* also lacks the poignancy and humor of *Cynthia* or the heat of young desire of *A Date with Judy*. Taylor is rather too calculated here, too self-conscious. Her looks are sharp, her darkened eyebrows arched. Occasionally she warms, particularly in scenes with twenty-four-year-old love interest Peter Lawford. The final effect, however, is a performance of obedient indifference.

Taylor avowed she was never trained as an actress, but by the time of *Julia Misbehaves* she knew the ropes. After the humiliating encounter with Michael Curtiz on *Life with Father*, she now needed just one take in close-ups. Her credible scenes with Lawford were good enough to get her more romantic roles, and the two of them were immediately assigned to the studio's upcoming remake of *Little Women*. Taylor was infatuated with Lawford for a time, and he had the wisdom to see big trouble if they were to tangle off set. She turned sixteen during the production, and her birthday celebration illustrates how far removed she was from anything resembling a normal adolescence. Taylor was gifted a shining blue Cadillac by her parents, then donned a white mink for a night of dancing at the Coconut Grove.

Julia Misbehaves was the last film of prolific contract director Jack Conway, whose credits started in 1912 and include *A Tale of Two Cities* (1935) and *Libeled Lady* (1936) as two of his best. *Julia Misbehaves* turned a modest profit but didn't put Garson back on top. In fact, leading *New York Times* critic Bosley Crowther was embarrassed for her, finding *Julia Misbehaves* crude. But while Garson struggled and failed to regain her status, Taylor was climbing ever higher. Columnist Hedda Hopper saw something in her beyond phosphorescent beauty. Around the time of *Julia Misbehaves*, she wrote, "I will go far enough out on the limb to predict that [Taylor] one day may likely be the Number one lady of the screen."

Little Women (1949, MGM, directed by Mervyn LeRoy)

Louisa May Alcott's 1868 semi-autobiographical novel of the four young March sisters of Massachusetts—Jo, Amy, Meg, and Beth—and their Civil War–era struggles has been a favorite of filmmakers almost since the birth of feature films. There were three adaptations before this MGM glossy affair, the first in 1917, and still more recent

ones on film and TV. There have been two Japanese anime series and a Hindi-language web series. *Little Women*'s evocations of growing up alongside love and sacrifice in many forms—parental, sibling, and romantic—transcend time and culture.

Despite the cache of young talent on the MGM lot, this version doesn't rate high among fans of the book and its multiple film counterparts. By orders of the front office, the script deemphasizes the hungry neighbors, the war, or Beth's illness, instead focusing on budding romances. The costumes, décor, and sets are candy-store busy, fantastical, and eye-catching, with the film winning the Best Color Art Direction Academy Award.

The performances are largely just adequate. Most all the attention goes to Jo, played by June Allyson with spunky overcompensation for being past thirty. Janet Leigh as Meg turns to cardboard, her character poorly delineated, while Margaret O'Brien as sickly Beth diminishes nobly. Allyson and O'Brien were the studio's big draws at the time, and they received top billing. Mary Astor of *Cynthia* bristled at playing another sacrificial mother, yet she fulfilled her assignment capably.

As the selfish, snooty Amy, Taylor pulls off the film's only genuine comic performance. She's prone to malaprops, and they're all the more effective by Amy's belief in her own superior breeding. While fellow students call her a "stuck up thing," she takes excessive pride in expanding her "vocabilary." She delivers a non-sequitur about the picturesque dirt of Europe, oblivious to the nearby snickers and eye rolls. If director Mervyn LeRoy had pushed her just a mite further, she'd be delivering slapstick. Her unladylike enthusiasm for a popover foreshadows Elizabeth the Earth Mother, all passion and appetites, her chewing an exercise in disguised ecstasy. *Little Women* offers an early glimpse at the eating-as-metaphor-for-passionate-living theme that would color many of Taylor's performances to come. "My taste buds get in an uproar, and I get a lusty, sensual thing out of eating," she told an interviewer in 1956.

Taylor is on a precipice here. Sweating under a strawberry blonde wig and layers of period costuming, this is her last gasp of cinematic girlhood. Her Amy is naïve enough to straighten her nose by sticking a clothespin on it but desirable enough to steal a dashing and rich neighbor (Peter Lawford) from Jo. Early on she's the petulant schoolgirl; later she's a shrewd and ambitious player of love and romance. But most of Amy's growing up happens offscreen. Just as *Julia Misbehaves* was a showcase for Greer Garson, *Little Women* belongs to Allyson. The story and screen time tilts heavily in her favor, treating Jo's creative restless temperament sympathetically. Amy, in contrast, pursues men and wealth through a conventional vision of social status. She's the jestering counterbalance to her three more sincere sisters.

In October of 1948, soon after completing *Little Women*, Taylor had a historic photo shoot for *Life* magazine. The cultivation of Taylor's sex appeal was now underway. She appears suddenly in command, understanding the new architecture of her body and its relationship to her wardrobe and the camera. It proved to be training for her next film, where her sexuality would be highlighted beyond *A Date with Judy* or anything else she'd done until then.

The impact of that session was not lost on Taylor. She recalled portraitist Philippe Halsman as "the first person to make me look at myself as a woman. . . . In 1949 I went from portraying Amy in *Little Women*, another child-woman, to playing a full-fledged romantic lead in *Conspirator*. . . . I learned how to look sultry and pose provocatively. I developed sex appeal, even though I knew that, somewhere inside, the child had still not completely grown up."

Conspirator (1949, MGM, directed by Victor Saville)

Conspirator harbors Taylor's first start-to-finish adult performance, with all the attending complex emotions. The role was

no easy chore. Taylor plays Melinda, the newlywed wife to Major Michael Curragh of the British Army. His long absences are explained when she discovers he's a communist spy, reporting back to the Soviets. Once they know she knows, the authorities order Michael to kill her. *Conspirator* thus becomes another spin on the menacing-husband-torments-innocent-bride trend made popular in the 1940s with *Suspicion* (1941), *Gaslight* (1944), *The Stranger* (1946), and *Shadow of a Woman* (1946). But with the Cold War accelerating, *Conspirator* has a red scare twist. Panic at communist infiltration in Hollywood was taking hold, and MGM was eager to burnish its anti-Soviet credentials.

Victor Saville directs a stilted first half, with a lot of comings and goings through doors. It's a strange brew of British reserve and gauche obviousness. The bad guy Russian communists come with thick Dracula-like accents. Michael is initially lit to embody a dashing British officer, but he later shows up in severe dark shadows out of a horror movie. Elsewhere *Conspirator* strains even a generous overlooking of plausibility. Michael's decisions to get married, not tell the Party, and not tell his wife he's a spy are colossally stupid. Shouldn't an operative for the Russians know better? Did he think he'd keep this secret from Melinda when his actions scream, "I'm hiding something!"?

The most glaring compensations in *Conspirator* come from the casting of Robert Taylor (no relation, he was born Spangler Arlington Brugh) opposite Elizabeth. He was thirty-eight. To illustrate the absurdity of older man/younger woman pairings so common in Hollywood, Elizabeth noted, "No one ever suggested that Barbara Stanwyck, Taylor's wife, play opposite Roddy McDowell or any of my other contemporaries." The screenplay by Sally Benson and Gerard Fairlie tries to address the age disparity by painting Melinda as inexperienced and blind in love. And perhaps the studio was in a bit of a panic. When asked her age, Melinda's lips form "seventeen" twice, but "eighteen" is dubbed over. In fact, Taylor was sixteen during production. If youthful innocence didn't

register, then the script writers tried something else. To her girl-friend Joyce, played by Honor Blackman long before *Goldfinger* (1964), Melinda sounds like a middle-aged divorcee nursing a martini when she says, "If you've read as much as I have, you'd know that practically every man in the world has a mother complex."

Taylor loved being in London, where *Conspirator* was filmed. She found the production agreeable, enjoyed her costar, the generous budget, and the camera work of the great cinematographer Freddie Young. But *Conspirator* looks like a product of gross studio exploitation of its young star. The whiplashing of the script spilled into her life. She was still going to school yet lonely in MGM's glass cage. Studio personnel and Sara planned everything, from dates and shopping to interviews and costume fittings. Elizabeth wasn't allowed to be sixteen yet was asked to play a fully mature woman in mortal danger. One minute she received Robert Taylor's passionate kisses, and the next she was being tutored in math and geography. But with encroaching maturity came wisdom on how the system worked, and her place in it. "LB Mayer and MGM created stars out of tinsel, cellophane, and newspapers," she said years later of her studio contract days.

Certain emotions were needed that Taylor was simply too callow to possess. *Life* magazine reported that "she is a bland, not particularly knowledgeable girl who talks in a high voice, has a tendency to squeal when pleased and thinks any number of things are 'just wonderful.'" As Melinda, she makes discoveries that play hollow, as though she was not in full command of or compliant with the expected action. But that is less a criticism than a reminder of her youth. She could articulate a technique of sorts, though her approach to acting was superficial. "Usually it isn't at all hard to get a character," she said at the time. "It's either one thing or another. . . . I don't figure should I do this gesture or should I do that. I know it sounds funny for me to say, but it just seems easy, that's all."

For all the skill yet to be realized, Elizabeth was still a revelation. When I consider what a typical sixteen-year-old high school

sophomore would pull off in a drama class, I am reminded of her astonishing concentration, clarity of purpose, and availability of emotions. Saville saw it. He said, "She's a natural—and it didn't come through dramatic training. There are forty ways to enter a room and say 'Good morning' and Elizabeth will give you the correct one first time."

I love those moments early in Taylor's career when she signals the commanding siren yet to arrive. In *Conspirator*, she initially appears as the ornamental wife but is made of tougher stuff. She gives her husband a great subtle glare of defiance when he tells her to promise secrecy. She doesn't promise. She shows steely willpower when she first discovers he's a spy. She begs him to stop. She insists he quit the Party, even "joking" about his being a communist with his friends. We see here an early version of something Taylor would come back to in increasingly consequential ways over the years: a woman underestimated by her man.

Then she flips. In an unevenly written and played role, Melinda turns into a screaming hysteric when convinced her husband wants to kill her. She is desperate to leave him, not by wits, but by sprinting out the door. She even suggests madness by terror, with tears pouring. The responses are fine in themselves, but overall the effect is discordant. To help Melinda jump off the script pages, she needs less confidence in the beginning and more at the end. Or she ought to exercise her intelligence throughout, not just at opportune moments. Taylor delivers a number of promising scenes, but even then, she was elevating material beneath her.

The Big Hangover (1950, MGM, directed by Norman Krasna)

If *The Big Hangover* isn't Taylor's worst movie, it must be counted as one of her strangest. It's got a plot that lands somewhere between preposterous and nonsensical. David (freckled nice guy

Van Johnson) comes home from the war with an unusual problem. Trapped in the cellar of a French monastery, he nearly drowned in gallons of brandy, and now suffers from a rare disorder known as "liquor recoil." Even the slightest sip renders him a screeching lunatic. He sings, shouts, talks to a floor lamp, and hears a dog talking. (We do, too, thanks to a voice over.)

David's ostensibly funny malady jeopardizes his rise at a fancy law firm, until he meets Mary (Taylor), the boss's daughter. Mary is kindhearted; she takes in strays and misfits and can't resist a worthy cause. As an amateur psychologist, she's determined to cure him. But just as farce looks to be *The Big Hanover*'s métier, David uncovers crooked schemes at the law firm. What will he do now?

Norman Krasna was a respected comedy screenwriter, winning an Oscar for his script of *Princess O'Rourke* (1943). His credentials might have excited anyone to work with him. But Taylor was cast as replacement for June Allyson, never warmed to Mary, and sleepwalked through the film. It's all very awkward and far from Krasna's best. Between a talking dog, a spiked bowl of soup, and a housing discrimination subplot, his script is a cross-purposed mess. At David's law school graduation address, he says valedictorians end up in corporate firms, while the lower end students turn to social justice. A self-serving David then announces he is going to say no to big money and work defending underdogs. Fine, but does he have to call those laboring to make the world a better place academic losers?

With *Conspirator* and *The Big Hangover*, Taylor found her first grown-up roles uninspiring. "Miss Taylor is beautiful and cannot act," sniffed *The New Yorker* in its *Big Hangover* review. "This puts her one up on Mr. Johnson." She contemplated leaving the film business. But just as she was slogging through *The Big Hanover*, *Time* magazine put her on the cover of the August 22, 1949, issue. However mediocre her recent output had been, she was in high demand. Less than four hours after completing *The Big Hangover*, she

and her mother were on the train to Lake Tahoe to film her first scenes in *A Place in the Sun*.

A Place in the Sun (1951, Paramount, directed by George Stevens)

This is where it happened. *A Place in the Sun* is where Elizabeth Taylor transitioned from popular young star to screen immortal.

In the 1930s, George Stevens made his name as a reliable director of musicals, comedies, and costumers, but World War II changed everything. He applied his considerable abilities to documentary footage of D-Day and the concentration camps at Dachau. Following the war, he couldn't imagine returning to light fare.

In looking for material with viscera, Stevens landed on Theodore Dreiser's 1925 novel *An American Tragedy*. The tale of an impoverished drifter who allegedly murders his pregnant working-class girlfriend while falling in love with a beautiful socialite was a grim vision of the long odds that a poor man can someday live the American Dream.

Stevens faced resistance. Paramount had produced a film version in 1931 and owned the rights, but it had failed at the box office. The House Un-American Activities Committee Hollywood blacklist was destroying the careers of hundreds of suspected communists and their sympathizers. Material even vaguely anti-American was suspect, especially if germinating from a political liberal like Stevens.

In adapting *An American Tragedy*, Stevens's concessions were brilliantly realized. He played down any anti-American capitalist stance and played up the central triangle. He signed the poetically beautiful twenty-eight-year-old Montgomery Clift as George Eastman, a penniless man hoping for a toehold in his rich uncle's business. Shelley Winters, heretofore a blonde bombshell in the

movies, was cast against type as Alice Tripp, the drab factory worker George romances to his everlasting regret.

Stevens had always envisioned Taylor as the dream girl Angela Vickers. He pursued her via MGM's production head Dory Schary, intuiting she could handle the challenges of a mature and emotionally demanding role, even at seventeen. Stevens went further in emphasizing the three primary characters, with the screenwriters instructed to make George more sympathetic by making the socialite less haughty and the girlfriend more pathetic. Renamed *A Place in the Sun*, the film's tragic arc shifted from America's class structure to ill-fated love.

Stevens called Taylor and Clift to his office at Paramount. She was petrified. Clift was a serious New York actor, while she had a low regard of her abilities when placed alongside his. Both Clift and Winters had made inroads as film stars, but were accomplished stage actors as well, and lobbied Stevens to be cast. Taylor, in comparison, was a pampered and passive studio girl rarely expected to make a decision for herself. She felt like a trained seal—MGM trained, that is—hit your mark, say your line, glance upward, don't move. Repeat tomorrow.

She found Stevens intimidating. "I was so in awe of him and he was putting Monty just as much ill at ease as I was," she recalled. "We were both scared witless and George was like the puppeteer. He was playing us both off watching and seeing our reactions to each other." But Taylor came around. Stevens's high regard for her may not have been verbalized, but she felt it. According to Taylor, he had pets and he had peeves, and on *A Place in the Sun*, she was his pet.

Principle photography began on October 4, 1949, at Cascade Lake, elevation 6,600 feet, just southwest of Tahoe in the Sierra Nevada Mountains. Angela has invited George to her family's bustling summer home, and the two pull away from the crowd to go for a swim and be alone. Taylor and Clift were barely acquainted, but they combusted instantly. Stevens knew something remarkable

was happening between them, and he ordered endless takes in the frigid water. Meanwhile, the crew brushed snow off the sand and nearby evergreens, while Taylor wanted to kill Stevens. She was unaccustomed to location filming, much less at the risk of hypothermia. Blankets and hot tea were supplied for warming between takes.

Stevens was not merely being sadistic. His retakes came with a purpose, as he was the first to witness Taylor and Clift's phenomenal screen rapport. Clift brooded and conveyed untapped depth like no one else, while Stevens noted that Taylor "had enormous beauty but she wasn't charmed by it. It was there. It was a handicap and she discouraged people being over impressed with it. . . . The only thing was to prod her a bit into realizing her dramatic potential." He sought to capture the undercurrent of humility and humanity behind her shockingly beautiful face. For the film to succeed, Angela cannot be merely gorgeous. She needs to be the ultimate object of idolatry, a goddess of flesh and blood.

Despite shivering through the Cascade Lake sequence, Taylor thrived. She noted the intensity Clift and Winters brought to their scenes. She watched the rushes and took in every word Stevens said as he explained why this take was good and that take was bad. She was mesmerized by Clift's technique and his ability to feel George Eastman so acutely he could sweat and shake on cue. Clift "was a great believer in the psychological gesture," noted his biographer Patricia Bosworth. "It could be expressed in a look—how he stares into Shelley Winters' face before he kills her . . . the sidelong glance of astonishment and desire when he sees Elizabeth Taylor for the first time. . . . In his greatest performances Monty personified, rather than impersonated, character."

Taylor claimed she was left alone by Stevens as he mapped out every scene with a precision she had never encountered at MGM. "I trusted him absolutely and totally," she said. "He gave me the freedom to experiment, which I'd never felt before." He was an insinuating director, not giving precise instructions, rather helping

actors find their scenes. He enabled them to believe they were originating their performances.

Stevens treated the material with exceptional sensitivity. He played Franz Waxman's swooning score to get the actors in the mood. He asked them to go through the motions of their dramatic scenes without dialogue in a sort of emotive pantomime. Taylor was unfamiliar with such exercises, but Stevens was patient, and she was motivated. Eventually this new way of working thrilled and fed her as an artist.

Clift was at least as influential as Stevens. He and Taylor met to study their scenes, with him coaching her and even switching roles so she could watch him be Angela. Taylor then realized she was merely playing dimensions of herself before *A Place in the Sun*. "For the first time in my life, I started to take acting seriously," she said with a kind of fond reverence. "My leading men before had been dogs and horses. This was my first leading man and my first real actor." (The point is taken, but that comment might have stung Mickey Rooney, Robert Taylor, and Van Johnson. It at least signaled Taylor's reach for a greatness she had not found in her previous costars.)

Taylor's screen character began to emerge. Angela is impulsive and assertive if a bit underwritten. (The film spends much more time on the details of George's trial than on Angela's character development.) She is full of youthful energy, but with a mature longing and a huge capacity to love. Nowhere is this more apparent than in the famous balcony scene. Stevens rewrote much of the dialogue and gave it to the actors shortly before filming. Taylor read the revised script and summoned her snooty young lady demeanor. "Forgive me, but what the hell is this?" she asked. She was referring to the following exchange:

George: If I only could tell you how much I love you, if only I could tell you all.
Angela: Tell mama. Tell mama all.

She bristled and resisted, finding the line perverse. But Stevens demanded it, insisting she invest it with the believability that only comes from intense love. They played the scene.

Angela has invited George to a large party, and they are dancing slowly. Their foreheads almost touching, George softly blurts, "I love you." Taylor instinctively wanted to look immediately into Clift's eyes, but Stevens directed her to keep her gaze downward. She's in shimmering black-and-white soft focus and begins to speak haltingly. In a moment of pure cinematic ecstasy, she breaks the spell, looks directly into the camera, and says, "Are they watching us?" She hurriedly moves them both to the balcony, where they can have some degree of privacy, but the relationship has been established. In looking right at us, Angela has implicated the audience as voyeurs. Fair enough, but when two lovers are as rapturously beautiful as Elizabeth Taylor and Montgomery Clift, how could we look away?

Following George's initial declaration, it is Angela who lets forth a torrent of feelings. "I wanted the words to be rushed—staccato," said Stevens. "Monty had to let loose—he was so enormously moved by her. Elizabeth must be compelled to tell him how wonderful and exciting and interesting he is, all in the space of a few seconds . . . it had to be like nothing they had ever said to anyone before."

They're filmed in extreme soft-lit close-ups, effectively consuming the screen and audience consciousness. Only in the assembled finished scene does "Tell mama all" make sense. Angela possesses a nascent maternal quality, something she discovers in herself over the course of the film. She's intrigued by George's mystery, "so deep and far away," but she's equally prone to nurture. He rests his head on her shoulder or lap. She wraps her arms around him and shushes him when he's frightened. The frivolity she expresses early on gives way to protectiveness and a newfound understanding of life's great joy and pain.

Angela is a different young woman from her first scene to her last. She meets George through exquisitely choreographed staging. We see her pass by an open door as she moves through a hallway with girlfriends. A moment later, she appears before George at a pool table just as he plays a tricky shot and sinks a ball in a corner pocket. Sexual illusion so noted. Taylor has perfected the art of moving into a room and owning it. Electricity accompanies her glide. She's wearing an Edith Head designed white lilac party dress so ideal it was copied for senior proms nationwide. With George, Angela is aloof and flirty, confident and entitled. Immediately she is drawn to the deep waters of his psyche. From there she moves from rich party girl to soulful woman with such technique and conviction that her declaration of love on the balcony becomes all but inevitable.

Stevens captured Taylor's maturation as an actress through her infatuation for Clift. Yes, she was acting, but she was also feeling powerful emotions with and for her costar. When Angela hears George may be executed, she calmly excuses herself from the company of her mother and maid, goes to her bedroom, closes the door, walks a few steps, stops, and faints. But this was no generic movie body crumble. In imagining Clift in the electric chair, she doesn't go limp to absorb her landing. She incautiously falls board-like onto a rug, landing on her right arm. I've never seen anyone defy all involuntary self-protection quite like Taylor in that moment.

Angela's devastation is complete in her last scene, when she confirms for us that nothing, not even a murder conviction and death sentence, has altered her feelings for George. It was the last scene Taylor filmed, and she had fallen in love with Clift. She knew the realities of moviemaking, and that she may never see him again. She was inconsolable and played on that as well as emotions swirling in Angela. She'll break your heart. She's equally earnest and frail—as though the truth of her love could shatter her into a million pieces at any moment. Taylor remembered the final scene as the

most difficult. The challenge, she said, was not in finding tears, but in keeping them controlled. Stevens was appropriately bedazzled. "She has been associating with older people a good many years and there was a great maturity about her," he said. She "had all the emotional capabilities, the intelligence. . . . Anything she wanted to do, she could do."

A Place in the Sun was filmed from October 1949 to March 1950, but Stevens edited for well over a year. It finally premiered at the Fine Arts Theatre in Beverly Hills in August of 1951. Taylor had since made *Father of the Bride* and missed the adulation of the fans as she was in London beginning production on *Ivanhoe* (1952). Reviews generally ranged from positive to raves. Stevens was praised for whittling Dreiser's rambling book into a tight film. The negative critique of America isn't entirely gone, but it's secondary. What remains is a supremely well-made piece of romantic filmmaking. When wealth and privilege look like Elizabeth Taylor, Stevens is saying, money *does* buy happiness.

A Place in the Sun had its detractors who found the drama calculated and sterile, but most were enamored. Stevens invests the film with entrancing visual poetry, using dissolves to move George from Alice's world of time clocks and dingy apartments to Angela's world of cut-glass punch bowls and speedboats on the lake. The balcony scene, that perfect blend of music, photography, direction, and acting, continues to leave its mark. "Clift and Taylor were the most beautiful couple in the history of cinema," wrote noted film critic Andrew Sarris. "It was a sensuous experience to watch them respond to each other. Those gigantic close-ups of them kissing was unnerving—sybaritic—like gorging on chocolate sundaes."

A Place in the Sun became a major financial and critical triumph, scoring nine Oscar nominations. Clift and Winters were nominated, with Stevens winning Best Director. It won six Oscars total, including three for key contributors Franz Waxman (Score), Edith Head (Costumes), and William C. Mellor (Cinematography). It was expected to win Best Picture but lost in an upset to MGM's splashy George Gershwin jukebox musical *An American in Paris*.

Taylor was overlooked. The omission was an early clue that her beauty accompanied an undervaluing of her acting. *A Place in the Sun* also confirmed that Taylor not only bypassed any clumsy adolescent phase, but also she had perhaps the most seamless and spectacular transition from child to teen to grown-up movie star ever recorded on film. She rode the choppy waters with grace and ease, at least when the cameras were rolling. "I don't presume to be a great actress," she once said. "I presume to be an effective actress." She's all that and more. At seventeen, we already see the self-awareness combined with acute intelligence and perception, as well as her ability to simultaneously disarm, comfort, and enthrall her costars and audiences.

For all the benefits Taylor eventually gained professionally on *A Place in the Sun*, the film's greatest gift was her lasting friendship with Montgomery Clift. He was a moody and gifted stage actor; she was a well-assembled product of studio era Hollywood. A friendship seemed unlikely, but they balanced each other. He scoffed at premieres, ducked out of interviews, and loathed all the attending nonsense of movie stardom. Taylor, in contrast, had rolled with it since *National Velvet*. She was already playing the game like a seasoned pro and guided Clift on how to pull it off. Gossipmongers and tabloid rags supposed a real-life romance ensued. She wanted to marry Clift but came to realize it wouldn't happen. Clift was gay, so the two were free of the fraught drama of heterosexual romance under the microscope of movie fame. Instead of becoming lovers, they became best friends and remained so to Clift's death in 1966.

Father of the Bride (1950, MGM, directed by Vincente Minnelli)

Few if any films in Taylor's output were made and marketed with such well-timed calculations as *Father of the Bride*. Thanks to MGM's marketing department, the film became the launch pad for the public's ceaseless and sometimes harrowing interest in

her private life. As this film well demonstrates, the studio was not merely manufacturing an actress and movie star. It was also producing a remunerative media asset. (Taylor would later refer to her value to MGM as "chattel.")

Father of the Bride has Taylor in one of her few ingénue roles as suburbanite Kay Banks. Based on a novel that was adapted by a husband and wife writing team, it was strengthened considerably by the directing prowess of Vincente Minnelli and the acting of Spencer Tracy as Stanley, Kay's father. Told through Stanley's eyes, Father covers every stage in the making of a white American family's midcentury middle-class wedding. The film is simple and well crafted, mixing pointed humor with a dusting of tenderness, becoming something of an American cultural touchstone.

As with A Place in the Sun, Father of the Bride was another opportunity for acting lessons by proximity. Tracy and Taylor formed a quick and enduring rapport, calling each other by their screen nicknames "Pops" and "Kitten." They got rowdy and pulled a few tricks on set. In a father-daughter scene, when the camera was on his back facing her, he kept his eyes crossed to test her concentration. "I could have killed him, but I didn't bust up," she said. She marveled at his acting skills. "I learned so much by just watching Spence," she said. "It was his sense of stillness, his ability to use economy of movement, vocal economy. It seemed almost effortless. It seemed as if he wasn't doing anything, and yet he was doing everything. It came so subtly out of his eyes. Every muscle in his face."

Taylor believed the only path to independence from studio and parents was marriage, so she looked for a husband. Now at young adulthood, she was going on studio-arranged publicized dates. She had even been engaged to football player Glenn Davis, but that didn't last. She met Conrad Nicholas Hilton Jr., scion to the Hilton hotel empire, when he pursued an introduction during production of A Place in the Sun. A lavish courtship followed. On February 10, 1950, in the midst of making Father of the Bride, Taylor announced her engagement. Hedda Hopper broke the news that the wedding

was to be held on May 6. MGM scheduled *Father of the Bride* for a June release.

The wedding was bought and produced by MGM with all the trappings of a mega-production. Held at the Church of the Good Shepherd in Beverly Hills, it was thronged with several thousand fans competing with an army of photographers and reporters for a sighting of Taylor and her handsome young fiancé.

As publicity went into hyperdrive, MGM sought to put its brand on the wedding. The church was decorated to look like the one in *Father of the Bride*. Taylor's various screen parents came and were instructed to sit side-by-side in a kind of fantasy-reality mash-up: Donald Crisp and Anne Revere from *National Velvet*, Greer Garson and Walter Pidgeon from *Julia Misbehaves*, and Spencer Tracy and Joan Bennett from *Father of the Bride*. Gowns for the bride, bridesmaids, and mother of the bride were designed by MGM's Helen Rose, who also designed Taylor's wedding night white satin negligee. Edith Head designed Taylor's going away outfit. MGM contractee Mary Jane Smith sang "Ave Maria." Guests included Fred Astaire, June Allyson and Dick Powell, Ginger Rogers, Gene Kelly, Van Johnson, and dozens of other celebrities.

MGM worked overtime to make this wedding a commercial tie-in to the film. The strategy paid spectacularly well. When *Father of the Bride* opened, it was an immediate box-office smash. In addition to the attending matrimonial fuss, it also proved to be a fine entertainment. Taylor's observations of Tracy's acting are spot-on. His absence of grand gestures and emotive speeches is a textbook study in naturalistic acting.

Taylor, vastly less experienced than Tracy, holds her own. She also responds well to Minnelli's energetic direction, but whether that's acting or beauty is hard to distinguish. Minnelli was as entranced by her as Stevens was on *A Place in the Sun*. Taylor delicately tastes a spoonful of vanilla ice cream, and I'm not sure I've ever seen such loveliness on film. I'm not alone in that admiration. Peter Bogdanovich uses the ice cream close-up for a film within a

film in *The Last Picture Show* (1971). She is so ravishing as to be incongruous. She's too plush for such ordinary surroundings. Since when did the girl next door look like Elizabeth Taylor?

Minnelli expertly directs another moment when Stanley rushes upstairs, opens the door, and finds Kay in her bridal dress and Mona Lisa smile against a three-paneled full-length mirror. We're well familiar with Kay by now, but *still* her looks have the power to induce gasps. No wonder millions wanted a piece of her. Here is our MGM princess, our Velvet Brown, all grown up and about to embark on a rite of passage dreamed by many as the onset of life's true purpose.

For all the heavenly visions of Taylor, I find *Father of the Bride* disturbing in ways probably unintended by its makers. If Stanley isn't getting drunk, he's being ritually emasculated. He's badgered, shamed, and cajoled into spending gross amounts of money. He feels poor in the company of the groom's very wealthy parents, oafish with the wedding planners, and cheap with his wife and daughter. It's not named, but Stanley is suffering from extortion and emotional blackmail.

This isn't lost on Minnelli. *Father* appears poised to be an indictment of American materialism and romantic delusions. There's even a nightmare sequence for Stanley that includes a scream from Taylor so full-throated it foreshadows the histrionics of *Suddenly, Last Summer*. Nothing comes of it. Stanley's frugality is vanquished somewhere amidst the frenzied wedding preparations, while his open wallet confirms a father's love.

Kay has no discernable ambition but to be married. She goes from daddy's little girl to husband's little woman. I'd like to think Taylor was not okay with this arrangement, at least subconsciously. There's the slight edge of the siren to Kay, despite the domestication of Taylor's screen persona. She gives Kay an ardor for fiancé Buckley, and her lust is barely contained. When she announces the wedding is off due to a lover's spat, she plays it straight. We know it's trivial when she's outraged when he said, "Nothing as romantic

as a fishing shack in Nova Scotia." She's not forcing the line on us, leaving us to laugh knowingly.

Perhaps what most disturbs me about *Father of the Bride* was its possible effect on a manipulated and sheltered Taylor. The differences between this gentle domestic comedy and the MGM-produced marriage to Hilton are frightening. Taylor bought into the marriage complex as displayed so thoroughly in *Father of the Bride*, and it repeatedly brought her deep misery. Due to years of studio exploitation, as well as the manufacturing of fantasy, Taylor never had reason to doubt "happily ever after."

Father of the Bride makes me grumpy, but it's possible to ignore my misgivings and enjoy it as a well-made perennial light entertainment. Remakes in 1991 and 2022 with updated sex roles prove there's lasting appeal. Certainly American-style weddings are easy targets for comedy. But I'd be more admiring if it dared to put so much celebratory consumerism on notice.

Quo Vadis (1951, MGM, directed by Mervyn LeRoy)

The story of Taylor in *Quo Vadis* is part history, part legend. In 1949, MGM fashioned a remake of the tale of Imperial Rome, with Taylor to star opposite Gregory Peck, and John Huston directing. But the project was delayed, then shelved. When *Quo Vadis* was rejuvenated, Deborah Kerr and Robert Taylor were cast in the leads. Mervyn LeRoy, the man who coaxed such a delightful performance from Taylor in *Little Women*, was now directing.

Meanwhile, Taylor's recent marriage to Hilton turned catastrophic. Traveling from Paris to Berlin to Rome in the summer of 1950, Hilton drank and gambled, and he was increasingly violent toward Taylor. Despairing, she contacted LeRoy, who was filming *Quo Vadis* at the Cinecitta studio in Rome. Could she be sheltered within the Technicolor colossus for a few days? LeRoy said yes

and cast her as an extra. She played a Christian slave, released into the Roman circus to a pack of hungry lions. Finding Taylor in the crowd is a feat I'm not sure anyone has yet accomplished.

Father's Little Dividend (1951, MGM, directed by Vincente Minnelli)

To capitalize on *Father of the Bride*, MGM slapped together the follow-up *Father's Little Dividend* in a few weeks with the same major personnel: director Minnelli, stars Spencer Tracy, Joan Bennett, and Taylor, and screenwriters Albert Hackett and Frances Goodrich. In this one, Kay (Taylor) and Buckley (Don Taylor, no relation) buy a house and have a baby. The film ignores the medical and physical comic possibilities in impending motherhood and instead focuses on the myriad ways family members drive each other insane. At the center of the action is Stanley Banks (Tracy), that lovable crank now unhinged by impending grandparenthood.

Father's Little Dividend can't be discussed fairly without reference to Taylor's off-camera life. Her *Father of the Bride* marriage tie-in to Nicky Hilton was disastrous, even life threatening. He was reportedly neglectful, drunk, and abusive, beating her until she miscarried their child. *Father's Little Dividend* was filmed in October, and divorce was granted in January, so Taylor was under tremendous physical and emotional stress during production. She lost twenty pounds, was chain-smoking, and had high blood pressure, colitis, and an ulcer. Not surprisingly, and despite her professionalism, she often comes off as nervous and jumpy in *Father's Little Dividend*. When everyone talks about names for the unborn, Kay slowly unravels. She bursts forth with a "Butt out!" message to her parents and in-laws, and it must have played on her experience of constant studio interference in her life.

The trauma she was enduring may have limited her range. Taylor either wouldn't or couldn't be funny, while *nobody* appears happy

to be making *Father's Little Dividend*. Minnelli's indifferent direction and the ensuing performances curdle quickly. Bennett as Kay's mother Ellie is particularly bad, shallow, and controlling. When Stanley can't stop the kid from squalling, Ellie all but accuses him of child abuse. Maybe she was on to something. Stanley leaves his infant grandson unattended in a city park *for nearly 30 minutes*. Lo and behold, the kid goes missing, and the ensuing panic was unworthy of a bad sitcom. Both *Father of the Bride* and *Father's Little Dividend* are lessons in the delicacy of domestic comedy, and how badly it can age in a changing society.

Father's Little Dividend, inexplicable winner of the Best Written Comedy award from the Screen Writers Guild, offers minor points of interest to Taylor fans. It was the only sequel she ever made, and the first time she played a mother. She has a wonderful scene with Tracy, as Kay contemplates motherhood with chatty anticipation. Tracy gives her the scene in a lovingly paternal way, their mutual affection in plain view.

Father's Little Dividend did well at the box office and spawned a 1995 remake. But not so well that an unenthused cast, director, and screenwriters could be compelled to return for a third outing, *Father's Big Breakdown*.

Love Is Better Than Ever (1952, MGM, directed by Stanley Donen)

Love Is Better Than Ever has a plot and characters ill-suited to a film marketed as "Sparkling Romantic Comedy!" Taylor plays against type as a small-town working girl, rather than her customary rich girl looking to steal somebody's boyfriend. She's Anastacia Macaboy, a sheltered New Haven children's dance teacher. She lives with her parents in a cozy bungalow packed with actual pictures of Elizabeth Taylor as a child. When she attends the Dancing Instructors Convention of America in New York, she learns a new

routine for "Itsy Bitsy Spider" that's no more challenging than the "Hokey-Pokey." She also meets a brash talent agent named Jud Parker, who persuades her to ditch the convention and spend a week with him sipping coffee, going to baseball games, and falling in love.

Soon Anastacia wants to quit dancing, get married, and have his babies—until he dumps her. Hometown gossips label her a hussy, so to save honor and livelihood, she fakes an engagement to the manipulative and egotistical Jud. The end goal, abetted by her parents, is to hook him, gross character failings and all. A plot with this much deceit and bad behavior requires a zany script and snappy direction lest the comedy turns rancid. It has neither. Part of my dyspepsia for the ironically titled *Love Is Better Than Ever* comes from MGM's treatment of Taylor. The film was wholly unworthy of an actress who turned in those performances in *A Place in the Sun* and *Father of the Bride*. This looks like punishment, but for what?

Now was not a happy time for Taylor, and she does little to pump joy into the film. Larry Parks as Jud makes allusions to violence, which must have unsettled her as she was coming off her marriage to Nicky Hilton. She was either couch surfing with friends or living with her mother, who was too possessive to suit Taylor. Despairing and despondent, Taylor had a brief affair with the film's director, Stanley Donen. He was in the midst of a fantastic winning streak of musicals with *On the Town* (1949), *Royal Wedding* (1951), and *Singin' in the Rain* (1952), but you'd never know it looking at the charm-deficient *Love Is Better Than Ever*. Parks was preoccupied with his own troubles, as the McCarthy anti-red hearings were about to destroy his career. He made only two more films. No wonder both he and Taylor are more convincing in their angry scenes than their romantic ones.

Love Is Better Than Ever was filmed in late 1950 and into early 1951 but wasn't released until February of 1952 due to Parks's blacklisting. Reviews were predictably tepid, while Taylor was referenced more as a creamy dessert than an actress. Of her

performance, Bosley Crowther of *The New York Times* noted she "is a very shapely lady, in case you didn't know, and her dark, round madonna beauty is almost too luscious to be true." He didn't comment on her effort to infuse this film with some real feeling. It is a screwball comedy from the 1930s minus the very elements that made them special: timing, double-edged dialogue, and star chemistry. What a dispiriting moment this must have been, as hopes of a serious career faltered. Taylor later said *A Place in the Sun* gave her hope, but that was soon dashed among a string of mediocrities.

Callaway Went Thataway (1951, MGM, directed by Norman Panama and Melvin Frank)

Callaway Went Thataway is a second chance show business redemption comedy Western. Howard Keel plays a singing cowboy idolized by millions, but off camera he's a mean drunk. There's plenty of room for self-improvement. The succession of star cameos as themselves, including Clark Gable and Esther Williams, offers some modest pleasure. Taylor shows up at the popular Sunset Strip night spot Mocambo as herself, looking every inch Hollywood's next generation Glamour Queen. She is uncredited and not mentioned by name, ostensibly because her fame made that unnecessary.

Ivanhoe (1952, MGM, directed by Richard Thorpe)

No doubt MGM thought it was doing Taylor a favor after the dreary little *Love Is Better Than Ever* by next casting her as the sad Jewess Rebecca in *Ivanhoe*. This is a big movie, with impressive budget, box office, and an eye-popping production. It even squeaked out a

Best Picture Oscar nomination. It's grand scale, but it leaves a small footprint in Taylor's career.

This was Taylor's only Saturday matinee swashbuckling historical romance-adventure film of the Robin Hood sort. It looks a bit silly and satire-worn today. *Ivanhoe* is all medieval kitsch, with ravenous plunderers swilling wine and chewing on drumsticks. Drawbridges, flying arrows, caparisoned horses, stone fortresses, moats, and chained-link uniforms dominate. *Ivanhoe* looks like prime inspiration for *Monty Python and the Holy Grail* (1975). Remove the horses and we're left with the Knights of Ni.

Ivanhoe is not without historic interest. It is buttressed by two Christian cultures, the Normans and Saxons, with the nomadic tribal Jews a third variable in the interpersonal dramas of twelfth-century fact and fiction. Anti-Semitic tropes, that Jews are mercenary and threatening to the moral order, while excelling at witchcraft and sorcery, are in service to the story rather than sincere beliefs among the filmmakers.

Director Richard Thorpe mishandles Taylor, suppressing her until Rebecca becomes only decorative. He probably went in this direction to make sense of the ultimate coupling of the Christians Ivanhoe (Robert Taylor of *Conspirator*) and Rowena (Joan Fontaine) and to avoid the sticky plot point of marriage outside the faith. In any case, we're not allowed to forget who's who. In a moment of supreme otherness, Rowena asks the placid Rebecca if a Jewish woman experiences jealousy. Rebecca explains she was taught to leave her feelings unexpressed as a kind of survival technique against religious intolerance. Ivanhoe couples with Rowena, while Rebecca slinks off camera, a loser in love.

Taylor worked with three directors three times each. Two of them, George Stevens and Vincente Minnelli, are famous. One, *Ivanhoe*'s Richard Thorpe, is not. Fontaine said he cared more about the performance of the horses than the actors. Taylor didn't openly criticize Thorpe, but she called *Ivanhoe* "a piece of cachou." Her acting is shackled by limited expectations. She doesn't appear until

nearly thirty minutes into the film. Much of her performance is understated reaction shots, mannequin-like, all expressive eyes with perfectly glossed lips slightly parted.

Taylor spends considerable time posing—every floor-length dress highlights her tiny waist and large breasts. She's other-worldly, the stuff of adolescent fantasies, but oh so empty. Thorpe's direction appears to have been, "stand in the light and look beautiful." He didn't try, and she didn't care—with predictable results.

The Girl Who Had Everything (1953, MGM, directed by Richard Thorpe)

The courtroom drama-romance *A Free Soul* was a big hit for MGM in 1931. It has a fine elevator pitch: spoiled rich girl falls for a criminal defendant who is represented in court by her father. The studio decided to mount a remake and cast the roles originally filled by Norma Shearer, Clark Gable, and Lionel Barrymore with Taylor, Fernando Lamas, and William Powell (*Life with Father*). The studio still owned the rights and produced it for a paltry $665,000.

A Free Soul is quite racy, with Shearer braless and coming onto Gable with all the allure available to her. The final courtroom scene is so heated lawyer Barrymore makes his case and drops dead. The original was somewhat important culturally in its treatment of an emancipated American woman following her sexual longings. *The Girl Who Had Everything,* in contrast, is a sixty-nine-minute snooze. The Pre-Code freedoms of 1931 gave way to the censorships of the 1950s.

This was Taylor's third and final effort with director Richard Thorpe. His indifference, on evidence in *A Date with Judy* and *Ivanhoe,* reaches a peak here. He directs the entire cast in line readings instead of performances. His insipid work is full of phony fight scenes and walk-walk-walk-wait-for-him-to-grab-your-arm-before-turning type business. The esteemed Helen Rose designed

costumes for Taylor, who appears advantageously in a succession of sexy ensembles. (Filming was rushed to stay ahead of a pregnancy.) Variously in swimwear or formal gowns, she comes off as a runway model objectified by Thorpe's leering camera.

Despite the limitations around her, Taylor makes something of her character Jean Latimer. It's fun to watch her test run the bad girl attitude that would fully bloom with *BUtterfield 8* in 1960. Here she is predatory from the moment she hits the screen. Her face at seeing criminal stud Vic (Lamas) on the TV news conveys everything. Suddenly fiancé Vance (Gig Young) seems quite dull. For much of the film, Jean pursues Vic for sport and adventure in a bid for self-determination. "I shall make my own mistakes," she announces to her father. To prove it, she romances a man declared to be "a depraved and moral parasite."

Like *Ivanhoe*, this one's about who's right and who's wrong in Taylor's romantic pairings. Jean wants the dangerous Vic, but defiance, not love, is her motivation. Her focused intent is gleeful. When she sees Vic is bidding for a horse against Vance, she gives us a smile of luscious satisfaction. But Jean can't sustain this affair. Once she is confronted with Vic's sinister dealings, her resolve collapses, leaving nothing but regret and the desire to put the whole fetid episode to bed. The movie goes soft, with Jean running back to the safe and sane Vance.

Taylor is the single merit of the film. A rumpled Powell was nearing retirement and phones in his performance. A wooden Lamas is worse. *The Girl Who Had Everything* needs noir lighting and some barbarism and primal longings in the Jean–Vic relationship. It needs the kind of kink directors Nicholas Ray or Sam Fuller could have supplied. As is, nothing rings true except Jean's pursuit of the wrong man.

Elephant Walk (1954, Paramount, directed by William Dieterle)

In the 1950s, the big screen and the small screen were far less integrated than they would become, and television was a serious threat

to theatrical films. To lure audiences back to theaters, filmmakers increasingly used exotic locales to give folks what they couldn't get at home. *King Solomon's Mines* (1950), *The African Queen* (1951), and *Mogambo* (1953) are of this ilk. So, too, is *Elephant Walk*.

Elephant Walk was a novel bought for distribution by United Artists as a vehicle for Douglas Fairbanks Jr. and Deborah Kerr. Set among the tea plantations of Ceylon, bad weather caused delays, and the property languished. It was then bought by Paramount for Laurence Olivier and Vivien Leigh. But Olivier backed out, leaving Leigh to star opposite Peter Finch. Leigh's emotional and physical instability caused her to withdraw. Though Taylor was nearly twenty years younger than Leigh, they were of similar coloring and stature, and long shots of Leigh filmed on location were used in the final film. A contract was drawn and signed, and Taylor was put on loan to Paramount for a hefty $150,000. Taylor adored Paramount's costume designer Edith Head, and their affection born on the set of *A Place in the Sun* was solidified on *Elephant Walk*. Taylor called her a surrogate mother. "Whenever I was in trouble, whenever I wanted a place to hide out and avoid socializing, I would go to Edith Head's house," she said. "It was a haven where I could get away from everyone and work out my problems on my own."

Head's contributions make sense only through the nonsense of Hollywood. In *Elephant Walk*, Taylor shows up in a new gown every few minutes. There must have been trunks full of original Edith Heads arriving by steamer at Colombo, then caravanned through the jungles to arrive at Elephant Walk bungalow in time for Taylor to make her selection before afternoon tea on the veranda. Through much of *Elephant Walk*, Taylor is a ludicrous vision of old school Hollywood glamour. Fantasy gowns challenge a restricted Taylor to make any contribution to the film as a dramatic presence.

Elephant Walk borrows too obviously from Alfred Hitchcock's 1940 classic *Rebecca*. In both there's a hasty marriage, with a timid bride who must adapt to her husband's strange home. Taylor as Ruth walks into a mystery, with the ghost of husband John's father hanging over the Elephant Walk much as the spirit of Rebecca hangs over Manderlay. Appuhamy, principal caretaker and servant,

is the Mrs. Danvers of *Rebecca* counterpart. He's mysterious and brooding, with a strange fixation on the late lord of the bungalow. And, finally, as in *Rebecca*, there's insanity, disaster, and fire to cleanse the troubled star couple so they may begin anew. *Elephant Walk* veers from *Rebecca* in its love triangle, with Dana Andrews as the plantation manager who desires Ruth. She grows stronger and more discontent as she realizes John (Finch) is neglectful, contemptuous, and psychologically damaged. In contrast, she's bored, lonely, and ripe for an affair.

Ruth is rather colorless to begin but grows with curiosity for Appuhamy (Abraham Sofaer) and the cult of dead Father Tom buried in the yard. When cholera strikes, and she pitches in to do the laundry, she's in a sweaty blouse and disorganized hair. Now she's at her most radiant. She's stripped of baubles and rouge, and her skin is shiny with sweat. She's even more startling in reduced makeup. When John accuses her of interfering, her temperature rises as she gives him the subtlest of expression changes with a minutely raised left eye. In that single moment Taylor reveals that her skills as a screen actress, as well as her knowledge of what the camera registers, are expanding.

Elephant Walk is somewhat redeemed by its production. Isolated shots of Ceylon are gorgeous and approach the pictorial beauty of Jean Renoir's *The River* (1951). Franz Waxman (*A Place in the Sun*) supplies another fine score. But *Elephant Walk* isn't as high minded as either of those films. Instead, it excels in a loopy pile-up of disasters. Just as the cholera epidemic abates and the huts are torched, the pachyderms stage a march, busting through walls, smashing furniture, and overturning tanks of kerosene. This provides a rarity in motion pictures—Elizabeth Taylor as a damsel in distress. Due to a delay in her survival response (what takes her so long to attempt an escape?), Ruth gets trapped in the fire. John rescues her, and they climb down a tree to safety. It takes a cholera outbreak, devastating fire, marauding herd of angry elephants, and straying wife to teach John that maybe the spirit of his dead father has had too much control over him.

This one went on Taylor's list of regrets. When a reporter asked her about *Elephant Walk* in 1976, she said, "*Forget* it!" then jokingly pointed him to the door. Rather like *Ivanhoe*, *Elephant Walk* works if expectations are low for character development, authenticity, or dramatic integrity. But undemanding popcorn entertainment? Sure, *Elephant Walk* supplies that.

Rhapsody (1954, MGM, directed by Charles Vidor)

The Euro-flavored *Rhapsody* is a typically well-polished MGM production, overdecorated and overdressed, with a plot too thin to support the high investment. Macho ladies' man Paul Bronte (dark and foxy Vittorio Gassman) is a gifted and dedicated violinist. If rich girlfriend Louise (Taylor) is to keep him, she must accept being, ah, second fiddle. To give the film triangular complications, Louise is pursued by the adoring James (handsome blonde John Ericson), a lesser musician who rents the attic of her posh Zurich flat.

As Paul mistreats Louise, Taylor begins to exhibit some of the angry fire that would color the performances at her career zenith in the late 1950s. She's been making small but undeniable steps in that direction since *The Girl Who Had Everything*. In *Rhapsody*, the sensualist is yearning to break free and express herself.

The source novel by Henry Handel Richardson concentrated on Paul and James. By studio directive, the screenplay was adapted to make Louise the center of attention without giving her character any vivacity. As a gorgeous accessory, Taylor is given the unenviable chore of prolonged reaction shots of the music her boyfriends are making.

Rhapsody is flat and safe. It plods when it should smolder and explode. The soundtrack is saturated with the music of Romantics Liszt, Rachmaninov, and Tchaikovsky, yet the characters and their drama remain small and uninvolving. Helen Rose fashions Taylor

in a succession of formal suits, chic but stiff. Wouldn't Louise put on flats, sun hat, loose skirt, and a casual blouse to stroll Zurich once in a while? Taylor the clotheshorse was satisfied, but Taylor the actress was idling. "All I did was just sort of whistle and hum my way through those films," she said, "powdering my nose and getting a great kick out of wearing pretty clothes—dying to wear more makeup, higher heels, lower-cut dresses."

Louise barely exists outside the cages built for her by men. She wants to be needed, but Paul only wants a part-time groupie who will wash his socks and feed his ego. It's hard to watch the rhapsodically beautiful Louise being sidelined and humiliated, skulking off with a hurt look on her face. It reminds me a bit of Rebecca as the loser in love in *Ivanhoe*. In a few years, emboldened by Second Wave Feminism, men so disfavored by Taylor's characters will receive a riding crop or a well-deployed stiletto heel.

Rather like *The Girl Who Had Everything*, we spend much of *Rhapsody* waiting for Taylor to choose the man who will love her evermore, rather than the man who would destroy her. She supplies the film its best moments near the end, when James is triumphant in concert performance. Her face in extreme close-up registers attention, then hope, a vague smile, more hope, and finally rapture at his success as she bounds to her feet to join the chorus of "Bravo!" This visual metaphor for sex consummates her relationship to James. He, we suppose, becomes a great artist *and* a faithful husband. Louise's fulfillment comes only in landing the right man. And that's how retro sexual politics are perpetuated in 1950s American moviemaking.

Beau Brummell (1954, MGM, directed by Curtis Bernhardt)

The parade of mediocrities was beginning to strain Taylor. "The films I did [at this time] have sort of blanked out in my mind,

because they were so distasteful to me," she said later. "A lot of them I haven't seen, but I must have been appalling in them." She didn't see *Beau Brummell* until the 1960s, when it showed up on TV. She changed the channel after five minutes. "I was so embarrassing in it."

As told in the film, fashion stylist George Bryan "Beau" Brummell (1778–1840) was an impudent and vain ladies' man. He came from low rank but distinguished himself in the court of King George III through sass talk. Played with controlled bravado by Stewart Granger, Brummell had the guts to say what others wouldn't. This endears him to the Prince of Wales, played by the reliably flavorful Peter Ustinov. Brummell and the Prince form the film's primary relationship, a kind of on again off again regency bromance. Decorous object of desire Lady Patricia (Taylor) is peripheral. The Prince gets a scene at Brummell's deathbed, but she doesn't.

Historical people figure in the film, including Lord Byron, Maria Anne Fitzherbert, William Pitt, and Sir Geoffrey Baker. Patricia is an amalgamation of women in Brummell's life. That renders the film less interesting, at least for Taylor fans hoping to see her play someone plucked from history. Worse still, she's betrothed to the dull but wealthy and high-ranking Lord Mercer (James Donald), also fictitious.

Taylor is again mishandled and underserved at the hands of an MGM director. She's squeezed into a powdered platinum wig and unflattering stiff gowns. (Fortunately, the blonde wig disappears during the film, never to return.) She was reportedly displeased with Curtis Bernhardt's long-winded instructions, openly yawning at him. He asks nothing more of her than to stand about and provide glances alternating between seduction and worry. She was becoming the Ming vase of MGM—too exquisite for anything but distant admiration. She has but one moment of pique, when Patricia thwacks an aggressive Brummell with her riding crop. Even that is subdued, and far less potent than the same gesture aimed at Marlon Brando thirteen years later in *Reflection in a Golden Eye*.

Beau Brummell was filmed in England, but Taylor's childhood accent was obliterated precisely when it could be employed. And Patricia's admission of love to Brummell is one of the worst scenes Taylor ever played. Her lines sound read from a script rather than felt in her heart. She's breathy and unpersuasive. I felt relieved for her when the scene ended.

Beau Brummell opened to high fanfare, even meriting a Royal Command Film Performance in London before the newly crowned Queen Elizabeth II. The film's depiction of a mad King George didn't go over well, and it became a rare money loser for Taylor. It's colorful, and much of its big budget appears on the screen, but it's set bound, and it lacks the adventure and derring-do of *Ivanhoe*. Its elementary history lesson is loose and misleading at best. No surprise, then, that a desultory Taylor was temperamental on the set. Conditions had brought her to a place of rare self-pity. "What's the use of being a good actress?" she said to Richard Brooks, the director of her next film. "People pay no attention to it anyway. They just say, as usual, Elizabeth Taylor looks beautiful."

The Last Time I Saw Paris (1954, MGM, directed by Richard Brooks)

Finally, a film with promise. MGM announced plans to adapt F. Scott Fitzgerald's short story "Babylon Revisited." The melancholy tale of Charlie, an American expat in 1920s Paris, has two meaty roles for women. Marion's "fresh American loveliness" is complicated by an "expression of unalterable distrust." Donna Reed is Marion and delivers all the ice that role demands. Helen (Taylor) is present as a ghost in the story, and in long flashbacks in the film, reflecting on a past evermore dusty and sorrowful. "Babylon Revisited" is steeped in loss, the residue of one terrible night, and the longing for a time of deluded happiness.

The studio committed a series of unforced errors in adapting "Babylon Revisited." The title was changed for at least two reasons. The 1940 Jerome Kern-Oscar Hammerstein II song "The Last Time I Saw Paris" had a wistful sound in keeping with the story and can be heard with numbing repetition throughout the film. And reportedly MGM was concerned that "Babylon Revisited" would be mistaken for an ancient history epic. If so, this proves there is no bottom to the studio's ability to underestimate the intelligence of its audience.

Van Johnson (*The Big Hangover*) is Charlie, an alcoholic writer who grows more despondent and self-pitying with each publisher's rejection letter. As Fitzgerald's alter ego, Johnson doesn't have the chops to convey the shame, insecurities, creative torment, and longing for Helen that the tough role requires. He bellows when he should hum and purr. It may be predictable to say so, but Montgomery Clift would have been an ideal Charlie.

"Babylon Revisited" is short, so director-screenwriter Richard Brooks expanded a literary work for the screen. He invented James, Helen's father, played jauntily by Walter Pidgeon (*Julia Misbehaves*). Meanwhile, Helen and Charlie get married, have a daughter, take lovers, and grow evermore drunk and miserable. Their bacchanalian excesses are largely screenwriter inventions, and the film dares to probe the growing abusive strain in their marriage.

Other changes veer more dramatically from Fitzgerald. At the insistence of studio head Dory Schary, the story was sentimentalized and updated to post–World War II with a tacked-on pseudo-happy ending. Brooks complained but was overruled. We get languid scenes of Johnson and Taylor saddled with dull talking points as they wander the MGM backlot amidst leftover sets from *An American in Paris*. They even recycle that film's black and white costume party.

For all the shortcomings of *The Last Time I Saw Paris*, it does offer Taylor her most demanding and rewarding role since Angela Vickers in *A Place in the Sun*. Helen has an undisguised love of

wealth. She's sybaritic and desperate for fun and flirtation. If that isn't obvious, she says so with, "I want to live like every day is the last." She steals her sister's beau but eventually transitions into a respectable wife and mother. Helen comes at us in bits and pieces. We're not sure what drives her; the script explores only so far. She is a dim shadow of Fitzgerald's wife, novelist and mental patient Zelda, after MGM sanitized her for general audiences. But Taylor doesn't suggest mental instability as much as an impetuous spirit, with Helen rather more vapid by way of a softened caricature.

Taylor enjoyed making this one, liked Johnson and Brooks, but she wasn't yet fully challenged. While calling *Paris* "a rather curiously not-so-good picture," she added, "[My character] was off-beat with mercurial flashes of instability—more than just glib dialogue." She is engaged and lively on screen. This was several degrees higher than *Rhapsody* and *The Girl Who Had Everything*, but *The Last Time I Saw Paris* lands short of excellent. When Helen wanders through a winter scene, her blood red gown in shocking contrast to the fallen snow, the film's aspirations crash. This should be a great romantic movie moment of the Max Ophüls or Ingmar Bergman kind. The heroine's tragic fate is set by love, rejection, the confines of society, and her own mad impulses. But it doesn't happen. *The Last Time I Saw Paris* tries to be something else. Fitzgerald's unsentimental story and Jazz Age ambiance are sacrificed for MGM's post–World War II Technicolor gloss, with nothing gained in the transition.

Giant (1956, Warner Bros., directed by George Stevens)

How many ways do I love *Giant*!?

With *A Place in the Sun* and *Giant* five years later, George Stevens ushered in two eras of Elizabeth Taylor the movie star. Her stature ascended with both. But my gratitude goes beyond *Giant*'s fortuitous location in Taylor's career. Her Leslie Benedict is a stand-alone

creation. She never played a character more socially and morally engaged, more quietly authoritative or warmly maternal.

Giant is a four-generation family saga of modern Texas. While much of the grand 1950s movies were intellectually reductive (*This Is Cinerama* [1952], *Around the World in 80 Days* [1956]), committed to spectacle for its own sake, *Giant* takes an expansive canvas and fills it with visuals that give meaning to the story. It's the most thematically rich film Taylor ever made, and its cultural relevance hasn't faded one iota all these years later.

With *Giant*, Stevens translated another massive novel to the screen, but one with less literary prestige than *An American Tragedy*. Edna Ferber's long 1952 bestseller was ripe for an ambitious filmmaker—and an ambitious actress. Leslie, the mid-Atlantic bride who marries cattle rancher Bick Benedict and moves to their sprawling Texas ranch, dominates the novel. She ages from young newlywed to grandmother. She observes the family empire transform from cattle to oil, while children grow to defy parents and follow their own dreams. She's also an uncommonly well-defined character. Before production, screenwriter Ivan Moffat wrote a seven-page profile on Leslie's background, personality, and growth over the years of the film.

Taylor was not the preordained chosen one for *Giant* as she was for *A Place in the Sun*. This was a wholly different enterprise. Where *Sun* was intimate, *Giant* was epic. Oil. Greed. Sex. Sexism. Cattle. Patriarchy. Consumerism. Property rights. Racial and ethnic discrimination. Family. Immigration. Miscegenation. Taylor had yet to demonstrate she could carry a film this rich.

Stevens considered Audrey Hepburn or Grace Kelly for Leslie. Both had greater critical respect and stature than Taylor at the time. But they dropped out, and Taylor went after the role rather like she went after Velvet Brown. She had seen her career languish, stuck at MGM while losing good roles at other studios. She was short listed for *Roman Holiday* (1953) and *The Barefoot Contessa* (1954), losing both. She wasn't going to let that happen this time. After

Taylor's coaxing, MGM agreed to loan her to Warner Bros., *Giant's* producing studio.

Stevens's affection and respect for Taylor as an actress, and her *potential* as an actress, won out. "We gave her a very difficult part; she is the pivot of the whole picture, and she plays five different ages," said Stevens. He also acknowledged the challenge Taylor confronted due to her looks. "Beauty of her kind is hard to overcome in characterization. We put a real burden on her shoulders."

The first scenes on location were filmed over four days in the spring of 1955 and had Leslie and Bick (Rock Hudson) meeting at her home in Ardmore, Maryland. Shot at the Belmont Plantation of Albemarle County, Virginia, the two fall in love, and very soon Leslie is whisked off to Reata, Bick's enormous West Texas cattle ranch.

Following the Virginia shoot, the *Giant* company moved to tiny Marfa on the eastern edge of the Chihuahuan Desert. The company shot under the charring sun for forty-four days. I like actress Mercedes McCambridge's description of the locale best: "The ugliest landscape on the face of the earth. Sheer nothing! No hills, no water, no trees, no grass, just vast acres of creepy-crawlies and dive-bombing bugs and biddy towns thousands of miles apart."

Warner Bros. took every available hotel room in Marfa, with main headquarters at the Hotel Paisano. Taylor and Hudson lived in private homes. Isolation brought the company together for dinner, guitar playing, and drinking. Taylor's favorite place to eat was the Old Borunda Café, serving terrific Mexican food. She and Hudson, who grew to be close friends, got drunk on chocolate martinis made with vodka, Hershey's syrup, and Kahlua. When third star James Dean as loner Jett Rink arrived, relations grew more complex. He and Hudson didn't like each other, while Taylor befriended them both. She and Dean would stay up until three swapping life stories they both took to their graves.

Lording over the grand production was George Stevens, nicknamed "The Great White Father" by Taylor. As well displayed

in his recent film *Shane* (1953), Stevens loved the West and its vast spaces. And, unlike many film sets, he kept this one wide open. Bit players were gathered from the local population, while hundreds stood behind barricades to watch *Giant* take shape. Stevens wanted the residents to be involved and invested in the film. His approach could simultaneously promote goodwill and provide him an ethnographic knowledge of local culture.

Taylor was the only cast member who had worked with Stevens before, and she found *Giant* significantly different from *A Place in the Sun*. Though she didn't complain at the time, she later declared the shoot one of her most grueling. Workdays were often twelve hours long. She was ill with bladder and blood infections and fatigued from the recent birth of Christopher, her second son with Michael Wilding. Gone was Stevens's guiding paternalism now that Taylor was a twice-married adult with two kids and several years more experience. He often didn't state what he wanted from his actors, instead calling for take after take. One onlooker saw him demand thirty different shots of Taylor getting off the train at Benedict Station, each one looking fine and usable. "George shoots extensive footage on the smallest or largest scenes—reels and reels and reels of film that he cuts down to maybe two angles," said Taylor. "He's a brilliant editor. But he protects himself so thoroughly that you tend to become slightly cross-eyed, really satiated, by the time you've finished the scene."

Stevens was displeased with Taylor's and Hudson's playing of an early scene where Leslie challenges Bick on history: "We really stole Texas from Mexico, didn't we, Mr. Benedict?" He had the actors play different roles or had dialogue coach Bob Hinkle feed them lines. When he demanded multiple readings, Taylor finally blurted out, "Damn it, George, what the fuck do you want me to do? I don't understand what you're trying to do here." Still, he explained nothing, but instructed the actors to return to the set and film the scene. Stevens had slyly instilled the precise states he wanted in his actors for the scene, including annoyance.

John Rosenfield of *Southwest Review* was a journalist on the set and made a number of observations. Taylor needed the most direction, and Stevens fed her lines before each take. He would give her specific emotions he sought—wistful, surprised, angry, distressed, happy, and so forth. Stevens wasn't concerned about Taylor's conceptual understanding of Leslie; rather, he focused on her emotional presence with each take. He followed the script closely, but he didn't make Taylor say freshly written lines she didn't want to say. He backed off as he witnessed her growing awareness and affinity for the character.

Rosenfield found Taylor to be a "shrinking violet" but "genial, modest, and unassuming if you take the lead." She talked mostly about clothes and family. But Taylor certainly was no *guaranteed* shrinking violet. When Leslie and Bick's marriage is in trouble and she leaves to visit her family in Maryland, Stevens wanted her in a dumpy outfit to make her appear pitiful and depressed. Taylor thought the idea was ludicrous, that even if Leslie was miserable, she would present herself well. Taylor confronted Stevens about his choice, and he bellowed to cast and crew that she only cared about her looks. That incited her to wipe off her makeup, twist her hair, pull it back, and fasten it with a rubber band. She then presented herself for the scene, and it was shot. Said Hudson: "George was a tyrant and she could be a termagant. Whenever they clashed, I stood well back."

Early in production, Dean was reportedly an insecure jerk, keeping cast and crew second-guessing his moods and intentions. As a self-important alumnus of New York's mythic Actors Studio, he resented appearing with the pretty movie studio inventions of Hudson and Taylor. He became rude and sullen and dedicated to stealing the film. Stevens found him exasperating, and everyone was annoyed at him for flubbing lines, mumbling, and ignoring his marks.

Conditions on the set could have grown intolerable without Taylor as peacekeeper. She was navigating two leading men with

contrasting screen images. Hudson was quiet, withholding, and in pursuit of stardom via hard work and a chiseled face and body. Dean was wiry and spontaneous, with a simian way of moving. Looking closer, she found him endearingly shy and vulnerable. "I was very connected to both Rock and Jimmy, but they had no personal connection at all," she recalled decades later. "I was in the middle, and it just would be like a matter of shifting my weight. I'd bounce from one to the other with total ease."

In a 1982 interview, Taylor sat down with Stevens's son, director George Stevens Jr, and told stories of the *Giant* set. Because there was usual business, adjusting lights and props and what not, Taylor slipped into her trailer and took a nap. She later woke to a dark and quiet set. Standing by were about seventy-five extras and various costumers and cameramen. All just standing.

"What's going on?" she asked.

Stevens fixed his piercing eyes on her and said, "Who the hell do you think you are? You are no better than any of those other people who have been standing up there for an hour and half waiting for you."

She was duly shocked, expecting one of the assistant directors to rap their knuckles on her trailer door when she was needed. "What? Nobody called me. I was sound asleep. I didn't know."

She started to cry. Then wardrobe and makeup swooped in and assembled her for the camera. They were ready to roll, and she did a scene with Hudson.

"I was a quivering mass of jelly," she recalled, with tears flowing. Stevens never apologized, and she never knew if he set her up for the humiliation.

"Was it genuine or in his Machiavellian way was he trying to get some deep emotion out of me for the scene?"

The fight at Sarge's Diner, a key scene at the end of the film, was shot from September 23 to 28 on the Warner lot in Burbank. Dean had completed his role and left the production. There were a few more pick-up shots and miscellaneous scenes to cover when

Dean slammed his Porsche 550 Spyder into another car outside of Cholame, California, at the junction of two state highways. An ambulance took him to a hospital, where he was pronounced dead on arrival. Taylor sobbed uncontrollably at the news, but Stevens kept her working. Finally she collapsed and was hospitalized. The attending doctor concluded her condition came from Dean's shocking death and the demands Stevens made on her.

Taylor returned to work on October 4, then relapsed and was out for a week. When she returned, the final scene was filmed in which she expressed loving pride in her husband for standing up to Sarge. The last shot with the two babies and the Christian iconographic calf and lamb was filmed on October 12. With 114 shooting days, 875,000 feet of film, and one star dead at twenty-four, *Giant* was in the can.

Stevens edited and prepared *Giant* for a year, not premiering it until October 10, 1956, at the Roxy Theatre in New York. Warner Bros. conducted a huge marketing campaign promising a BIG motion picture experience. The Roxy was bedlam that night, with Taylor getting her hair yanked and losing one of her earrings in the crush of fans. Audiences and critics were strongly impressed, turning *Giant* into a popular and critical triumph. It earned the highest ticket sales in Warner Bros. history to date and notched a place on *Variety*'s list of top-ten all-time film rentals.

Over the years, *Giant* has achieved something altogether extraordinary. It's become much more than an immensely popular film of its time. The huge gothic ranch house of Reata perched in the middle of lunar Texas has become, if not quite Tara in *Gone with the Wind* (1939), an indelible image of cinematic fantasy architecture. But *Giant* has further merits stemming from a master director in full command. Wonderful details of West Texas culture appear throughout, with the rituals of barbeque and cattle ranching alongside strict protocols of gender and race.

Stevens's sure hand is well evidenced. His background in comedy inoculates *Giant* from the lugubriousness that can afflict long

dramas. He crosscuts liberally as two stories unfold, one of the land, one of Reata. But the second half of *Giant*, as the Benedict's world transforms from frontier to industry, is predominately interiors. That connection to the land is lost, diminishing some raw pleasure in the film, and I believe Stevens *wants* us to feel reduced.

The latter part of the film, as Stevens introduces us to the children and grandchildren of Leslie and Bick, loses the sharp focus of earlier scenes. Stevens becomes more interested in themes than characters, but by then Leslie, Bick, and Jett are well established. Old age makeup on Taylor, Hudson, and Dean is unconvincing, but Stevens has them subtly change how they walk, stand, and fold their arms to convey the lowered center of gravity, rounded posture, and creaky joints that come with age. While Stevens loses a bit of his directorial inspiration, the great pulsing subjects of *Giant*, of race, class, gender, and multiple forms of heroism, are all realized. The Benedicts effectively symbolize the transformation of America in the twentieth century.

Reata is a vision of imperial splendor improbably plopped in the middle of a featureless landscape. The interior is done up in leather, with damask walls and wood paneling completing a stern and oppressive environment. Over time, Reata becomes bright and cheery, and a place for the new generation to gather and confront stodgy father and big-hearted mother. It's the décor oil can buy, but only with Leslie's influence. The maternal yearnings Taylor introduced in *A Place in the Sun* fully bloom in *Giant*. She is forthright, with an unwavering sensitivity to justice and dignity. She had embraced a false romantic myth of Texas in her youth but would not be consumed by it. She points out what ought to be common decency but isn't: that Mexicans be treated with respect, while a sick brown child deserves all the medical care given a sick white one. She defends her young son against a machismo imposed by his father. She's impetuous but loyal, sensible and confrontational, but not argumentative. She's the outsider who must adapt or be swallowed up by loneliness, homesickness, and despair.

Leslie radiates the warmth of motherhood, marriage, hospitality, and big meals around the family dining table. If pushed, she stands up to women, men, and the entire Texas patriarchy. One memorable scene has her hovering over the menfolk as they light their cigars and talk politics, refusing to slink off with the wives to talk recipes and childcare. Taylor finds a new voice in *Giant*. She takes it down as she fixes her eyes on the men and says derisively, "I'll join the harem section." The poise and control she learned at MGM are present, but the compliant studio-bred star is gone. That scene "came very naturally to me. I didn't need much direction in that," she said with a smile.

In another scene, Leslie schools her husband on the need for proper medical services for the poor Mexican families that work Reata. She ignores his racism, instead tending to the immediate business of care. Taylor had gained stunning control of line deliveries. "I don't think you understand . . ." Leslie says to her husband with such clear purpose. Her back is to the camera, while her voice is resolute but not condescending. Mealy-mouthed politicians would be well advised to study Leslie Benedict for lessons in delivering history and populism directly and effectively.

I love Taylor's scenes with Dean for what they reveal of Leslie. She knows Jett is smitten with her, but she lets him down gently with a reminding mention of her husband. She plays no games, exercises no overt power, and delivers no insults. Yet she still manages to set him right without sacrificing one molecule of her femininity. Her performance is filled with such fine grace notes. When Leslie learns son Jordy has married a Hispanic woman (Elsa Cárdenas), she is momentarily stunned, then smiles radiantly, then embraces her new daughter-in-law. Leslie is anticipating Bick's reaction and stays true to her character at the same time.

Taylor expertly balances Leslie's inherent goodness with personal foibles. She's overly solicitous on arrival, eager to squash the stereotype of the racist Southerner and embody the beneficent rich white lady of Reata. She makes a classic mistake of parenting in believing she knows what's best for her daughter. But she can laugh at herself.

After an argument with Bick, she sits up in bed and coos to him, "You knew what a frightful girl I was when you married me." Such moments boost the idea of Leslie as temperamentally close to the real Elizabeth.

Giant made a major impact on popular culture—and still does. It's a sturdy piece of moviemaking that doesn't demonize, idolize, or sentimentalize the Anglo-American experience. At Oscar time, it was tapped for ten nominations, including Best Picture, Director, Actor (Hudson and Dean), Supporting Actress (McCambridge), and Adapted Screenplay. Stevens was the film's sole winner, while Taylor was again passed over for a nomination. The Academy still wasn't ready to acknowledge the power of her screen presence was coming from stellar acting, not mere beauty.

The Oscars would have to wait, but *Giant* had a fantastic effect on Taylor's career nonetheless. There would be no mediocrities on her schedule—at least not for the near future. A selection of top directors and coveted properties would be the norm. *Giant* proved she had the ability to carry a film, even becoming the mouthpiece of a mighty director. Noted Stevens biographer Marilyn Ann Moss: "Given her powerful position *within* the story she is, in fact, a displacement for the director's creativity and his voice, powerful enough not only to change culture, as Leslie does, but also to *make* culture, as Stevens does with each of his postwar films." Leslie is even more than that. She is the greatest cinematic counterpart to Taylor the compassionate human being. In Leslie, Taylor found the fictitious predecessor and role model to the humanitarian she would become in the last chapter of her life.

Raintree County (1957, MGM, directed by Edward Dmytryk)

Raintree County had a literary origin, as did so many of Taylor's films. The massive 1948 book by Ross Lockridge Jr. was a generally

praised bestseller, and MGM quickly bought the rights. But the story of a Northern officer John ("Johnny") Shawnessy before, during, and after the Civil War, as well as his love for an unstable and conniving New Orleans belle, proved difficult to translate into a screenplay. Several writers labored for years. Something finally emerged by *Bad Day at Black Rock* (1955) screenwriter Millard Kaufman, and *Raintree County* moved down the studio assembly line and into production.

Like *A Place in the Sun, Ivanhoe, Rhapsody,* and *Elephant Walk, Raintree County* centers on a triangle, this one featuring Taylor, Montgomery Clift, and Eva Marie Saint. Neither Taylor nor Clift was enthused by the script, but they were thrilled to be working together again. Taylor was set on making something of it and her performance. She happily anticipated playing madness and was ready to chew some scenery, trusting this juicy role would enlarge her self-confidence.

Since *A Place in the Sun*, Taylor and Clift's friendship had grown deep and complicated. In Monty she saw someone at least as tormented as she, but in different ways. He was tightly coiled, introverted, and insecure, with escalating drug and alcohol addictions. Watching himself on screen was agony, and at the time of *Raintree County*, he hadn't made a film in three years. Taylor's steadying hand and loyal friendship made a huge difference.

Plans for *Raintree County* expanded, with Taylor's home studio at last ready to invest in a big budget film for her. MGM President Dory Schary dedicated a whopping $5 million to the production and declared *Raintree County* the studio's next *Gone with the Wind.*

Schary overplayed the comparison. Scarlett O'Hara is selfish and spoiled, but she has qualities of strength and resiliency to admire. *Raintree*'s Susanna, in contrast, has less appeal and fascination. She's a woman haunted by childhood trauma who's going insane by the notion of being part black. But Johnny, not Susanna, is the central character of the tale. By the end of the film, loyalties are

mixed among him, Susanna, and Nell (Saint), the woman vying for Johnny.

Production began on April 2, 1956, on the MGM Culver City lot. Despite Susanna's troublesome profile, Taylor quickly grew at ease. Her dialect coach instructed her to generally punctuate the first syllable and turn "ing" into "in.' " Taylor caught on fast. A southern accent simply agreed with her, and she would employ one or another when called for from *Raintree County* onward.

Director Edward Dmytryk found Taylor a total professional—cooperative and emotionally strong. He liked her enormously, though he made the unforced error of calling her Liz, a nickname she hated. "Liz was a hard worker, late for social engagements but rarely late on the set," he said. "She was . . . a remarkably caring person: Everyone's problems are her own. Within her range, she is one of the best actresses around. . . . On the set she was quite untemperamental—almost phlegmatic at times—but she does have fire and can achieve a fine anger at some stupidity, though I've never seen this anger directed at a coworker on the set. She also has great inner strength."

Taylor was also exercising increased acting skill. She delivers a monologue that reveals Susanna's twisted childhood. It totals several pages of dialogue, and she commands it admirably. Taylor was thriving. She and Clift fell into the common language and laughing flash points of deep friendship. Writer John Bowers claimed Monty "talked a lot about Elizabeth Taylor. He says that she can instantly catch a mood. Nothing has to be explained."

While Taylor's career ascended, her marriage to Michael Wilding was unraveling from boredom and prolonged separation. And Clift was drinking heavily, with a thermos of vodka and orange juice nearby on the set. Rightly or wrongly, Taylor kept quiet and remained supportive. And then the accident happened. After leaving a dinner party at the Wildings on May 12, Clift smashed into a telephone pole, suffering lacerations, heavy bleeding, broken nose, whiplash, crushed jaw, and cerebral concussion. Alerted to

the accident, Taylor went to be with Clift. There she cradled his bloody head and waited for the ambulance, pulling a tooth out of his throat. She offers gruesome and exacting descriptions of the scene in her memoirs. Over the weeks of his recovery, she visited almost every day.

With about half of *Raintree County* in the can, the production was shut down and assessed. Taylor wanted Clift to finish the picture in large part because *he* wanted to finish it, and she was concerned for his mental health should he be dropped. He had to contend with a face transformed. His left side was nearly immobile, his nose and mouth crooked, and upper lip scarred. His eyes were now glassy from painkillers. But ultimately, Taylor writes, his face "all restored itself and he is still a beautiful man. He is beautiful inside. I think his looks are even more poignant now because they are not so perfect."

Clift returned to *Raintree County* on July 23 with location filming in Natchez, Mississippi, where a key scene at a ruined old plantation would be filmed. Conditions could hardly have been less accommodating to Clift's physical and emotional fragility. Local folks by the hundreds assembled behind ropes just outside camera range. Clift and Taylor couldn't find privacy, as the hoards followed them to restaurants and hotels. When the production moved to Danville, Kentucky, Taylor, Clift, and Saint were mobbed by cheering fans, a squadron of reporters, and a high school band playing "My Old Kentucky Home." Clift was in horrendous pain and medicated with pills and alcohol. Taylor was suffering, too. The summer was hot and humid, and she was stifling in multiple layers of fabric and tight corsets. She endured hyperventilation, heat exhaustion, and tachycardia. She was given chloral hydrates for sleeping.

When the company returned to LA in October for the final two weeks of shooting, it seemed a lifetime had gone by. *Raintree County* hardly resembled the production that began with vague optimism back in April. Most lamentable, at least for Taylor, was Clift's reduced state. The beautiful young man she loved was now

drug addicted and rickety. He had been better than anyone at pushing Taylor's emotions to fill the screen, and now hers were surpassing his.

Raintree County opened in October of 1957 with its many problems on clear display. The script ambles and rambles about a mystical raintree, while failing to accumulate dramatic traction. It has Susanna and Johnny falling in love in less than ten minutes. The lighting is bad, and the battle scenes are dull, even with a clamoring score. And there was serious miscommunication. *Raintree County* was filmed in a new sixty-five-millimeter process called Camera 65 developed at MGM, but a lack of coordination with exhibitors left the film projected in standard widescreen.

Raintree County is lumpy. Key moments happen off camera and are merely described, blunting their power. Characters are inconsistent and denied complete form by a half-baked script. We don't see Susanna's lead-up to her lie about being pregnant, while Nell is a lovely wan thing until jealousy turns her demonic.

Clift as Johnny is hard to watch, more for his performance than his altered looks. A macabre pastime of sorts grew around distinguishing his pre- and post-accident scenes. Thanks to careful camera angling, it's not easy. But his presence is lacking. When Clift was sick with pain, high, and unable to deliver, Dmytryk instructed Taylor to give it her all. The result is a film revolving around Johnny but dominated by Susanna.

Dmytryk had to find excitement somewhere in his movie, and he realized Taylor was his brightest hope. He didn't rein her in, and she's certainly the extravagant movie star here. Symbolically, she's the wretched South contaminating the North with its flagrant racism. A southern accent sets her free to flirt, flash those darting eyes, and scheme with more fire than we've seen from her before.

As Taylor's marriage was floundering, she was being wooed by impresario Mike Todd. The excitement of that romance is concomitant with her ignition on screen. *Raintree County* is the beginning of Taylor's high-passion phase. She often doesn't work for

me when she's in full emotional upheaval mode, as she is several times here. There is an all out delivery that is too gaudy to be anything but attention grabbing. Susanna trembles at the thought of having one drop of Negro blood in her. She keeps a collection of creepy dolls. She gets ugly when Johnny expects her to free her slaves, accusing him of never loving her. The excesses of Susanna are well reflected in Taylor's fine willingness to be eccentric and unlikable.

My problem with Susanna is that she doesn't add up to anyone lucid. Unlike Angela Vickers or Leslie Benedict, she's never fully human. She is by turns flirt, shrieking racist, beneficent mother, vagina dentata, and finally martyr for her husband. She grows in her lunacy, and we see that progression. But by the time she's committed, she's merely discontent in solitary, while the other inmates are packed into a crowded cell, heads shaved, and acting full-on babbling crazy. Even in an insane asylum, Taylor gets the star treatment.

This is not to say she doesn't have her moments in *Raintree County*. She has many of them, actually. There is a tremendous close-up at the top of the stairs, peeking around a pillar, her eyes mesmerizing as she resolves her sacrifice. And in her last scene, saying goodbye to her son, she is sweet and loving, believably drawing on maternal feelings to bring home the aching climax of the story.

Raintree County earned Academy recognition with Taylor's first Best Actress nomination. Her performances in *A Place in the Sun* and *Giant* were more understated and consistent, but voters could not deny the histrionics on display. The Academy has always been less inclined to reward subtlety. That year the Best Actress winner was Joanne Woodward in the dissociative identity disorder saga *The Three Faces of Eve*. Her performance was even showier than Taylor's. But at least Taylor had something to hold on to. She had transitioned from a capable actress to one of singular power and authority, and the industry took notice.

Cat on a Hot Tin Roof (1958, MGM, directed by Richard Brooks)

When Taylor reported to the set of *Cat on a Hot Tin Roof* in February of 1958, she was a happy Mrs. Mike Todd. They were married in Acapulco just one year prior. And after the grueling location work of *Giant* and *Raintree County*, *Cat* would be a lark, shot on the controlled sound stages of MGM.

Cat had been a hit at the Morosco Theatre on Broadway in 1955, winning the Pulitzer Prize and running for nearly 700 performances. Tennessee Williams infused it with the kind of crackling dialogue and psychological intensity that make for spellbinding theater. Ex-football star Brick and his wife Maggie arrive at his family's Mississippi Delta mansion with other kinfolk to celebrate the birthday of patriarch "Big Daddy." What ensues is vintage Williams, with fantastically well-drawn characters devouring each other. They oscillate between truth and lies, strip away hypocrisy, artifice, and self-defenses, leaving egos shattered and wretched lives exposed.

Maggie confesses to an affair with Brick's best friend Skipper, who has committed suicide before act one. Brick drinks to oblivion and refuses sex with Maggie, while Big Daddy accuses him of denying his homosexual love for Skipper. In a rage, Brick reveals Big Daddy is dying of cancer. Worried that Big Daddy will disinherit Brick, Maggie lies that she is pregnant. She then throws away Brick's liquor, and says, "We can make that lie come true" as the play ends with hope for the survival of Maggie and Brick's marriage.

A long tradition of censorship and acquiescence to religious groups left Hollywood a stodgier place than Broadway in the 1950s. MGM bought the rights to *Cat*, then faced the stark challenge of tamping down its references to "sexual perversion." The word "homosexual" could not be spoken on film, but the play makes Brick and Skipper's love more than clear. They're a pair of jocks in the closet. Brick's internalized homophobia is spelled out in scenes with

Big Daddy. They utter "queer," "sodomy," and "sissies" in quick time. Studio producer Pandro S. Berman (*National Velvet*) suggested rewrites that shift the dysfunctional love story from Brick and Skipper to Brick and Big Daddy. Now Brick and Skipper only *seem* to be *potential* lovers. Brick's real problem is a father who denies him affection.

Brick was distorted and misshapen on his way to the screen, while Maggie suffered fewer revisions. She remained a woman of passion and determination who loved her husband and is perhaps Williams's least neurotic heroine. Her pleadings for marital sex are cauterizing, and if played well, they make peeping Toms of us all. Maggie is a plum role, and perfect for Taylor's maturing talents. She received a whopping $500,000 for *Cat*, and the promise of good friend Helen Rose as wardrobe designer. Paul Newman was cast as Brick. Not yet a mainstay of films, he was shuttling between Hollywood and Broadway.

There was friction on the set early on. Newman studied method acting from the Actors Studio which put him light years away from Taylor's apprenticeship at MGM. He searched for a character's interior life and expected long discussions with directors and fellow actors on behavioral motivations. In contrast, Taylor sometimes skipped read-throughs and showed up on the set ready to shoot. She did not unleash her full emotions until the cameras rolled, and this put off Newman during rehearsals. When director Richard Brooks yelled "Action!" Taylor was suddenly ON, and this further confused Newman.

"Cut," said Brooks.

"What's going on?" asked Newman.

"You have to understand. Elizabeth doesn't rehearse the way you do," he said. "She goes through all the business and learns to hit her marks, but she can't give a full performance until she knows it's for real." Given the intensity of much of Taylor's acting, her method is as much emotional survival as it is anything else.

Taylor caught a respiratory virus early in production. While she rested, Todd was honored as "Showman of the Year" by the New York Friars Club. Taylor stayed home as he boarded his private plane *The Liz* on March 28 to accept the award. While flying over New Mexico, one of the plane's two engines failed, and the pilot lost control. *The Liz* crashed in the hills west of Albuquerque, killing Todd and three others on board. Now it was Montgomery Clift's turn to attend to Taylor, as she had following his accident in 1956. He called repeatedly, booked a hotel in Chicago for Todd's funeral, and watched horrified at the unfolding scene. Thousands of fans were yelling "Liz! Liz!" more interested in a glimpse of her in grief than in honoring Todd's memory. The crowd broke through the barriers and rushed Taylor, tearing off her veil. "It was noisy, vengeful. I saw envy in their faces, envy and hatred and bleakness," he said.

Widow Taylor was quite unfit to work following such trauma. Production shot around her for almost three weeks, but there was no certainty she would come back or if the film would be completed. After convalescing under the attentive care of friends and family, she approached work again. She told Brooks she wanted to come back, but the decision was his. He wanted her return without hesitancy, and that was her salvation. She reported to the set eight pounds lighter.

She restarted with only an hour or so of work per day. She spoke with a stutter unless she was playing Maggie, but she never missed a day, and she was never late. Brooks got her to eat by ordering real food in the birthday scene, then shooting multiple takes. "By the time we finished the scene, I had my first solid meal in many weeks," she said. "In a way, he [Brooks] saved my life." So did the role. "I put myself into the world of Maggie the Cat—seeing feeling, touching," she said. "It was marvelous therapy."

Todd's death freed something daring in Taylor, something ready to scream and shout. She had the chops, the instincts, and

the professionalism to use what had happened to her to grow as an artist, and to use it with integrity. Todd had been keen on Taylor playing Maggie, buttressing her confidence with praise and encouragement. She was going to give the performance he knew she could deliver. In attempting to move her husband, she cries, "I am *alive! Maggie the Cat is alive!*" It's a great enduring moment for Taylor. Said as a desperate proclamation, it comes with the slightest edge of uncertainty, as though Elizabeth *and* Maggie are affirming themselves amidst so much real and metaphoric death.

Taylor's burden was enormous. She has lengthy scenes with Newman in which she does almost all the talking. Brooks was hamstrung by the censors, and he instructed her to insinuate Brick's longing for Skipper between, around, and under the text. She's got to show us what's going on in their marriage, and how she perseveres despite Brick's rejection. As Brick is shut down, her yearning has to reveal the eroticism that was once there between them. Her various relationships with other family members are similarly challenging and run the range from open contemptuousness for sister-in-law Mae to warm affection for Big Daddy.

The dramatic pleasures of *Cat on a Hot Tin Roof* do not emanate from Taylor alone. This film is a masterpiece of casting, down to those obnoxious no-neck monsters. Burl Ives as Big Daddy and Madeleine Sherwood as Mae reprised their roles from the original stage production. Judith Anderson as Big Mama and Jack Carson as Gooper complete a perfectly integrated acting sextet of cross-purposes, lies, denial, and greed. For me, Taylor rising to take her place among this ensemble of extravagantly gifted actors is one of the great pleasures of her career.

The fantastic heat Taylor and Newman generate confirm her affinity for method actors, earlier promised with Montgomery Clift and James Dean. And they are ridiculously beautiful together, their dual sets of blue eyes burning through the screen. He's in pajamas, and she's slinking around the bedroom in a form-fitting white satin slip, but their connection is so strong they might as well be naked.

Audiences had never been more exposed to the intimacies of two such godly screen beauties.

I savor *Cat* for its buffet of great performances, and not for the holes punched into its script. As adapted by Brooks and James Poe, Brick's guilt at Skipper's death turns him frigid. That makes a lot less sense than unresolved homoerotic longings as written by Williams. The connection between Brick's rejection of Maggie and his Big Daddy issues are similarly muddled. The hammer of censorship came down hard on *Cat*, leaving outcomes and motivations baffling. Scenes are individually stellar and wildly entertaining, but summarily unsatisfying. Wait . . . Brick and Maggie are ready for bed again—how did *that* happen? What's missing is anything explicit. Homosexuality is there if you look for it, or just as easily invisible. Explicit language is missing, but inference, implication, and insinuation take its place.

How did Taylor do it? How did she repair her shattered heart and grief-wracked body and give such a revealing and raw performance? It does not diminish her accomplishment to say she had help. She was not only well served by Brooks and her fellow actors but by Helen Rose as well. She has just three costumes in *Cat*, but each is a marvel of simplicity and character enrichment.

While Taylor's short raven black hair remained sprayed and immobile throughout, her wardrobe keeps moving. Each costume gives her a variation on Maggie's tactility and sensuality. The first, all business, includes a blouse, skirt, and wide red satin belt. It's relatively stiff and formal and should be removed in private. Stripping to a basic satin slip in a guest room she shares with Brick, Maggie gives no suggestion of manufactured sexuality. She is concentrated, present and aware, but not putting on a show for our prurient eyes. She struts across the room and owns the space. Her body moves fluidly, but with no performance affectations drawing attention to her round hips and large breasts. It's a persistently kinetic performance, but not obviously so, and all in response to a frustrated desire for her husband. The third costume, a white chiffon summer dress with

V-neck and white satin belt, finishes her performance and is worn for the third act family showdown. The fabric moves with the ease of a dress we'd expect on Cyd Charisse twirling with Fred Astaire. And in it Maggie is her most commanding and feminine.

A new gift emerged with *Cat*, something Maggie and possibly Richard Brooks brought out of Taylor. From *Cat* onward, she acquired an ability for conveying the truth of her character with a certain inflection, and a magnetic calm possesses her face and body. Maggie and others in Taylor's gallery came to this late in their films. They seem to say, "Everything before this moment might have been bullshit, but honesty has now arrived." Artifice collapses, she's emotionally spent, and nothing's left but revelations. It's heard in her calmly adamant voice when she says, "Skipper worshipped Brick. Skipper was nothing without Brick . . ." We hear it again at opportune moments coming up in *Suddenly, Last Summer*, *BUtterfield 8*, and even in dross like *The Sandpiper*. How fortuitous for her, and for us, that this gift conforms so well to the fundamentals of Western drama and the third act climax.

Taylor enjoyed great public affection following Todd's death. She shot to number one actress at the box office in 1958. That honor arrived not by public sympathy alone, but by a string of exciting performances. *Cat* earned her a second consecutive Best Actress Oscar nomination. I marvel at how present and forthcoming Taylor could be in her acting, baring all for a gawking world. The scrutiny of her life spilt over into her performances, with onlookers seeking connections that united the public and private Elizabeth Taylor. The appetite of millions of strangers didn't inhibit her with a camera. As of *Cat*, there were three movies with three horrors—*Giant* and James Dean's death, *Raintree County* and Montgomery Clift's accident, and now *Cat* and Todd's death. Taylor wasn't overcome by neuroses and superstitions as a result, nor did she retreat to a cave in the wilderness. If anything, tragedies and the media glare emboldened her to take more chances in her acting, not less.

Taylor gave herself some deserved credit for her accomplishment. "I'm pleased with *Cat* and proud of it, mainly because I was able to finish it," she said at its release. "Maggie was a clearly defined character. Playing Maggie, I just had to become the character and assume a real identification with the part, and not just act it. If I hadn't felt this way I wouldn't have been able to finish making the film. I guess that's what enabled me to go back to the studio and go through the routine of production and be with people. God knows I didn't want to."

If *Cat* was the right film at the right time, so was Brooks as director. He shortened scenes and added locations, turning *Cat* into something less stagy and more cinematic. And, as evidenced by the uniformly fine performances, he had a gift for coaxing actors to greatness. He had brought out good work in Taylor in *The Last Time I Saw Paris* and came to see her in ways both tender and clear-eyed:

Here's a girl on the big screen—bigger than life—idolized in thousands upon thousands of dark theaters all over the world by men and women, some who want to emulate her, some who love her, a fantasy, a dream. But she is also so vulnerable that she could easily be hurt. Vulnerability is a counterpart of humility, and Elizabeth really was a humble person. That's one of the things that made her such a great star. One could ask, well, who could hurt Elizabeth Taylor? She has wealth, she's affluent, she has men, she's a power, a turret, a fortress. But she wasn't, and the audience knew it. It came out of the screen, this vulnerability, and the audience reached out to her and wanted to protect her. That was Elizabeth.

Cat is a deliciously rewatchable drama seething with sexual undercurrents and family tensions. It's also another transition film for Taylor. While vulnerability was never far away, more and more her characters would be reproachful and outspoken. She will directly strive to convince that she's not crazy, monstrous, or slutty.

She will loudly and vociferously target hypocrisy, greed, and weakness in others, especially men. The reign of Elizabeth the Angry has begun.

Scent of Mystery (a.k.a. *Holiday in Spain*) (1960, Michael Todd Jr., directed by Jack Cardiff)

In the long history of Taylor career oddities, few are odder than *Scent of Mystery*. Michael Todd Jr. fashioned an *Around the World in 80 Days* type film extravaganza to do his late father proud. *Scent of Mystery* features a novelist in search of an elusive woman targeted for murder. Before he finds her, we're treated to gorgeous vistas of Spain, and many, *many* car chases. But the real draw of *Scent of Mystery* was Smell-O-Vision, a new technology that had specially installed misters spraying odors into theaters on cue. Audiences could whiff facsimile roses, gasoline, and coffee.

To add to *Scent of Mystery*'s marketability, Todd asked stepmother Elizabeth to do a silent cameo. She agreed and appears in the last moments of the film. The mystery woman turns to face the camera, and she is the beauteous Taylor, framed in a wide brimmed white hat and a powder blue scarf.

The film was given a huge build-up, filmed in super widescreen, and presented in roadshow format with reserved seats, overture, intermission, entr'acte, and exit music. Alas, for all the fuss, *Scent of Mystery* was an exercise in tedium. And the odors didn't aerosol properly, leaving audiences confused as well as bored.

After its loud flop, *Scent of Mystery* was deodorized and put back in theaters as *Holiday in Spain*. It flopped again. Taylor had filmed her one scene as a lark in May of 1959. She then jetted from Spain to London to begin production on *Suddenly, Last Summer*, a film she took on in complete seriousness.

Suddenly, Last Summer (1959, Columbia, directed by Joseph L. Mankiewicz)

After Tennessee Williams's Broadway smash with *Cat on a Hot Tin Roof*, he mixed a bubbling cocktail of insanity, homosexuality, and cannibalism in his shocking 1957 one-act play *Suddenly Last Summer*. The script for the film adaptation was so scandalous it didn't pass the Production Code. But producer Sam Spiegel (*On the Waterfront* [1954], *The Bridge on the River Kwai* [1957]) and director Joseph L. Mankiewicz (*A Letter to Three Wives* [1949], *All About Eve* [1950]) were both feeling nervy. They decided to make the film anyway, then present it to the appeals board.

The wealthy Mrs. Violet Venable summons a psychiatrist to her vaguely sinister New Orleans mansion with its backyard jungle evoking the creative and destructive powers of nature. In this nightmare setting she presents the film's plot engine: if the doctor performs a lobotomy on her niece Catherine (Taylor), Violet will make a generous contribution to his underfunded hospital. According to Violet, Catherine has been babbling obscenities about the late Sebastian, Violet's son. On a trip to the beach town of Cabeza de Lobo last summer, Catherine says that Sebastian used her as bait to "procure" young men for his sexual pleasures. This didn't go well, as Sebastian is attacked by a swarm of hungry street urchins, ritually dismembered, and eaten. Catherine's witness to the unimaginable act leaves her mentally incapacitated and in an asylum.

Taylor's attraction to the perverse story illuminates her state of being following Todd's death. This was the closest to horror she would get until *Night Watch* in 1973. The safe and insipid films that irritated her artistic temperament were vanquished. *Cat on a Hot Tin Roof* was sensitive material to film, but *Suddenly, Last Summer* would push Taylor, and the movie industry, further into subjects unspeakable only a few years prior. It had no obvious antecedents on the American screen.

Production began in May of 1959 at Shepperton Studios in Surrey, England. Taylor was now in the highest order of film stars, with an enormous $500,000 payday. Katharine Hepburn was cast as Violet, and Taylor insisted Montgomery Clift, evermore drug addled, be cast as the doctor. His reputation was shot, but his ever-loyal friend said no Monty, no Elizabeth.

Clift was perpetually late and missed his lines. He was drinking heavily and put the production in jeopardy, but Taylor squelched all talk of cancelling the picture. The women overshadow him, while his best moments are with Taylor. Mankiewicz and Spiegel were openly contemptuous of Clift, enraging both Taylor and Hepburn. And apparently Taylor was not always a model citizen. When she showed up at 11:30 on her first day, the set was empty and a note was taped to the camera: "Dear Elizabeth, We were all here at nine. So sorry to have missed you. Love, Joe." She was reportedly never late again. To *Suddenly, Last Summer*, at least.

While Taylor's new husband Eddie Fisher was hovering on the set, the press made a fuss of the alleged contretemps between Taylor and Hepburn. They had fun posing for photos of them playing at war and mocking the inherent sexism in the rumors. In reality, Taylor admired Hepburn and said so on record. Apparently it wasn't realistic that two strong but stylistically different actresses could learn their lines, hit their marks, be professional, and make a movie together without drawing blood.

And what a movie they were making! *Suddenly, Last Summer* contained the most demanding acting challenge Taylor had yet faced. Catherine delivers a twelve-page monologue late in the film. Taylor and Clift rehearsed many times in preparation. It was shot over two days, with the entire cast watching as Mankiewicz filmed Taylor in continuous close-up recounting the awful events of last summer. Catherine under truth serum relives how Sebastian was attacked and killed, and her agitation swells until she screams and collapses. To compound Taylor's onus, flashbacks accompany

Catherine's story. They become floating images on the screen, neatly visualizing the storm in Catherine's brain.

"It tore Elizabeth's gut out," recalled Mankiewicz of that scene. But he saw in her "a tremendous primitive talent on which very few demands had been made." He prodded her to dig deeper into the character and meet the challenge of a tremendously difficult role. On a break, she excused herself, found a private spot on the set, reclined face down on the floor, and sobbed. Mankiewicz found her "broken up completely." She kept saying, "That poor girl!"

Mankiewicz decided to call it a day. "Okay, everyone," he announced. "Fresh start in the morning."

"Fresh start, my ass," said Taylor on the rebound. She was ready. They shot it. She was spent and kept crying as Fisher walked her off the set.

Mankiewicz declared it "one of the finest pieces of acting in any motion picture ever made," describing the monologue as "an aria from a tragic opera of madness and death." Taylor's delivery is a wonderment of technique. She builds in tension and volume steadily and seamlessly, like Ravel's *Boléro* turned into drama and language. Controlled discomfort climbs to delirium in Catherine's accelerating recall. Finally, she can do nothing but screech *"H E L P!!!"* to anyone, everyone, and no one. But Taylor *in extremis* can leave me wondering: Was that a great performance or merely an emphatic one? She scores points for turning the extended monologue with its quite crazy story into something dramatically compelling. She delivers the necessary dose of intensity to transfer insanity from her to Violet before the film's tidy resolution. And she proves that she is an inherently cinematic actress—gauging camera and close-ups with an intensity not casually summoned. (I wonder how Anne Meacham, the original stage Catherine, tempered such emotional distress night after night.)

Suddenly, Last Summer endured fewer wounds than *Cat on a Hot Tin Roof* in its journey to the screen. Williams and co-screenwriter Gore Vidal perform a minor literary miracle in an

age of homosexual erasure. Motivations and explanations remain coherent by the film's climax, while the stench of compromise is minimal. Mankiewicz called the censorship cuts "more irritating than damaging." The word "homosexual" is never spoken, but it doesn't need to be. Unlike the de-eroticizing of Brick and Skipper in *Cat*, Sebastian's desire for the men of Cabeza de Lobo, as well as Catherine's role in his seduction, is spectacularly clear. Sebastian "used us as bait," she recalls. He was "famished for blondes" and "fed up with the dark ones."

Meanwhile, press treatment of her passionate marriage to Mike Todd followed by the scandalous coupling with Eddie Fischer gave the public an impression of a nymphomaniacal Taylor. Likewise, Catherine's sexuality is unchained and dangerous. Note how Taylor catches slightly on the word "nude" in her monologue. Catherine may display her body, but its power frightens her. When she emerges from the sea at Spain's Costa Brava wearing a white maillot with a low neckline and a keyhole cutout beneath her breasts, she is pure female animal carnality. *Suddenly, Last Summer* earned huge sums of money and it's likely the marketing of Taylor's unbridled sex appeal was a leading cause.

Raintree County gave us clues, but no one could have known Taylor's high capacity for self-flagellating before *Suddenly, Last Summer*. She rattles herself in this one, letting loose a succession of primal howls. Her lush beauty enclosed in a hospital for the insane is a brilliant piece of visual incongruity, highlighting the grotesque injustice befalling Catherine. Her showdown with Hepburn is sulfuric, and I want it to go on and on. Neither ever had a female co-star of such power. Taylor assumes a faintly girlish voice to enhance Catherine's innocence and strange obliviousness. But as Taylor plays her, there's never serious doubt of Catherine's sanity.

Taylor was rarely pleased with herself on film, but she was this time. "*Suddenly, Last Summer* was the most difficult, most complex ever worked on," she said. "It certainly was no musical. Katharine Hepburn, Monty Clift—in fact, everyone—had to concentrate to make it what it was." Reviews for her florid portrayal were lauding.

She won the Golden Globe Award for Best Actress in a Motion Picture Drama in advance of the 1959 Academy Awards. Hepburn and Taylor were both Oscar nominated for Best Actress, with the winner Simone Signoret for the British kitchen sink drama *Room at the Top*. Taylor's eventual Oscar victory came for a film most everyone agreed was beneath the sublimely ripe back-to-back dramas of Tennessee Williams.

BUtterfield 8 (1960, MGM, directed by Daniel Mann)

Taylor is sleeping under the lurid red widescreen credits of *BUtterfield 8*, twitching intermittently. She wakes up naked in a bed that we soon realize isn't hers. She's pornographically enticing in groggy close up, her head tilted back on her bare shoulders, her eyelids heavy, her raven black hair mussed. She's alone, and for the next few minutes, she gives us a complete saga of this stranger's tawdry life as she pulls herself together in silence. She steps into a white slip, lights a cigarette, clears her throat with scotch, gives her teeth a perfunctory brushing, examines last night's torn dress, samples another woman's perfume, and wanders the ostentatious apartment done up in blue in one room, pink in another. Then she finds a note from her lover in her purse. She registers the faintest beginning of a smile—this is an actress who knows exactly what the camera reads. She finds $250 cash with the note and immediately grows agitated. She approaches a large wall mirror to apply her lipstick. She brings the stick to her mouth, pauses, sways forward slightly, pursing her mouth. She then collects herself, hardens, gets a new idea, raises the lipstick to the mirror, and scrawls

No Sale

in big pink letters. She then wraps herself in a mink coat, leaves the cash and struts out into Manhattan by daylight. The opening

sequence of *BUtterfield 8* is sheer movie star audacious wonderfulness. Taylor overacts just enough to let us know we're in for a good time.

Not before or since *Beau Brummell* did Taylor loathe a film as much as *BUtterfield 8*. "I think it stinks" was her usual summation, calling it *BUtterball 4* to her friends. (The title references a telephone exchange prefix and the fastest way to reach good-time gal Gloria Wandrous.) During pre-production, Taylor was distracted with a film deal of far greater promise: an epic retelling of *Cleopatra* at Twentieth Century-Fox. But she owed MGM one more film, and the studio threatened to blacklist her should she break her contract. The one they force fed her, a modernized adaptation of a 1935 John O'Hara novel, was based on the life of Starr Faithfull, a party girl whose body was found on a Long Island beach in 1931. It served heaps of prostitution, alcoholism, and nymphomania. Taylor was offended, calling it "the most pornographic script I have ever read." It's certainly spicy stuff for the last lap of the Eisenhower era and all the retrenched traditional social roles that went with it.

If Taylor was in a temper, it didn't extend to the production. "She was very sweet," said *BUtterfield 8* editor Ralph Winters. "She was the nicest person in the world. Everything was always easygoing with her. So it was a good picture to work on." Costar Laurence Harvey, who misses opportunities to makes his character more interesting with hints of guilt and revenge, quickly adored Taylor. "She is wildly professional to work with, I absolutely love her. When she comes onto a set, she gets on with her job and does it in the most extraordinarily professional way. There's a special sort of thing which goes on between her and the camera. She is no automaton doing what the director tells her to do. She *thinks*. She is imaginative. She starts little things going which help her interpretation of the role. With her there is never a lot of phony theatrics and clutching at herself to portray emotion. Nor does she need soft music to get into the proper mood before a shot. If you don't mind another superlative, I find her most enchanting to work with." Harvey and Taylor

became good friends, his nickname for her being "fat ass." Can't you hear her guffaw at that one?

No doubt she hoped *BUtterfield 8* would disappear fast, but that was prevented by her performance. Character and actress unite in their shared dyspepsia, and the results are dynamite. She does a stiletto prance through much of the film in a state of high anger, as I imagine her pissed off at every user, abuser, hanger-on, milquetoast, wannabe, sycophant, and mercenary that crowded her life Each frame tells us she wants it to be over, but Taylor gives a helluva show in spite of her quite reasonable misgivings. She pulls a mink from a closet so forcefully the hanger tumbles to the floor. She doesn't bother to pick it up or even look back. She doesn't give a damn, and that serves the character of Gloria extremely well. She's animated far beyond anything the script, direction, or costars provide. Yes, *BUtterfield 8* is trash, but Taylor singlehandedly transforms it into *quality* trash.

Gloria is a complex patchwork of impulses and motives. She is a call girl—sort of. She refuses money and gifts, so she maintains a measure of control. She's a sometimes model sometimes escort. And she might be the most popular party girl in all of Manhattan; one admirer joking that her fans meet annually in Yankee Stadium. Director Daniel Mann scribbled in his shooting script: "Finds men her source of regeneration. She needs to call the tune. A will to find and lose herself. She has a great sense of humor. Changes come fast. Emotion flows—flips—flops. She's up, she's down. Big-hearted."

Taylor dazzles in her scene at the Trading Post, lighting up the smoky bar with her brio and pearls. When she's photographed in profile, her voluptuous lower lip juts forward in a full sneer aimed at Harvey. She asserts the line, "I'm not *like* anyone. I'm *me*" with such authority it becomes a clarion call to her entire career. She even threatens to puncture his dress shoe and cripple him with her spiked heel for daring to attempt domination.

Gloria lives with her head-in-the-sand mother and borrows money from emasculated best friend Steve, amateurishly played

by Taylor's husband Eddie Fisher. She calls the shots however she can, but gender roles are against her. Late in the film, we learn her important backstory, that her mother's boyfriend molested Gloria when she was thirteen. She cries to Steve in horrible revelation, "And I liked it! Every last stinking moment of it!" Today we might lay blame on her statutory rapist and her pitiful mother in denial (a pitch-perfect Mildred Dunnock). We might even rewrite Gloria as expressing a healthy young sex drive misapplied by circumstances. But it's 1960, and she must be punished for living outside the boundaries of acceptable womanhood. Sure enough, she meets a tragic end in a high-speed escape from New York.

This is mid-career Elizabeth Taylor at her most stupendous, all id and hunger. There's great pleasure in her details, some of them funny. Taylor was an inveterate mugger for snapshots and home movies, and she lets loose with the occasional grin or smirk as Gloria. She sifts through used cigarette butts looking for one to re-light and orders up a second plate of French fries without pause. She won't let anyone shame her, though she lays plenty on herself late in the film.

BUtterfield 8 eventually fails Gloria and Elizabeth, leaving her to enact a succession of scenes rather than enliven a character with the emotional continuity of Leslie Benedict or Maggie the Cat. It repeatedly avoids a confrontation with its own themes. When Harvey says, "Everything in her was struggling for respectability," he is speaking the language of the Production Code, which insisted Gloria turn sick. She is remorseful for her emancipated and hedonistic ways, just as she announces to her psychiatrist she's "normal" for falling in love with a married man. The script has a schizophrenia that mirrors the public's ambivalence about Taylor—celebrating her yen for sex and adventure, while denouncing her for being, to quote Gloria, "the slut of all time."

Taylor reviled *BUtterfield 8* not merely for itself but also because of its transparent exploitation of her public image. Not yet thirty, she was married a fourth time. Following Mike Todd's death, she

was condemned for stealing Eddie Fisher from Debbie Reynolds. To maximize sympathy, Reynolds paraded her kids on innumerable fan magazine covers, everyone pouting under a "Where's Our Daddy?" headline. Taylor didn't help matters when she insisted Fisher be cast as a man whose love is not returned. Susan Oliver plays his churlish paramour, and she has an undeniable resemblance to Reynolds.

MGM sent *BUtterfield 8* into a dozen cities on its initial release, rather than the standard dual openings in New York and LA. Studio marketing capitalized on Taylor's knack for attracting enormous media attention. Here was a film that some fans believed had Taylor playing herself. Shots of her in a form-fitting slip (shades of *Cat on a Hot Tin Roof*) or the mink crucial to the plot were splayed everywhere. *BUtterfield 8* became a must-see movie largely because of timing and the promise of Taylor baring her fangs if not her soul.

Like it or not, this was Taylor's film entirely. Harvey was her ostensible male costar, but neither his stature nor performance was a balance to her as was Montgomery Clift, Rock Hudson, or Paul Newman previously. Her performance was good enough, and came with just enough contrition, to steer public sentiment toward her again. She went from scarlet hussy to "functioning voluptuary," as Newman once described her. With *BUtterfield 8*, she was a champion of self-determination and sheer life energy, becoming a stand-alone screen alternative to the perky domesticated blondes of the time, including Doris Day, Sandra Dee, and, yes, Debbie Reynolds. In her own unintentional way, Elizabeth Taylor heralded the sexual revolution—or at least offered the screen an unapologetic modern vamp.

For a fourth consecutive year, Taylor was nominated for the Best Actress Academy Award. Would they finally bestow her the statuette? After wrapping *BUtterfield 8*, Taylor jetted to Pinewood Studios outside of London to begin production on *Cleopatra*. Her health had been shaky for weeks, and on March 4, 1961, she collapsed with double pneumonia so dire an emergency tracheotomy was

performed to save her life. By now it seemed the entire world was rooting for her recovery. She was barely well enough to attend the Academy Awards on April 17. Wearing a Christian Dior gown with a pale yellow bodice and white sheath skirt, and a pair of South Sea cultured pearls and diamond ear pendant earrings, she appeared frail on the arm of Fisher. When Yul Brynner unsealed the Best Actress envelope and read "Elizabeth Taylor . . ." the Santa Monica Civic Auditorium broke into whoops and thunderous sustained applause. A stunned Taylor brought her white-gloved hands to her mouth, then rose to ascend the stage. She reached the podium and spoke in a breathy whisper: "All I can do is say thank you, thank you with all my heart."

There is a continued perception that the *BUtterfield 8* Oscar was won on sympathy. That certainly may have been part of voters' consideration, but I think there was more going on. After all, Taylor was damned as a home wrecker only two years earlier. She had also been nominated for Best Actress four times in as many years, and the Academy is as likely to hand out a delayed Oscar as it is a sentimental one. Also, and this may be the most controversial stance of all, she's really quite good as Gloria. Many contemporary critics thought so. "Liz Taylor Great in 'BUtterfield 8'" shouted the *Chicago Sun-Times* headline. "Liz Superb in O'Hara Classic," declared the *New York Journal-American*. "Elizabeth Taylor in a strong dramatic role . . . is a bravura one with all the stops out," wrote the *Hollywood Reporter*. *Cue* called Gloria "the finest performance of her career," and the *New York Mirror* said she's "well nigh perfect."

Taylor never agreed. After gaining an Oscar, she was asked if her opinion of *BUtterfield 8* had shifted. Her reply? "I still say it stinks."

Cleopatra (1963, Twentieth Century-Fox, directed by Joseph L. Mankiewicz)

If there's one Taylor film that requires context to make sense of what's on screen, it's *Cleopatra*. And if there one that tempts me to

stray from my primary purpose, to explore Taylor's acting, it's also *Cleopatra.*

The queen of ancient Egypt was no stranger to the movies, and she inspired pageantry and splendor from the beginning. Early vamp Helen Gardner played her in 1912 under her own production company. She set a standard for female regal bearing on screen that followed to Taylor and beyond. Theda Bara's 1917 *Cleopatra* survives only in bits and pieces. The Cecil B. DeMille–Claudette Colbert 1934 version is sumptuous enough to offer comparisons to Taylor's, though at one hundred minutes it's only 40 percent as long.

The making-of story of 1963's *Cleopatra* has been told many times, certainly enough to blur myth and fact. The short version goes something like this. Ancient history was popular movie fodder in the 1950s, with *The Robe* (1953) and *The Ten Commandments* (1956) doing tremendously well. *Cleopatra* was designed to continue that trend, and with some modesty of budget. Producer Walter Wanger first met with Fox president Spyros P. Skouras in 1958 to discuss *Cleopatra*, with Wanger lobbying for Taylor. Skouras wanted someone less volatile. Susan Hayward, perhaps.

Wanger couldn't see past Taylor. "She is the only woman I have ever known who has the necessary youth, power, and emotion." he said. She found the idea ludicrous. When the offer came by phone, she instructed husband Eddie Fisher to tell the suits she wants a million dollars. No actress had ever been paid anything near that sum. They called her bluff and said okay. "If someone's dumb enough to offer me a million dollars to make a picture, I'm certainly not dumb enough to turn it down," she said. Taylor went further, securing a percentage of the gross profits, and stipulating that *Cleopatra* would be filmed in Todd-AO, her late husband's film technology process.

Taylor's outrageous and highly publicized payload opened the checkbook at Fox, and the production budget swelled accordingly. Filming was set for Rome in 1960, but the Summer Olympics filled too many hotel beds. Someone at Fox had the idea that drizzly England would be a reasonable substitute for sun-parched Egypt. Colossal sets were built for location shooting outside of London.

Peter Finch (*Elephant Walk*) as Julius Caesar and Stephen Boyd as Marc Antony were signed as costars, with Rouben Mamoulian directing. Then the trouble started. Not only did the weather not cooperate, but also Taylor suffered acute respiratory distress on those first days of costume fittings, test footage, and rehearsals. She developed double pneumonia, stopped breathing, and was pronounced dead in a London hospital. She was resurrected by an emergency tracheotomy.

Taylor was shaky but getting stronger in time to pick up her Oscar for *BUtterfield 8*. Meanwhile, *Cleopatra* started over. The English footage was scrapped, and the sets bulldozed. Mamoulian, Finch, and Boyd were gone. This would have been the time to dump Taylor, but Skouras kept her despite the known risks. He came around to Wanger's thinking—no woman of the moment had her quadruple status of movie star-actress-celebrity-media sensation.

Mamoulian was replaced by Joseph L. Mankiewicz, Taylor's admiring director of *Suddenly, Last Summer*. He was also in charge of the screenplay. Her new costars were Rex Harrison as Julius Caesar and Richard Burton as Marc Antony. All's well—but not for long. As Mankiewicz said, "The picture was conceived in a state of emergency, shot in confusion, and wound up in a blind panic."

When production resumed in September of 1961, the script was only half written. The film spans eighteen years. It includes the founding of the Roman Empire, Cleopatra's introduction to Caesar, her romance with Antony, his defeat at the Battle of Actium, and her suicide by asp bite. As costs and delays swelled, it was too much for Mankiewicz. He was directing by day and writing by night with the assistance of Dexedrine. He called *Cleopatra* "the hardest three pictures I ever made."

Taylor's early scenes with Harrison went smoothly, with mutual respect flowing. "She knows exactly what she's doing with the slightest movement of an eyelash or curve of a lip," he wrote. When Burton appeared on the set, everything changed. He and Taylor had an atomic reaction, and an affair ensued. Burton, a great

practitioner of frilly speech, said, "I fell in love with her at once. She was like a mirage of beauty of the ages, irresistible, like the pull of gravity. She has everything I want in a woman." A post near-death Taylor wasn't going to stand on the sidelines of love and romance, and she charged toward reckless passion. Fox publicity manager Nathan Weiss was more blunt: "It's no rumor, no guesswork, about what Burton is doing to Taylor," he wrote. "It's plain fact . . . and is now the hottest thing ever."

Actually, it's rather banal, two people caught in adultery. The difference is the megaphone of movie stardom that turned their sudden love into a global event. Taylor's shock waves on conventional morality complimented the 1960 arrival of the pill and the publications of Helen Gurley Brown's *Sex and the Single Girl* (1962) and Betty Friedan's *The Feminine Mystique* (1963). She was contributing to nothing less than society's redefinitions of womanhood and sexual autonomy.

Adding immeasurably to the fuss was a film growing in its own notoriety. The production was dragging, and expenses were rocketing out of earth's atmosphere. The crew exceeded 1,000. One count listed seventy-nine sets and 29,000 costumes. Five thousand extras assembled for the filming of Cleopatra's entrance into Rome. By then, the Taylor-Burton affair had been dubbed *Le Scandale* by the press, while Vatican Radio went tsk-tsk, noting some people view marriage as "a game which they start and interrupt with the capricious make-believe of children." There had been bomb and death threats, and Rome's anti-terrorist police unit was summoned. Conditions were horrifying as Taylor climbed onto a three-story structure to film the gargantuan scene. She was combating the jitters in a weighty twenty-four-karat gold threaded robe topped with a two-and-a-half-foot headdress. "Action!" echoed through the mammoth set, and the extras screamed "Cleopatra! Cleopatra!" ecstatically as instructed. Then they surged toward Taylor, cheering "Leeez! Leeez! *Baci! Baci!*" and blowing kisses. The moment had her in tears, but still she kept her

queenly composure for the rolling cameras. She had conquered the pope's condemnation.

Costs were out of control, but Mankiewicz and Taylor have insisted that was not due exclusively to the production. There was plenty of old-fashioned corruption going on, with executives writing off their expenses to *Cleopatra* whether they were attached to the film or not. Tom Mankiewicz, director-screenwriter son of Joseph L., summed it up concisely: "Once you start saying, 'All right, I need 500 Praetorian guard outfits, I need 600 Nubian slave outfits, I need 10,000 soldier outfits'—this is like an invitation." Joseph L. defended Taylor, who was getting much of the bad press for runaway spending. "Any effort to saddle blame on Miss Taylor for the cost is wrong," he said. She "may have had problems of illness and emotional problems, but she didn't cost Twentieth any $35 million!"

Taylor declared *Cleopatra* a nightmare of lying, spying, and blackmail. "Friends" sold her story to the press; paparazzi dressed as priests, plumbers, or crewmembers searched for access. As shooting continued in early 1962, she was often late, and "Waited for Miss Taylor" became the most common entry in Mankiewicz's diary. Much of the tardiness was due to the paparazzi's unrelenting and aggressive efforts to get her photograph, but she was not entirely a victim. There were reports of migraines, toothaches, and an eye infection brought on by stray glitter. She filmed very little in the first months of 1962. By April, she was back and reported to the set *early*. That same month she and Fisher announced plans to divorce. Then a black eye in May meant she was off again or photographed in profile whenever possible.

She and Burton were meanwhile carrying on *Le Scandale*, much to the international humiliation of their respective spouses. Burton was the first man since Todd who could match, or attempt to match, her great lust for life. She didn't apologize or defend her affair publicly. That was handled privately with the people involved. She maintained it was nobody else's business, least of all the press. And

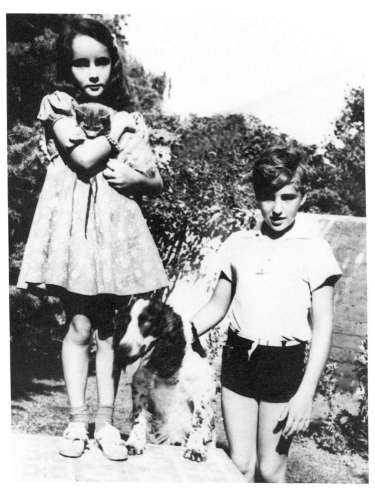

Elizabeth Taylor with her brother Howard, and various pets, circa
1938. Taylor kept precious memories of her bucolic early childhood in
England before film stardom was ever imagined.
Credit: Photofest.

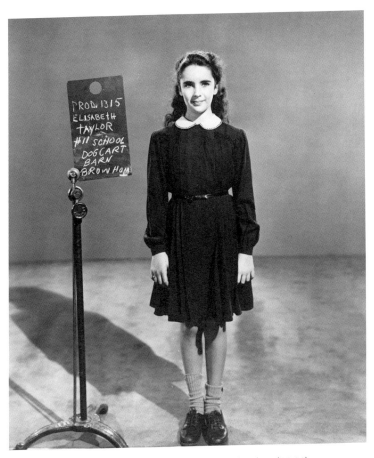

Taylor in a wardrobe test for MGM's *National Velvet* (1944).
Credit: Photofest.

Taylor with what director Clarence Brown called her "Act of God" face as Velvet Brown in *National Velvet* (1944). This was the film that made her a star.

Credit: Photofest.

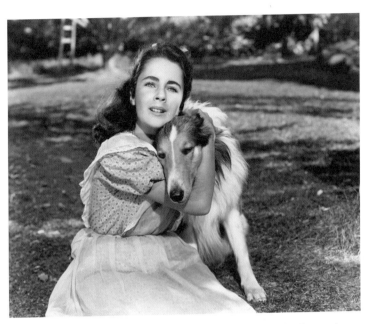

Taylor's deep love of animals was abundantly expressed in her early films, including *Courage of Lassie*, filmed in 1944 but released two years later.
Credit: Photofest.

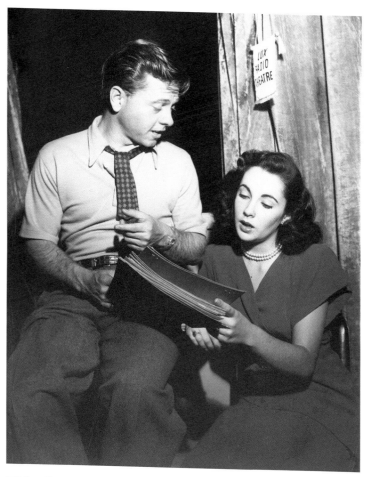

Mickey Rooney and Taylor in the Lux Radio Theatre broadcast
production of *National Velvet*, early 1947.
Credit: Photofest.

Taylor with Jane Powell in *A Date with Judy,* filmed in late 1947. At fifteen, a visually spectacular Taylor was already being transitioned into roles requiring the self-awareness of a confident and seductive young woman. It's no wonder she later said she was denied a childhood and adolescence.

Credit: Photofest.

Taylor experimenting with makeup and hair circa 1948.
Credit: Photofest.

Taylor posing in costume and wig for MGM's *Little Women*, June 1948. Her performance as Amy revealed a too rarely explored knack for comedy.
Credit: Photofest.

Taylor and another pet, with father Francis and mother Sara, circa 1948.
Credit: Photofest.

"Tell mama. Tell mama all." Taylor with Montgomery Clift in *A Place in the Sun*. Director George Stevens coaxed a strong performance out of Taylor. With *Sun*, she made the perilous transition into grown-up roles.
Credit: Photofest.

Taylor in costume pours tea for fellow cast member George Sanders during a break in the shooting of the medieval drama *Ivanhoe* (1952). Credit: Photofest.

With John Ericson in *Rhapsody* (1954). This was one of a series of MGM films from the early 1950s that asked very little of Taylor the actress. While exactingly styled, she added spark to her underwritten role. Credit: Photofest.

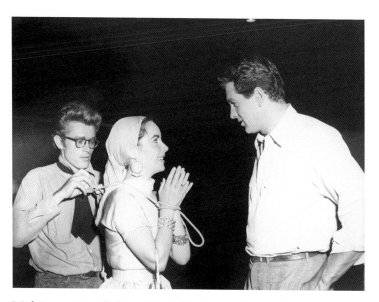

With James Dean (left) and Rock Hudson on the set of *Giant* in 1955. While Taylor's two costars did not take a liking to each other, they adored her. She became a good friend to both, although she knew Dean only briefly before his fatal car accident in September of 1955. Hudson would remain a good friend to his death in 1985.

Credit: Photofest.

In costume with costar and close friend Montgomery Clift in *Raintree County* (1956).

Taylor with her third husband, impresario Mike Todd, in 1957.
Credit: Photofest.

Madeleine Sherwood, Taylor, and Judith Anderson costumed and on the set of *Cat on a Hot Tin Roof* in 1958.

Credit: Photofest.

Taylor and costar Paul Newman going over business on the set of *Cat on a Hot Tin Roof* (1958). Their scenes had a frisson that turned *Cat* into a major hit.

Credit: Photofest.

With husband Eddie Fisher during production of the harrowing
Suddenly, Last Summer (1959).
Credit: Photofest.

Taylor poses for the news cameras in 1960 as she signs an unprecedented $1 million contract to star in *Cleopatra*. With her are Twentieth Century-Fox head of production Buddy Adler (left) and producer Walter Wanger. Credit: Photofest.

Taylor backstage at the Santa Monica Civic Auditorium following her Best Actress Oscar win for *BUtterfield 8*, April 17, 1961. Credit: Photofest.

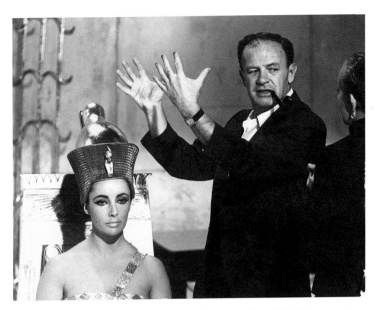

Director Joseph L. Mankiewicz gestures dramatically while Taylor remains calm and in character during the long production of *Cleopatra* (1963).
Credit: Photofest.

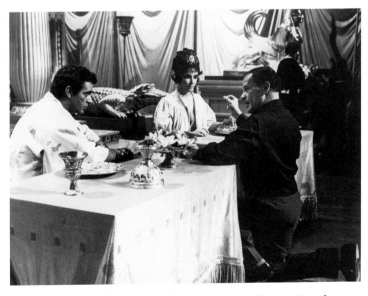

Richard Burton (left) and Taylor listen intently to director Joseph L. Mankiewicz on the set of *Cleopatra*. Taylor and Burton's extramarital affair was dubbed *Le Scandale* and became huge international news.
Credit: Photofest.

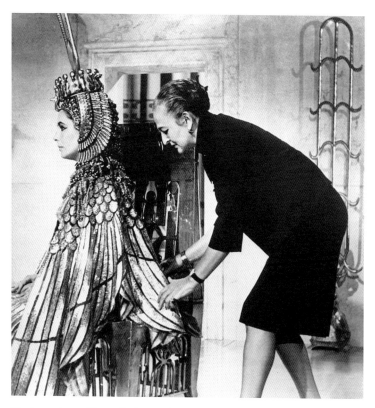

Designer Irene Sharaff adjusts the massive costume Taylor wore for
Cleopatra's entrance into Rome, made of 24-carat gold cloth in the
pattern of the wings of the mythological phoenix.

With screenwriter Terence Rattigan on the set of *The V.I.P.s* (1963).
Credit: Photofest.

Taylor adopted a refreshingly natural hairstyle and makeup for her role as an anti-establishment artist in *The Sandpiper* (1965).
Credit: Photofest.

Taylor with director Mike Nichols in 1965 at the onset of their bold artistic adventure in filming *Who's Afraid of Virginia Woolf?*
Credit: Photofest.

With the crew hovering, director Mike Nichols confers with Taylor and
Burton during the filming of *Who's Afraid of Virginia Woolf?*
Credit: Photofest.

Filming George and Martha's pillow talk in *Who's Afraid of Virginia
Woolf?*, from left to right, director Mike Nichols, director of
photography Haskell Wexler, Taylor, and Burton, 1965.
Credit: Photofest.

Director Mike Nichols, Taylor, and Burton confer while filming *Who's Afraid of Virginia Woolf?*
Credit: Photofest.

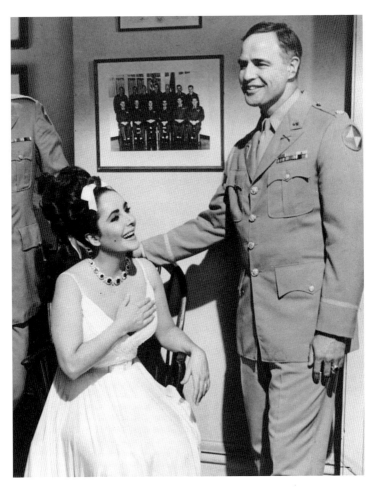

Taylor shares a light moment with costar Marlon Brando while making *Reflections in a Golden Eye* (1967), a macabre film largely absent of light moments.

Credit: Photofest.

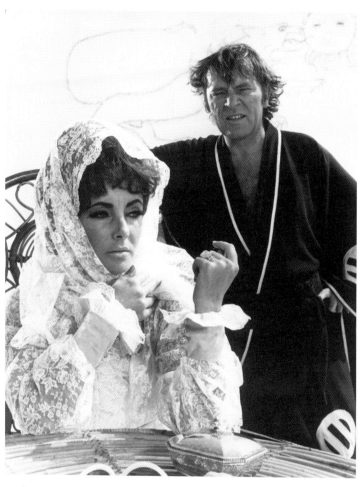

Taylor as the perpetually sour Sissy Goforth and Burton as the Angel of Death in the bizarre yet compelling film like no other *Boom!* (1968). Credit: Photofest.

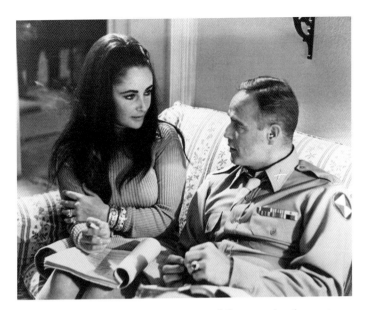

Taylor and Brando look over the script and figure each other out as costars in *Reflections in a Golden Eye* (1967).

Credit: Photofest.

Taylor is coiffed to perfection by Alexandre de Paris on the set of *Boom!* (1968).

Credit: Photofest.

Taylor and Mia Farrow share a bath in a scene that was cut from television broadcasts of *Secret Ceremony* (1968).
Credit: Photofest.

The Burtons give a relaxed and forthright interview with journalist Charles Collingwood for *60 Minutes* in March 1970.

With director Harold Prince during the production of the ill-fated
film version of *A Little Night Music* (1977).
Credit: Photofest.

With husband and US Republican senator from Virginia John Warner, circa 1979.
Credit: Photofest.

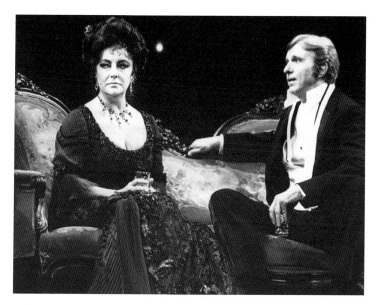

Taylor enjoyed a professional triumph as Regina Giddens in a Broadway revival of Lillian Hellman's *The Little Foxes* in 1981. With her is actor Joe Ponazecki as Oscar Hubbard.

Taylor enjoys a game of Scrabble while making the 1983 TV movie *Between Friends* with costar Carol Burnett, while director Lou Antonio looks on.

Taylor confers with costar Mark Harmon and director Nicolas Roeg on the set of the 1989 TV movie *Sweet Bird of Youth*. This was Taylor's fourth and final screen encounter with the work of playwright Tennessee Williams.

Credit: Photofest.

I can suppose Taylor's unimaginable burdens brought with them some problematic behavior. *Cleopatra* occupied her professional life for five years. The success of a mega-movie, survival of a major studio, and the livelihoods and careers that go with it were largely dependent on her. A bit of acting out could be expected.

Production manager C. O. Erickson observed the birth and rise of the "Liz and Dick" phenomenon. "They were terrific. They were lovely," he said in an interview. "You know, they were *fun*. We loved being around them, because they were having a *great* time. And, of course, we were . . . (laughs) all there just standing by! But who's going to say to them, 'You shouldn't be doing this, you know, please, help us . . . ?'"

Mankiewicz's diary entry of June 23 read, "MISS TAYLOR COMPLETED HER ROLE." All filming ended in early July, and the wrap party went into the wee hours. Taylor was there, attracting a crowd as usual, but there were no tears or overt show of emotions from anyone. By now, Twentieth Century-Fox had suspended production on all films but *Cleopatra*, and the home studio was a virtual ghost town. Fox executive David Brown said they kept going by the promise that from obsession comes money. *Cleopatra* had to make money, or there would be no more Twentieth Century-Fox. And still more chaos followed. Toward the end of production, Skouras was forced to resign, and Fox's new head of production, Richard D. Zanuck, fired Mankiewicz. Taylor protested loudly, and Mankiewicz was rehired to finish editing.

Cleopatra was a risk like no other. There was so much advance publicity, and the world had to wait an eternity for its release, that it could have been tired news before it shipped to theaters. Everyone at Fox breathed easier when long lines formed around the block in advance of *Cleopatra*'s June 12 premiere at the Rivoli, New York's premiere roadshow movie palace. *Time* offered an account of how enlivening and communal a big movie premiere could still be in 1963: "Cleopatra. In scarlet letters volted with excitement the notorious name hung throbbing and enormous in the night sky over

Broadway. Beneath it 10,000 rubberneckers milled on the macadam and roared at the famous faces in the glare. One by one, smiles popping like flashbulbs, they disappeared in the direction of the screen. What did it hold for them? Surely no Shavian conversation piece could conceivably have cost all that money."

Now is the time to dispel the notion of *Cleopatra*'s box-office failure. With a price tag somewhere in the $40 million range, it wasn't going to turn a profit soon, but it was a hit with ticket buyers. Barely six months after its release, *Cleopatra* rose to number nine among all-time highest rental-earning films in the North American market. It moved from red to black ink when Fox sold the TV rights to ABC for $5 million in 1966. According to Box Office Mojo, adjusted for inflation *Cleopatra* ranks forty-sixth among the all-time box-office champions. That puts it ahead of three *Star Wars* movies, and all titles in *The Return of the King* and *Harry Potter* franchises.

The myth of *Cleopatra* the critic's punching bag may be put to rest as well. Some printed responses were harsh, but just as many were glowing. "*Cleopatra* is not only a super colossal eye-filler (the unprecedented budget shows in the physical opulence throughout), but it is also a remarkably literate cinematic recreation of an historic epoch," said *Variety*. At Oscar time, it was nominated for nine statuettes and won for Cinematography (color), Art Direction (color), Costumes (color), and Visual Effects. Taylor, however, was nowhere mentioned during awards season.

Cleopatra has frequently been mistaken for a lousy movie, but it has never been mistaken for a great one. Too often it is merely impressive when it should be awesome, and silly when it should be thrilling. It's reaching for greatness, however. It's got intrigue, power grabs, and alliances formed and broken. It's a rich story richly told, and a sincere effort to bring alive the psychological complexities of three major figures of ancient history.

Cleopatra surprises in its first seconds, with a restrained title sequence. The main theme is more a musical lamentation than a call

to arms or a glorification of mighty civilizations and very expensive moviemaking. Faded images of ancient Mediterranean frescos dissolve into moving action, and back again to ossified history through freeze frames. The effect calls on the deep caverns of history, of then and now, life and death. Alex North's score is sometimes avant-garde and a marvel of confounded expectations for the audio landscape of a 1960s epic. It evokes birds in flight, swirling eddies, and blustery winds giving rise to plots, counterplots, and intrigue. Music producer Nick Redman found it quite admirable. The score "brings to it all of the Machiavellian madness of the period," he said. It "gives you the impression of snakes slithering across the floor."

Mankiewicz's script reminds us Cleopatra was pagan and a living goddess ("I am Isis!") devoted to augury. Caesar is ruthless and ambitious, but not evil. Antony is weaker, crippled by envy of Caesar, and made foolish in love for Cleopatra. He loses critical faculties just as he needed to keep his head and direct his battles. Cleopatra's banter with Caesar can sound like a chirping rom com. "You have such boney knees," she whispers playfully to him as she kicks a pillow his way during a state ritual. Mankiewicz injects saucy dialogue throughout. To her big hulking soldiers, Cleopatra says, "The corridors are dark, gentlemen, but you mustn't be afraid. I am with you." In contrast, the Cleopatr–Antony scenes are played with precious little levity. Some found them lacking, and they certainly didn't live up to the lurid accounts of on-set fireworks as reported in the tabloids.

Taylor and Burton's new rapport is generated from a sexual attraction, not by the properties of their acting. Their first screen union is a bit discordant. His voice is projecting stage trained and hers is whispering studio trained. She's used to close-ups; he's used to playing to the upper balcony. She leads with her gimlet eyes; he leads with his mellifluous voice.

The sets, costumes, even hair and makeup conspire to upstage anything Taylor contributes as an actress. She appears in iridescent

green, noisy ornamental braids, and a serpent armband. Her eyelids are buttered with lapis blue eye shadow. Many costumes land far from any evocation of ancient Egypt and appear more suited to Taylor at the Cannes Film Festival than Taylor on the Nile. But she has to be more than a rack for Irene Sharaff's fantastic costumes. Blessedly, Taylor was always more interesting than anything she wore. And considering some of her outlandish get-ups here, that's saying something. Amidst so much plumage, she found traces of warmth, vulnerability, and humanity not always present in either the film's visual design or its script.

Some of the sets are as big as basketball courts and as long as airport terminals. Each one is packed with enough tchotchke, spot lighting, billowing fabrics, and multitextured surfaces to fill an entire movie. The actors adjust, often shouting their lines to fill the space. Only an actress as mighty as Elizabeth Taylor could have filled those costumes and occupied those sets without being smothered.

Taylor is sphinx-like here. She's never been more feline, not even in *Cat on a Hot Tin Roof*. But while she prowls in *Cat*, she keeps still here. She's more statuesque, impersonating royalty through immobility and constriction. This can work against her, as Cleopatra's sorrow and defeat are eclipsed by Antony's loud wounded animal cries for deliverance. And critics were gunning for her, almost predestined to slam her portrayal. When TV talk-show host David Susskind writes "overweight, over bosomed, overpaid, and under talented, she set the acting profession back a decade," something is going on besides a fair assessment of Taylor's work.

Taylor's voice is small in *Cleopatra*. It gets raspy and lacks projection. It has none of Harrison's and Burton's controlled diction and theatrical flourishes. But the distinction points out a dilemma. No one knows what the ancients sounded like. It's strictly movie convention that gives these characters the chesty baritones of classically trained English-speaking actors. And Taylor's voice may not

be resonant or conventionally powerful, but she learned to cajole, purr, or snarl with it as needed.

Taylor supplies a more ethereal quality to *Cleopatra*, conveying great power channeled from some unknown origin. It well suited her and is a quality no other star could touch. It's a primal allure that melds with Cleopatra's steadfast myth. And it's the one occasion when Taylor played a character whose fame mirrored her own. *Cleopatra* wasn't the apex of Taylor the actress, but it was the apex of Taylor the celebrity goddess. Imagine any contemporary star of formidable stature and popularity, and the necessity of Taylor becomes obvious. Riding high at the moment was Audrey Hepburn, Marilyn Monroe, Debbie Reynolds, Doris Day, and Sandra Dee. If *Cleopatra* works at all, and some of us find it much better than its reputation, it's because of Taylor and her pagan queen irreplaceability.

Taylor's heroines in *Giant, Cat on a Hot Tin Roof,* and *Suddenly, Last Summer* are saved by love. In contrast, Gloria of *BUtterfield 8* and Cleopatra are destroyed by it. Gloria goes down by society's condemnation of an independent woman's sexual pleasure. Cleopatra's downfall comes from an admixture of military defeat and love itself. When she says, "Without you, Marc Antony, this is not a world I wish to live in," she means it. The fatal asp is uncoiled just three minutes later. This mighty leader, this ruler of all Egypt, is brought down by her tender heart.

Taylor came to disparage her performance and the film. Since the critics took her apart, her reaction may have been a defense mechanism to the pain of so much ridicule. "Surely that film must be the most bizarre piece of entertainment ever to be perpetrated— the circumstances, the people involved, the money spent," she said harshly. "I bared my soul for that role. Richard gave everything he had. Half of it ended up on the cutting room floor. I refused to see the film but was persuaded to go to the London premiere. They had cut the film down to three hours, and I only just managed to get back to the Dorchester where I threw up." Ten years after the

premiere, she saw it again. Time and distance softened her, and she formed a kinder opinion of her and the film.

Taylor in *Cleopatra* is not just another performance; it is a culminating statement between her, her fans, and the world. Her kohl-powder eye makeup, which she designed, became a fashion trend. The scar of her life-saving tracheotomy is on proud display on her throat as a shiny new warrior wound. The hundreds of circulating photos, first with Eddie Fisher, then with Richard Burton, were like snapshots of a girlfriend's romantic indiscretions. The *Cleopatra* phenomenon became the highest expression of Taylor's enormous passions for laughter, food, jewels, luxury, booze, men, sex, and the ego-centered business of movie stardom.

"There will always be movies of course, and presumably better ones than there ever were before; and yet they won't quite be as grand, as foolish, as wonderful as they used to be," said Nathan Weiss. The quote must apply to *Cleopatra*, a film more about Hollywood than Egypt. The sheer physical scale of it has never been matched. If for no other reason, see *Cleopatra* to marvel that Hollywood once so fervently believed in the power of its own magic.

The V.I.P.s (1963, MGM, directed by Anthony Asquith)

What was Taylor supposed to do after *Cleopatra*? Prolong the effect, perhaps, by appearing in another film with Richard Burton. *The V.I.P.s* was filmed at MGM's British Studios in Hertfordshire north of London over five weeks, with the two of them occupying adjoining roof-garden penthouses at the Dorchester on Park Lane. Neither of them enthused about the film. She later admitted it was an excuse to reunite with Burton.

Taylor and Burton's personal complications seem baked into *The V.I.P.s,* as though it was created to capitalize on the public's

fascination with *Le Scandale*. But the film had no such history. It's an ensemble drama, not a two-person love story. Sophia Loren was originally sought for Taylor's role. It concerns a group of affluent travelers, their personal stories playing out as they wait for the fog to lift at Heathrow. It carries on the tradition of the multi-plotted *Grand Hotel* (1932) and *The V.I.P.s* screenwriter Terence Rattigan's *Separate Tables*, both play (1955) and film (1958). But Taylor and Burton were such media draws their costars are demoted to afterthoughts.

The V.I.P.s marked Taylor's return to MGM, the studio that owned her from 1942 to 1960, but on her terms this time. She formed her own company, Taylor Productions, Inc., with the studio leasing her services for $500,000 plus expenses. Her vast income wasn't even in the same solar system as other cast members. Such conditions meant *The V.I.P.s* became all about Liz and Dick, especially Liz. Screaming headlines were splayed across the trailer: "THE MOST TALKED ABOUT—THE MOST READ ABOUT—THE MOST FAMOUS COUPLE IN THE ENTIRE WORLD."

The V.I.P.s was released in September 1963, while *Cleopatra* was still packing theaters. It's loaded with actors giving a range of good to terrible performances, but *The V.I.P.s* strikes me as an exercise in emptiness. It does not commit the sin of boredom; Taylor's films rarely do. It's glossy harmless fun, and entertaining if approached with low expectations. But with a screenwriter and director the rank of Rattigan and Anthony Asquith (*The Importance of Being Earnest*, 1952), it's reasonable to expect something more than what's delivered.

As an Australian businessman and the mousy secretary who loves him, Rod Taylor and Maggie Smith come off well. Others in the cast less so, including Orson Welles as a caricature of a temperamental film director. Margaret Rutherford spends her screen time rummaging through a bag in search of something or other, her hat forever bopped and askew. Her shtick-ridden cute little old lady routine is tiresome before it begins, but it earned her a Best

Supporting Actress Oscar. *This* is an Academy embarrassment, not *BUtterfield 8* for Taylor.

Taylor doesn't act as much as she presents herself for viewing. It's futile to separate the actress from the celebrity in *The V.I.P.s*. She's mask-like and inert, her makeup thick, her eyes and brows defined to otherworldly exactitude. Her low-cut Givenchy gowns exploit her cleavage. These are not conditions that yield bravura acting. Taylor can only hope to deliver her lines convincingly while we gaze upon this alien being of unimagined wealth and beauty.

Le Scandale had made Taylor more in demand, more expensive, and further beyond the reach of us lowly mortals. The celebrity effect is perhaps stronger here than at any other moment in her career. It exceeds even *Cleopatra*, where elephantine scale and ancient history could distract from Taylor the headline grabber. Here the setting and her thinly drawn character appear much closer to her modern jet-setting life.

Taylor and Burton were still married to other people when they made *The V.I.P.s*, so it's a bit discombobulating (and foretelling) that they play a couple dissolving their thirteen-year marriage. She plans to fly away with wooden gigolo Louis Jourdan. Alas, she and he exchange no sparks, while she declares her attraction to his helplessness. Once again, we get Taylor as a lover with misplaced maternal instincts.

The Taylor–Burton romantic scenes, the very raison d'être of the film, appear late. And while Taylor is a mannequin, Burton is a bastard. He packs a gun into the airport and is ready to pay off Jourdan to get his wife back. She must once again quibble over two men of elusive virtue, though the stakes are considerably less here than the fates of Rome and Egypt.

Soon after making *The V.I.P.s*, Taylor expressed some healthy detachment from her screen image, or at least didn't confuse it for who she was. "The Elizabeth Taylor who's famous, the one on celluloid, really has no depth or meaning to me," she said. "It's a totally superficial working thing, a commodity. I really don't know what

the ingredients are exactly—just that it makes money. I'm not even too sure what image the lady from Pismo Beach has of me—except probably she thinks I'm rather scandalous, unstable, a wicked witch with very little feelings—ruthless, fairly lame-brained, determined. Somebody who snaps a finger and gets what she wants."

The Sandpiper (1965, MGM, directed by Vincente Minnelli)

Taylor explained *The Sandpiper* by way of disabusing the world of her limitless superstar possibilities. "After we did *The V.I.P.s*, I didn't get a film offer for what seemed like ages and ages," she wrote in her memoirs. "Richard and I were both panicky. I think our notoriety was a factor, but not a large one. More important were all the accusations about *Cleopatra*. The industry was convinced that we had cost *Cleopatra* extra millions by caprice—all of which we have proven to be false. And I couldn't get health insurance. So we were risks. I didn't think I could get a job. So I grabbed *The Sandpiper*."

Dalton Trumbo, the most famous name of the Hollywood Ten blacklisted screenwriters of the McCarthy era, penned the screenplay. He wrote a part for Taylor with an unusually ripe backstory. She plays Laura Reynolds, a free-spirited artist living with her young son, Danny, in a stylish wooden beach house above the churning waves of Big Sur, California. Laura is a nonconforming atheist who ran away from the negative judgments of Indianapolis as a pregnant teen. Men defiled her, then branded her a dangerous temptress. Either way she couldn't win, with the stigma of unwed motherhood to endure as well. Laura's never known love and suffers from low self-worth.

Burton plays Edward Hewitt, the headmaster of an Episcopal boarding school attended by Danny on court order. As tribal chief, he believes the boy needs to break free from his mother and be socialized among males. The married Hewitt falls for Laura's

entrancing charms and grapples with the sins of lust and adultery. Laura also falls in love, complicating her long-standing allergy to ritual commitment and marriage. (Her line "I've never been married" must have gotten titters in first-run theaters, as Taylor was then on husband number five.)

This was Taylor and Burton's first film since their 1964 marriage, and both were keen on making lots of money. She got $1 million, he got $500,000, but neither kidded themselves about its artistic potential. Burton rather noted its embrace of celebrity voyeurism, saying *The Sandpiper* "hits pretty close to home." The esteemed William Wyler rejected a directing offer. Vincente Minnelli, who had worked with Taylor on *Father of the Bride* and *Father's Little Dividend*, said okay. He registered much ambivalence, though, calling the premise "ludicrous and dated." Taylor enjoyed the shoot but knew this one was not for the ages.

The Sandpiper was on location for about a month in Big Sur before moving to Paris for interior scenes. The Burtons were nearing the height of the media madness swirling around them, and scary mobs in Paris struggled for a glimpse while they were on the town with Ari Onassis and Maria Callas. But at work Taylor wanted to loosen up following her liberation from both MGM and *Cleopatra*. She did a nude scene, though it's less revealing than the body rub she received in *Cleopatra*. She wanted Sammy Davis Jr. to play her secondary love interest, thus disturbing Hollywood's all-white casting standards, but he was nixed for Charles Bronson.

When *The Sandpiper* opened, it was savaged in print but brought in truckloads of money at the box office. The Burtons, it seemed, could overcome critical raspberries. Backhanded compliments can be made. The Big Sur locations are glorious, enhanced by a Johnny Mandel–Paul Francis Webster romantic and melancholy theme song, "The Shadow of Your Smile." It became a standard, won a Grammy and an Oscar, and was used as intro music when Taylor was a presenter at the 1986 Academy Awards.

Taylor demonstrates that she's more adept and practiced at turgid movie dialogue than Burton. She breezes through so much ridiculousness, while he looks stiff and embarrassed when saying, "I've lost all sense of sin" and "I never knew what love was before." Taylor is refreshingly casual and earthy here, her untied hair tossing in the wind as she paints coastal landscapes. As liminal Goddess of Earth, Sky, and Sea, she is one with nature, but this is not to suggest she gives a good performance. She is, at kindest assessment, uneven in *The Sandpiper*. She overplays appallingly when learning that Hewitt told his wife of their affair. But she's fantastic on the beach, her musings on female oppression through the ages reminiscent of her noble outspokenness in *Giant*. Burton hands her the scene, standing by or asking questions to keep her animated. Then she turns and misfires again. When she's assaulted at home, she calls the man a "creep" and defends herself with a kindling axe. It's a silly word to level at a would-be rapist, and Taylor hardly elevates it in her delivery.

On other occasions, *The Sandpiper* is good for some laughs. An open fire blazes in Laura's free-standing midcentury fireplace, upstaging Taylor and Burton and turning whatever dialogue they're spouting into "blah blah blah." The symbolizing of a broken-winged bird and restless sea could hardly be more blunt. To burnish her credentials as all natural, Laura tends to a wounded sandpiper who recovers. It then flies back to light atop her head! Meanwhile Liz and Dick keep staring at each other in carnal hypnosis.

The Sandpiper plays on the widely circulating myth that Taylor brought down Burton morally and artistically. Edward and Laura are more Apollonian and Dionysian stand-ins than human characters. He's the voice of institutions—discipline, scholarship, history, respect for the law, custom. She's the voice of nature, art, music, unfettered and expressive. Both are transformed. She compels him to spend money for underprivileged children, not for a new chapel. Her views on marriage soften, and she voices envy for Edward's wife, played with enduring pain by Eva Marie Saint (*Raintree County*).

Laura is mixed up sexually. She decries "the male establishment" that keeps women as "unpaid servants" but falls short on consent. She scoffs at a complaint about Danny touching another student inappropriately, calling it an invention of the girl's uptight parents. Minnelli directs the schoolboys to gawk at Laura, and all she can do is give them a "boys will be boys" smile, not supposing they may grow up to be the lechers and rapists—and creeps—who have so damaged her over the years.

All that said, I love *The Sandpiper*. I saw it when I was a kid, clueless to its adult concerns. No matter, it lodged in my subconscious as a half-remembered dream. It has a scene at Nepenthe, the hippest of dreamscape restaurants hangouts perched on the hills over the Pacific. It has that siren Elizabeth Taylor, cool bohemian types, bonfires on the beach, aerial views of a fantasy coastline, and the promise of an artist's primeval life. It tries to be more than a succession of moral exercises. It's an interesting failure. Minnelli is so very miscalculating as director, infusing Old School romanticism when the mid-1960s were screaming for something with grit. And most gloriously, it gives us the Burtons at their most Burtonesque, pitching their appeal to everyone from teenage beatniks to distracted housewives. They labored to dignify this while adorning supermarket tabloids everywhere. *The Sandpiper* is their most we-are-so-into-each-other-the-rest-of-the-world-disappears movie.

Who's Afraid of Virginia Woolf? (1966, Warner Bros., directed by Mike Nichols)

This is the performance most often cited as proof Taylor was a real actress. Her Martha in *Who's Afraid of Virginia Woolf?* is a bold creation, showing Taylor's willingness to jump off a cliff when the personnel and circumstances are right.

Who's Afraid of Virginia Woolf?, a new play by thirty-four-year-old American Edward Albee, opened at the Billy Rose Theatre in New York on October 13, 1962. It caused immediate shock waves. All about George and Martha, a middle-aged college professor and his embittered wife, it lifted the polite façade of academe, revealing a world of gladiatorial savagery. They gleefully tear into each other while ensnaring a younger professor and his wife in their late night games. But *Virginia Woolf* is far more than merely clever—George and Martha have a monumental love for each other, however destructively expressed. This was "salacious and profound and allegorical" stuff, said Haskell Wexler, who would serve as the film's cinematographer. The linguistic artistry of *Virginia Woolf* inspires resourceful artists to experiment and fly.

Veteran mogul Jack Warner bough the film rights for $500,000 in 1963. He planned to delete the copious vulgarities in the script and cast Bette Davis and James Mason. He hired screenwriter Ernest Lehman, whose credits included such diversities as *Sweet Smell of Success* (1957), *North by Northwest* (1959), and *West Side Story* (1961), to produce and adapt the play. Even though this was Lehman's first outing as producer, he overrode or reformed Warner's casting ideas. He couldn't quite envision Davis and Mason, or Henry Fonda and Patricia Neal, who were also discussed. But he was committed to the film, believing it had the potential to be a "savage, humorous, sad, and terrifying picture."

The stakes rose when the Burtons expressed interest. This was an exceptionally fragile moment in Taylor's career. In the two years since *Cleopatra*, she had made *The V.I.P.s* and *The Sandpiper*. While both earned money, neither did anything to reestablish her as a fine actress. Quite the contrary, they both invited laughter at the melodramatic excess of her life spilling onto the screen. Now Burton was urging her to take on the Herculean challenge of Martha. At first glance, she was absolutely wrong. Her voice was too high, and her celebrity was blinding. No matter how good she would be as

Martha, she would be too young. And if she was additionally bad, this could be the ruination of her career.

The Burtons charged forward, aware of the risk to both of them. Taylor initially could barely conceive of herself as Martha: "It was the most difficult part I had ever read and made me feel as though in my whole life I'd never acted, never interpreted a line." But once the idea of Taylor as Martha was fixed, Lehman became enthusiastic. "People know how [original Martha on stage] Uta Hagen played it. They certainly know how Bette Davis would do it. But they wonder how Elizabeth Taylor would do it," Lehman said to Warner. She was paid over a million dollars plus perks and a percentage. "I would have done it for nothing," she said. Burton was harder to sell. "They didn't want me," he said, but for $750,000, they got him. "Elizabeth was very powerful in the motion picture business—she's the best businessman in film I know—and so they reluctantly gave me the part," recalled Burton. "She also picked Mike Nichols to direct and he'd never even made a film before. She had good instincts."

Who was this neophyte film director Mike Nichols? He was born Mikhail Igor Peschkowsky in Berlin in 1931, the son of Russian-Jewish immigrants. He became half of the improvisational comedy duo Nichols and [Elaine] May, their radio, television, and stage appearances big sellers until the duo split in 1961. Nichols then turned to stage directing, tackling classics by Shaw and Wilde and scoring a triumph with Neil Simon's *Barefoot in the Park* (1963). Taylor and Nichols had become friends, and she used her clout to get him *Virginia Woolf*, his first venture on film. She was also wise enough to surround him, and her, with supremely talented people, including editor Sam O'Steen and composer Alex North (*Cleopatra*). They would know how to turn verbal theater into something thrillingly cinematic.

So much was built on pure blind faith that Lehman, Nichols, and the Burtons could pull it off. With stage actors George Segal and Sandy Dennis cast at the couple in George and Martha's trap, the small cast assembled for a table read on Stage Two of Warner Bros.

on July 6, 1965. The Burtons arrived in comfortable street clothes, minus an entourage or other reminders of their extreme fame and wealth. Aware their presence may cause awe and paralysis, they relaxed the cast and crew with bloody marys.

In battling her inferiority complex, Taylor never saw *Virginia Woolf* on stage or listened to a recording. She wanted her Martha to be uninfluenced by anyone else's. After three weeks of rehearsals, everyone reported to Smith College in Northampton, Massachusetts, in August to begin filming. Wexler and Nichols fought and won the approval for releasing the film in black and white. The process resulted in the crisp contrasts of the film. Wexler's exactitude drove Nichols crazy, but the newcomer to film was not equipped to argue with so much more experience. It also made a thirty-three-year-old Taylor more convincing as a woman sliding into double-chinned baggy-eyed middle age.

Nichols made sure the set was packed with items meaningful to the actors, helping them develop characters with visuals that may or may not have shown up on screen. He stocked the fridge with a chewed ear of corn, an opened can of uneaten beans, and a plate of leftover spaghetti. Books were overflowing on George and Martha's shelves and tables. There's an unframed photo of a severe Louise Nevelson in the bedroom and a map of Martha's Vineyard over the fireplace. There's even a portrait of the Burtons on the desk in the living room. Everywhere are mementos of an insular, complex shared life. Nichols created a veritable art installation on the set. "Mike is a hinting director, which makes you get all excited and start inventing and participating in his inventions," said Taylor.

Though he and Taylor had become friends, Nichols was not convinced she had the stuffing for this tough assignment. He wanted her to take lessons to credibly lower Martha's voice. Taylor said she could train herself to bring it down, and she did. He even complained to Lehman about the casting. "It's like asking a chocolate milkshake to do the work of a double martini," he said. But Nichols must have known Taylor would come to the project fully

stoked. *Virginia Woolf* would be her liberation from the tyranny of beauty. She did, after all, once tell Nichols she couldn't wait for her looks to fade.

As they ventured deeper into the material, Taylor cried and Burton shook. And they both drank. Taylor sat for makeup for two hours every day, then squeezed into her salt-and-pepper wig and something lumpish from Martha's wardrobe. Nichols saw Taylor getting better, and learning, with each scene they shot. He was getting what he wanted and bedazzled at how she came alive. She mastered Martha's body language, voice (lower than her natural voice—the effects of so much booze and cigarettes), and finally laugh. She inhabited Martha physically with what she called a "stumpy walk," lowering her center of gravity. She gained twenty pounds to help the cause.

Eventually, Nichols offered the kind of recognition and praise that had always eluded Taylor even in her most acclaimed work. "Here were four stage people—Richard, George, Sandy, and me— and we were all awed by Elizabeth's knowledge of film acting. [We] watched her very closely and learned from her. The main thing that Richard learned was to do as little as possible. I have hundreds of thousands of feet of Richard listening in scenes. On the floor, over and over, I'd say after take eighteen, 'Okay I guess that's it, there's not going to be any more, thanks, Elizabeth,' and I'd see it the next day it was fifty percent better. All these things that you couldn't see standing six feet away were there. When I was editing, I realized she even left room for the score in some semiconscious way. Her essential nature informed so much of it."

Nichols was nurturing and complimentary without being solicitous, knowing Taylor could spot a phony twenty miles away. He observed that "Elizabeth is very, very physical. What helps her is to know where she'll be, what she'll be wearing, and so forth—the business. . . . Richard is about the sound. He would say, 'How should I say it? Say it for me.' We found each other through rehearsals."

Unlike so many, Nichols was not intimidated by their colossal fame. His ease and friendship with the Burtons allowed him to seize control with uncommon authority. Over the making of the film, and despite his lack of experience, Nichols became the alpha male. He kept supplying the film with inspired embellishments. In the critical scene outside the roadhouse, when George and Martha declare "total war," he ordered various background lights to enhance the scene beyond what he could reasonably expect from Taylor. Then she proceeded to deliver something monumental. In one thrilling low-angle shot, her hair frizzed in the dewy night air, her body wrapped in a formless jacket, she defines Martha with a primal rant: "I'm loud, and I'm vulgar, and I wear the pants in the house because somebody's got to, but I am not a monster. I'm *not!*"

In late September, the cast and crew packed up and left Northampton to resume filming in LA at Studio Eight on the Warner Bros. lot. Nichols tried to shoot the film as close to in sequence as time and schedules would permit. This allowed Taylor and all the actors to modulate each character's drunkenness, combativeness, and emotional and physical exhaustion. Martha evolves over the evening more than anyone, and Taylor had to go with the changes. She refused glycerin tears for her lengthy pre-dawn monologue about "our boy." She was delivering a magnificent reading, bringing tears to cast and crew alike, except for one electrician on the catwalk. He had begun to snore so loudly that Nichols had to yell cut. Elizabeth immediately said, "Don't fire him. Please don't fire him."

By the time *Virginia Woolf* wrapped thirty days over schedule, Nichols was a full-on admirer of the Burtons.

I am just constantly surprised at how good Elizabeth and Richard are . . . I love them. Their flexibility and talent and cooperativeness and lovingness is overwhelming. I can't think of one disagreeable thing. I've had more trouble with little people you've never heard of—temper tantrums, upstaging, girls' sobbing—than with

the so-called legendary Burtons. The Burtons are on time, they know their lines, and if I make suggestions, Elizabeth can keep in her mind fourteen dialogue changes, twelve floor marks, and ten pauses.

Impossible as it might be to imagine *being* Elizabeth Taylor, I can perhaps imagine her exuberance at becoming Martha. She was in a state of creative ecstasy. "I've never been so happy doing a film," she said. "It was so marvelous to have those words to say. It was the first character part I've ever played. It was my first part with comedy in it. That's part of the total devastation of the play—that it is a tragicomedy." At last, she played a character with little or no resemblance to herself. "It was stepping into somebody else's skin who was so remote from my own skin that it was like wearing a mustache and beard and old long wig and cloak," she wrote in her memoirs. "So I had Martha to hide behind, so I'd lost Elizabeth Taylor. There was a freedom that I've never known before in a role. I felt much more experimental. When I got into my Martha suit, I forgot me."

When *Virginia Woolf* opened in June of 1966, the film world was gobsmacked. Every department contributed something magnificent. Alex North's score underlines rather than overwhelms the drama, giving the film a needed aural tenderness. Sam O'Steen's editing meshes with Nichols, Wexler, and the actors, punctuated by jump cuts or slow dissolves as needed. Lehman's script incorporated much of Albee's play while cutting here and there and sending the foursome out dancing at a threadbare roadhouse. Wexler's photography, with its variety of pans, zooms, long shots, and close-ups, brings emotions to visual life. Hotly lit black and white, makeup lines, and a frowzy wig effectively added the necessary years to Taylor's newly rounded face.

Nichols was immediately hailed as a natural born film director. He had a canny ability to bore into characters' psyches with shrewdly designed and timed close-ups and to utilize the gifts of cinema with his first effort. He approached the material in fantastic

harmony with Albee's ironies. For all their screaming and abuse, George and Martha are deep in love, while Nick and Honey, the young golden couple, can barely stomach each other. *Virginia Woolf*, he said, "forces us to confront metaphors." He also knew it is screamingly funny, the witticisms arriving by Nichols's estimation every twenty seconds.

George Segal and especially Sandy Dennis were praised as the young couple scarred from George and Martha's games, their marriage exposed as a storehouse of animosities. Burton had never been better as "Georgie Porgie put-upon-pie" who plays offense at dawn to terrifying effect. Taylor braced herself to get broiled by the critics because that's what they routinely did. But this time was different. Every skeptic was silenced and sent to their paddock, including Warner, Nichols, and Albee. If they didn't confess to underestimating her, they at least came forward to shower praise on her Martha.

Nichols offered an insight to Taylor decades after *Virginia Woolf* that was rarely matched. When remembering Dustin Hoffman in *The Graduate* (1967), Nichols's follow-up to *Virginia Woolf*, he gravitated toward Taylor. Hoffman, he said, "had that thrilling thing that I'd only seen in Elizabeth Taylor. That secret, where they do something while you're shooting, and you think it's *okay*, but then you see it on screen and it's five times better than when you shot it. That's what a great movie actor does. They don't know how they do it, and I don't know how they do it, but the difference is unimaginable, shocking. This feeling that they have such a connection with the camera that they can do what they want because they own the audience. Elizabeth had it."

Taylor exceeded even the pyrotechnics she gave off when Maggie the Cat coincided with Mike Todd's death. Traces of the damaged harridan are seen in earlier performances, but here she is in full fury. It could have appeared as showy and artificial, but Albee's source and Lehman's screenplay, alongside Nichols's capacity for risks, and a trio of fellow actors at the height of their powers

avoided the limitations. And Taylor had such an affinity for Martha that son Christopher believed his mother "held on to a sliver of her Martha character for the rest of her life, pulling it out of reserve for those occasions when she really needed to get a point across with someone who probably deserved it."

Martha is a role of shocking multivalence. The first acquaintance with her might startle, with her rage pouring forth. Here was a woman who submerged her own identity to become a professor's wife, only to be met with disillusionment. Next viewing might reveal the less obvious grace notes of tenderness and vulnerability Taylor brings with her barely disguised femininity. I have seen other powerhouse actresses essay Martha on stage, including Kathleen Turner and Glenda Jackson, and they lacked the welcomed judicial softness of Taylor's interpretation.

The show of skill she brings to her line readings may come forth next, the pauses, stresses, and punctuation's. Then another realization: she's fantastically funny as Martha, pouring on the phony charm for the guests, comic in her shuffling around the house, stuffing a chilled drumstick in her mouth, assuming the role of predatory temptress matron bitch in her Sunday chapel dress. Nichols directs an overhead long shot of Martha wandering out to the car, her cocktail glass clinking with ice. Despite the far distance of the camera, Taylor brings us intimately close to Martha. She is an embodiment of the sloppy drunk. She swerves, sways, widens her stance, and sticks out her butt in attempts to stabilize her teetering body.

When Martha's desperation turns savage, we know her cruelty to George comes from an unexpected place. And so it goes, sadism as cover for weakness and need, subservience and humiliation as cover for strength and domination. By the time Crazy Billy delivers that fateful telegram, *Who's Afraid of Virginia Woolf?* has upended virtually everything we *think* we know about marital love and devotion.

George and Martha exist by the fluid dynamics of truth and illusion. Martha makes seemingly innocent little mistakes throughout

the film. She insists there's no moon out that night, but we see a full moon over the trees not once but twice. She's certain Nick is a mathematician, but he's a biologist. She calls George a floozy, but Honey is quick to remind her George can't be a floozy. Are these moments evidence of Martha's slipping brain? Each character lives in their own isolated ego-driven world, with George increasingly convinced illusion is intruding on truth too often in Martha.

When she commits the ultimate transgression, mentioning their make-believe son to Honey, George takes drastic steps. Maybe she *can't* distinguish truth and illusion anymore. The doubt is doubled when Martha delivers her "our son" soliloquy. She has soft spots, and George knows exactly where they are. His set-up for their son's death is horrible, yet becomes an act of love, saving Martha from madness. The depth of Martha's maternal fantasies must be fully displayed in her speech; we must believe Sonny Boy is *real* to Martha. And when the fantasy is shattered, Martha is left terrified at the emptiness before her.

Virginia Woolf was readily acknowledged as a watershed film. Its advertising came with a stark "For adults only" warning, but that was no easy stab at sensationalism. *Virginia Woolf* was coursing with profanity objectionable to the now impotent arbiters of film content at the Production Code. That, of course, was catnip to audiences. Reviews were rapturous and the box office was huge. Awards started piling up, though *Virginia Woolf* emerged as the *second* most lauded film of the year after *A Man for All Seasons*. (Seen today, that costume drama is one long yawn compared to the brilliant verbocity of *Virginia Woolf*.) While *Seasons* picked up Best Picture and Director citations, Taylor won Best Actress from the New York Film Critics (in a tie with Lynn Redgrave in *Georgy Girl*) and the National Board of Review.

In an age before film awards were handed out every other Tuesday, critics' recognition boded well for Taylor at the Academy Awards. *Virginia Woolf* earned Oscar nominations in every eligible category, thirteen total. At final tally, it won five: Supporting Actress

for the great Sandy Dennis, Cinematography (black and white) for Haskell Wexler, Art Direction (black and white) for Richard Sylbert and George James Hopkins, Costume Design (black and white) for Irene Sharaff, and Actress for Elizabeth Taylor. She and Burton were in Paris on April 10, 1967, when Lee Marvin called her name at the Oscars ceremony. Anne Bancroft accepted for her. The Burtons reportedly stayed away because the prospect of Taylor winning and Burton losing, as predicted, would be painful and humiliating.

Shallow journalism suggests *Virginia Woolf* was more a public reenactment of the Burton's stormy relationship than a demonstration of their bravura acting. Taylor found it more cathartic than traumatizing. She loved a good brawl, but *Virginia Woolf* as reflection of their marriage doesn't go very far. They were married a year, George and Martha were married for many more. The Burtons were worldwide celebrities, scrutinized as few couples in history have ever been. George was a low-level academic and failed author married to a bellowing alcoholic who is "expected to *be* somebody, not just a nobody." It doesn't add up. At some point we have to reject the idea we're watching the Burtons air their dirty laundry and embrace the possibility we're watching them *act*. Brilliantly.

The Taming of the Shrew (1967, Columbia, directed by Franco Zeffirelli)

Taylor perpetually undervalued her skill in front of the camera and overvalued stage acting, particularly of the classics. She envied Burton for his résumé peppered with *Hamlet*, *The Tempest*, *King John*, and *Henry IV*, "and the fact that he was not a movie star but a genuine actor," as if the two are mutually exclusive. Burton's admiration went in the other direction, and after *Who's Afraid of Virginia Woolf?*, he was confident Taylor could handle most anything. He envisioned her as Lady Macbeth. With her customary sparkle,

Taylor countered that Katharina in *The Taming of the Shrew* is closer to typecasting.

The idea took hold. This could be a great comedy vehicle for them, evenly matched, rambunctious, and giving fans the kind of full out sparring they wanted. Burton was a natural as fortune hunter and shrew tamer Petruchio, but there was doubt Taylor could handle Katharina. This would be her first Shakespeare, and opera director Franco Zeffirelli's first film. Naysayers would be waiting to pounce. The Burtons put up a million dollars of their own money and deferred their salaries, risking further criticism for mounting a vanity project. Shooting commenced at the Dino De Laurentiis Studios outside of Rome.

As uncredited producers, the Burtons sought and secured major talent. The great British cinematographer Oswald Morris, who had photographed Taylor in the regrettable *Beau Brummell*, was hired. *Shrew*'s art director John DeCuir had won an Oscar for *Cleopatra*. And the cast was packed with accomplished stage and screen actors, including Cyril Cusack, Michael Hordern (Cicero in *Cleopatra*), and Alan Webb. In their company, Taylor smirked and called herself "Muggins from Hollywood."

Zeffirelli faced a substantial challenge. "Elizabeth and I came from different planets—her world of the movies and mine of the theater—and Richard was the great leveler," he said. Richard "was the bridge. Elizabeth was very shy to play Shakespeare to begin with but she brought a marvelous devotion. On the first day, I remember, she was like a girl coming to her marriage too young; she had extreme concern and humility. That day she was really enchanting." She didn't see it that way. She was jittery and demanded the shot footage be scrapped. She was fine by day two, with cast and crew impressed with her quick mastery of the language.

Franco and Burton flared on the set early on, squabbling over costumes and such. Burton found Zeffirelli domineering, and he didn't initially appreciate someone who stood up to him, especially in matters concerning Shakespeare. Egos relaxed and the set grew

convivial. Apart from the usual vagaries in film production such as delayed set-ups and occasional nerves, written accounts recap a charmed environment over the long months of production. There were shopping and sightseeing field trips to Rome. Taylor pitched in to apply makeup on early calls. The Burton's hosted the cast and crew for grilled hamburgers at their rented Villa.

Much of the fun generated on the set came from the above-the-title stars. Michael York, a sweet-faced Pan with his trim beard and wide ready smile, was making his film debut with the Burtons.

> On my first day, I remember thinking, 'My God! These are the kings and queens of Hollywood, and at the top of their profession.' There was an overwhelming sense of glamour about them, intensified by the way they lived, you know, with their dressing rooms with dazzling white carpets and all their butlers and maids, and so on . . . the Rolls-Royces, the jewels. They behaved like movie stars; old-fashioned movie stars. But I also found them to be enormously kind. There was also a sense of family. For instance, whenever her children were around, they were popped into costume, and then onto the set as extras.

Taylor *was* a movie star, perhaps the biggest of them all, and she was treated as such. Exacting attention was paid to her look in the film. It was important to cleanse the screen of any *Virginia Woolf* residual frump, returning her to full beauteousness. Her hairstyles, costumes, and wigs are separately credited. And at Taylor's request, film engineer Takuo ("Tak") Miyagishima invented a Panavision "skinny lens" to make her look slimmer. It was used in medium shots only, implemented by Morris, and kept secret from Zeffirelli.

The Taming of the Shrew was written in the early 1590s near the beginning of Shakespeare's career. Its treatment of marriage and gender roles hasn't diminished its popularity centuries later, but Zeffirelli doesn't linger on sexual politics. He played up the rowdy fun of it instead, with scrums of extras milling about, spilling into

the noisy streets filled with fruit peddlers, livestock, and wandering musicians. The visuals are sumptuous throughout, burnished with the glow of sixteenth-century Paduan art.

Katharina (Kate) might be the most physically arduous role Taylor ever took on, chronic back pain be damned. She lunges and plunges under yards of fabric. The Burtons alternatively bite, claw, pummel, and kick each other, all the while maintaining a spirit of fun. "It would have been very difficult to do it with another actress," said Burton. "You can throw your wife about, but it's difficult to throw, say, Sophia Loren around. And with Elizabeth, I was permitted to do extreme physical things that wouldn't have been allowed with another actress. Anyway, there wouldn't have been the same *joie de vivre* with someone else."

Taylor celebrated her thirty-fifth birthday with a champagne party at the Dorchester the night before *Shrew* premiered in London on February 28. Anticipation was high at the Odeon in Leicester Square. Taylor let out a sigh of relief when the critics didn't eviscerate her or the film. Reviews were overall positive for a film awash in color, movement, and jolly good times.

Few seemed to care that Petruchio is a despicable man, ready to terrorize Kate for a small pot of gold. Or that Kate has few options in life but to obey her husband. Or that Zeffirelli extends scenes beyond their expiration, and in doing so diminishes his own priority for buoyant knockabout humor. For me, *Shrew* is a bit *too* knockabout, as though Zeffirelli was out to prove Shakespeare's accessibility to a mass audience. He achieves that, and *Shrew* became the steppingstone to his even more successful screen retelling of *Romeo & Juliet* the following year.

The production captures the play's nimble psychology and ironies. Kate's mammoth ill temper stems from jealousy over favored sister, the fair Bianca. Kate suffers dreadful humiliation; Dad's filial preference and desperation to wed Kate is a civic joke. She is further debased when Petruchio makes a public travesty of their wedding. Taylor never plays Kate for pathos, but we can

see the pain in her eyes as she is ridiculed and isolated. Soon that gets wiped away, and she's on fire again, looking to get revenge against her father, and so doubling his challenge to get her married. Petruchio's belligerence at the wedding mirrors Kate's with her exasperated father. In a fit of sympathetic magic, Petruchio feigns madness to discourage it in Kate, as she transforms from wild beast to becalmed wife.

There's little complexity in Taylor's playing of the early boisterous scenes. Kate transforms in three stages, from shrew to supplicant to post-shrew. Once Petruchio begins to tame her, she loses some of her great life force. She whimpers, squirms, and grimaces as he manhandles her into submission. Burton gets most of the good lines for much of the film, and it's a true delight hearing his sonorous voice interpret Shakespeare's jubilation of love: "She is my goods, my chattels. She is my house, my household stuff, my field, my barn, my horse, my ox, my ass, my anything."

This was the one and only time the Burtons made being the Burtons look like fun as they physically and verbally joust their way into the marriage bed. After a disastrous wedding night, Petruchio asks chipperly, "How fares my Kate?" She answers "ill" as if tasting a bad avocado. Taylor is once again playing the lonely stranger in her new husband's world, as she did in *Elephant Walk* and *Giant*. But this time, it's played for laughs.

Taylor gives full power to Kate's famous speech in act five, scene two. Its essential message is determined by delivery. By all appearances tamed, Kate chides the wives of Padua for their insolence and churlishness. She's ready to embrace woman's inferiority to man. Being a shrew got her nothing, but being a diplomatic sweet talker gets her everything:

> Thy husband is thy lord, thy life, thy keeper
> Thy head, thy sovereign; one that cares for thee, . . .
> And when she is forward, peevish, sullen, sour
> And not obedient to his honest will,

> What is she but a foul contending rebel,
> And graceless traitor to her loving lord?

The moment is so very delicious. Taylor's expressive face and sly smile as she hatches a scheme or feigns subservience to her "master" tell me this is not surrender, but victory. In naming her place, she asserts whatever power she can in a patriarchy where fathers sell their daughters in marriage. She delivers the speech with a well-rehearsed steady confidence and ease, never bruising the language with overemphasis. Katherine knows exactly what she's doing. The text massages her man's ego, while the subtext asserts the woman's authority over it. Kate, it seems, has tamed Petruchio. She loves him, she wants to marry him, and by giving herself, she captures him.

After Kate's soliloquy, Petruchio is left almost mute. At the same moment she says, "obey your husbands," he loses all interest in control. She offers a kittenish smile, then disappears into the crowd without him. He follows, desperate not to lose her. She's in charge now. This promises to be one wild marriage of two hot heads, not unlike the Burtons themselves. At the conclusion, I'm not convinced Kate was ever a genuine shrew or that she's been tamed.

Unlike other famous female characters of theater that undergo enlightenment (Billie Dawn in *Born Yesterday*, Eliza Doolittle in *Pygmalion*), Katharina grows *more* interesting after her transformation. She begins as a one-note harpy, throwing hard objects and smashing furniture. Taylor has fun with it, but she really shines in the last half hour of the film. She abandons disorderly business and conducts sexual and marital politics to her advantage. Her voice softens, she loses the scowl, and her performance achieves a fine confidence and composure. She has limited dialogue, but she doesn't need it. She conveys the schemes, hopes, and desires of a woman newly in love with her face and body.

Zeffirelli took note of Taylor's accomplishment. "I consider that Elizabeth, with no Shakespearean background, gave the

more interesting performance because she invented the part from scratch," he said. "To some extent, Richard was affected by his knowledge of the classics." A bit like Kate's conquest of Petruchio, quick study Taylor had tamed iambic pentameter.

Doctor Faustus (1967, Columbia, directed by Richard Burton and Nevill Coghill)

1966 saw the Burtons engaged in an unlikely project. With all disregard for commercial potential or career advancement, they lent themselves to an Oxford University Dramatic Society stage production of Christopher Marlowe's rarely mounted sixteenth-century drama *The Tragical History of Doctor Faustus*. Appearing alongside students and academics, Burton was the tormented medieval German professor who sells his soul to Lucifer in exchange for all human knowledge. Taylor plays Helen of Troy, conjured by Faustus as no less than the most beautiful woman in the world: "Was this the face that launched a thousand ships and burnt the topless towers of Illium?"

Co-directed by Burton and his mentor, literary scholar Nevill Coghill, the two rustled up financing to make a film version through Columbia Pictures, the studio behind *The Taming of the Shrew*. Burton reengaged *Shrew*'s art director John DeCuir, who hung yards of drapery then littered the sets with the ephemera of a tempestuous mind: skulls, chests, maps, books, skeletons human and animal, manuscripts, niches, and clocks. Primary color lighting gels and excessive double exposures give the film a certain queasy Kenneth Anger aesthetic. Burton's monotonous bombast is no match for the many visual distractions and peculiarities.

The Oxford film premiere of *Faustus* doubled as a hospital benefit, with the Duke and Duchess of Kent attending. The Burtons were greeted with a trumpet flourish upon entering the theater. Burton scoffed, knowing the very same people would have pilloried

them during *Le Scandale*. And who thought this would sell tickets? Taylor's role is secondary and comes with no dialogue. It's easy to suppose she did it for Burton in support of his performing ambitions. Nobody else could bring her superstar amplitude to the proceedings. But likely Taylor's intellectual and educational insecurities attracted her to it as well. It's a bold if misguided choice, self-indulgent and tedious even at ninety-two minutes.

I initially thought Taylor was merely on display in a succession of bizarre costumes and headdresses as a mannequin playing dress-up in her husband's pet project. In one scene she appears painted in silver under a wig of corkscrewing scrap metal. Her cleavage is exaggerated throughout. She wanders, she poses, she manifests erotic heat, she narrows her eyes in extreme close-up. The creeping waxworks of *Cleopatra* and *The V.I.P.s* are nothing compared to the shadowy Helen summoned by alchemy from the lower strata of ancient times.

Looking for all benefit of the doubt, I came to see Taylor's specific brand of movie star magnetism clarified here to its simplest form. Is she vacuously brilliant or brilliantly vacuous? She does not offer raw lust, but something more ethereal. She's a spectral light; her blank face and bewitching eyes take us to other worlds. Once again Taylor appears to be doing nothing, but she's doing everything. In the wrong hands, this Helen would be a narcotic Ziegfeld showgirl. Taylor is a magic act, and neither Raquel Welch, Ursula Andress, or any other goddess figurine of the era could have pulled it off.

Doctor Faustus isn't penny dreadful. It readily incited my Google searches for Mephistopheles, necromancy, Agnes Flanagan, and the seven deadly sins. If nothing else, it's a stroll through a foundational myth of Western civilization as reconceived by Burton. And Taylor isn't absolutely silent. The film ends with her releasing a demonic cackle as she pulls Faustus into deepest hell, her blood red lips offset by reptilian green skin. Who among *Doctor Faustus*'s tiny audience saw that as a comment on Taylor's corruption of Burton the great stage actor? *Doctor Faustus* did neither of them any favors.

It represents the initial split between worldwide celebrities and bankable movie stars.

Reflections in a Golden Eye (1967, Warner Bros.-Seven Arts, directed by John Huston)

Taylor's last six films had all costarred Burton, and he was concerned. "Must we *always* make films together?" he groused. "We'll end up like Laurel and Hardy." It was time for a busman's holiday, so she went looking for something to share with her *other* favorite costar, Montgomery Clift.

Clift's agent suggested *Reflections in a Golden Eye*, a strange 1941 novel by southern Gothic writer Carson McCullers. She lobbied for Clift, but he had become a recluse in his Manhattan townhouse. Years of drug and alcohol abuse and erratic behavior left him unemployable. Ever-loyal Taylor agreed to pay the insurance with her own money. But Clift was so far gone, only Taylor had any confidence in him anymore. He hadn't acted in four years.

Clift died in July of 1966, but *Reflections* moved forward. Marlon Brando, laboring under a career slump, would costar with Taylor. She saw this bizarre tale of violence and voyeurism as the last nail in the Production Code's coffin and a pathway to greater freedom on film. She approached John Huston to direct, who had impressed her as she watched him working with Burton in *Night of the Iguana*.

Huston was attracted to the offbeat, and *Reflections* was certainly that. As a study in repression and forbidden desires among a gallery of neurotics, it made *Cat on a Hot Tin Roof* look like *Sesame Street*. On a sleepy southern military base during peacetime, the rigid Major Weldon Penderton (Brando) is tormented by his homosexual desires. His lusty yet feebleminded wife Leonora (Taylor) is having an affair with a higher ranked officer (Brian Keith). His wife (Julie Harris) had a severe mental breakdown, resulting in her slicing off her nipples. She spends her time in the company of Anacleto

(Zorro David), a subservient effeminate friend. Penderton's sexual repression comes to a violent finale when a handsome young private (Robert Forster) rides horseback naked and spies on Leonora.

The script kept close to McCullers's short novel, with the approved content representing a quantum leap beyond what was allowed with Taylor's two great Tennessee Williams's vehicles, *Cat on a Hot Tin Roof* and *Suddenly, Last Summer.* Huston effectively visualizes McCullers's army post with its dull uniformity of barracks and officers' homes, cropped lawns, and duplicate two-story brick administration buildings.

Taylor expressed minor concern for Huston's style early on, but she soon enjoyed his methods. He was largely hands-off, letting the actors find their characters. He also wasn't a stickler for delivering lines with precision, hitting every "but," "and," and "the." Neither was Taylor. And he found her to his liking. "Elizabeth comes to the set beautifully prepared," he said. "If she does a scene six times, there'll be six renditions that are almost exactly alike."

This proved to be advantageous given the performance coming from Brando. Taylor started ad-libbing when Brando pulled a Brando and became incomprehensible. When Huston yelled, "Cut," he laid blame on her. s

"Elizabeth flopped," he said.

"No, she didn't," replied script supervisor Angela Allen. "She ad-libbed as long as she possibly could."

Taylor shot a glance at Brando, adding, "Yes. When Mr. Mumbles can open his mouth, so any of us can even hear what he says, it would be wonderful."

If she called him Mr. Mumbles in derision, then she missed the point. His shuffling inaudible performance made hers possible, giving her something to get riled up about. His terrible secret and her ripe deliveries result in a Brando performance that, for once, doesn't steal scenes. Taylor makes sure of that while loving his "acute animal sensitivity." Brando could play tortured and taboo desires metastasizing into blinding self-hatred. He's not just in the

closet, he's been swallowed by it. He, Keith, Harris, and Forster pitch their performances in the direction of the unrelentingly morose and depressing. That leaves Taylor (and David to a lesser degree) with the burden of giving this film some oxygen.

Reflections explores the polluted and degraded construction of manhood in America. Anaclado, limp-wristed and orientalized, is the most well-adjusted male of the cast. Living outside the boundaries of expected gender roles, he is content in himself. The other men of *Reflections* are emotionally crippled, Penderton most acutely.

As befits the pervading aura, Leonora is one of Taylor's kinkier performances. She's not malicious, though she's cruel and contemptuous of her tormented husband and his lack of sexual interest. Taylor punches almost every line, turning Leonora into an electrifying weirdo. While others mope in a depressive blur, she dares to be expressive. Her animated description of party food is like stuffing jellybeans into a turkey. We see Leonora as a dingbat, a shallow military wife on one hand, and a scary ball buster on the other. Taylor can't always hide her own intelligence. When Leonora focuses her derision on Penderton, her concentration and clear purpose have a volcanic intensity. The result is a split character. Taylor's brains and human insight reveal themselves in key moments, otherwise Leonora's feather-brained essence pervades.

Leonora's cuckolding and humiliation of Penderton has a *Who's Afraid of Virginia Woolf?* dimension, but Leonora is more assaultive than Martha. The novel is sparse on dialogue, and the script lacks the verbal swordplay, the backstory, or the marital dependence that undergirds *Virginia Woolf.* The action is more purely sadomasochistic here, with Leonora pitching and Penderton catching. "Have you ever been collared and dragged out into the street and thrashed by a naked woman?" she asks her husband before removing her bra and throwing it in his face.

Leonora is a reminder of Taylor's largely untapped abilities at comedy. At her flightiest, Leonora is funny, the imbecilic housewife

deranged by an overproduced cocktail party. But Leonora is also her husband's merciless tormentor, metaphorically mounting him in her fetishized jodhpurs and riding crop. Unlike Martha, there's nothing in-between. The script doesn't connect the two, resulting in a character as schizophrenic as she is compelling.

When *Reflections* opened, many were turned off by its startling perversity and self-conscious artiness. Huston gives us extended night scenes of skulking about, horseback riding naked, and wandering the military grounds without any forward propulsion of plot. Taking "Golden Eye" to heart, Huston had the film tinted a golden bronze, the effect resembling a high-alert smoggy day.

Made and released in the twilight era between the Production Code and the G-M-R-X ratings system, *Reflections* gets away with much. It comments unconventionally on misogyny, homophobia, and racism. Huston seems intent on exposing humanity's diseased underbelly, with Taylor and the entire cast committed to exploring McCullers's darkest authorial impulses. It dares to expose the intersection of homoeroticism and the military. It's one of the fundamental titles in LGBT film history and remarkably frank two years before Stonewall. It offers two movie tropes of the homosexual— the prancing preening sissy and the murderous closet case.

Warner Bros. didn't know what to do with this. Marketers opted for the prurient angle. "Leave the children home" was the tagline, while the posters screamed, "Most women in her situation would do the very same thing! They just wouldn't do it as well— or as often!" Business was strong in the first weeks of release but dropped off after that, landing *Reflections* among the lower earners of 1967. Warner Bros. ditched the golden eye effect and released it in standard Technicolor, but that made no obvious difference to revenues.

Even so, *Reflections* had an impact. C. O. Erickson, production manager on *Cleopatra*, wryly noted that, with *Virginia Woolf* and now this, "Liz Taylor was becoming a one-woman Production Code wrecking crew."

The Comedians (1967, MGM, directed by Peter Glenville)

The Comedians is another film that must have sounded great in concept. Acclaimed English author Graham Greene published the novel in 1966, and the screenplay was to be faithful. Set during the bloody authoritarian presidency of Haiti's François Duvalier ("Papa Doc") beginning in 1957, it tells various independent and interwoven stories of a businessman, ambassador, hotel owner, and doctor as they navigate the island's political crisis. Papa Doc was still in power at the time of filming, so Haiti could not serve as a location. Instead, cast and crew flew to the Kingdom of Dahomey (now Benin) in West Africa. Peter Glenville, who guided Burton so effectively in *Becket* (1964), was set to direct.

Greene was a passionate traveler, referring to Haiti as a "nightmare republic" terrorized by Papa Doc's Tonton Macoute goon squads. Papa Doc considered him an enemy, which Greene incautiously took as a compliment. But Greene's political rhetoric and whistleblowing is low-key in *The Comedians*. He never pretended to be an expert on Haitian culture and history. Neither the book nor the movie digs too deeply, though neither blink at the human atrocities committed during Papa Doc's reign.

Burton had the starring role as a jaded Port-au-Prince hotel owner named Brown, with Taylor as an ambassador's wife in support. He's billed over her, and was paid more, $750,000 to her $500,000. The production attracted major talent, including Alec Guinness, Peter Ustinov, James Earl Jones, and Lillian Gish. The Burtons enjoyed anonymity on location, where they could wander the streets and markets unrecognized. The kids were along, and the accommodations were more modest than usual, illustrating the vagaries of their nomadic celebrity existence in the 1960s. Burton raved about his wife: "Elizabeth is looking gorgeous—she blooms in hot climates. . . . I am madly in love with her at the moment, as

distinct from always loving her, and want to make love to her every minute."

The Comedians began production in January 1967 in Benin, then moved to the south of France. On April 10, barely a week before *The Comedians* wrapped, Taylor won the Best Actress Academy Award for *Who's Afraid of Virginia Woolf?* At the time of filming *The Comedians, Virginia Woolf* was winning Oscars and *The Taming of the Shrew* opened to strong reviews and box office. Taylor had yet to suffer the failures of *Doctor Faustus* and *Reflections in a Golden Eye*. Neither she nor Burton had yet confronted the possibility that their notoriety was overwhelming their reputations as actors.

Even with positive conditions, neither Taylor nor Burton thrived as actors on *The Comedians*. Her character, another woman named Martha, isn't well defined. She exists largely outside the political drama playing around her. She's married to Ustinov as the ambassador from Uruguay and engaged in a joyless affair with Brown. They rendezvous in a car on the outskirts of town and steal kisses and nuzzle when no one is looking. Since *Le Scandale* ended with marriage, watching Taylor and Burton play at having an affair in 1967 held little appeal, salacious or otherwise.

Martha is German as written, yet Taylor's accent lands somewhere beyond French and a half dozen other languages. Not surprisingly, Greene thought Taylor was miscast. It's a puzzling vocal performance, all the more so because she was capable of German pronunciations. She would deliver an exaggerated Teutonic accent for laughs in a guest spot on the TV series *Here's Lucy* in 1971.

Ustinov was blunt in his assessment of the Burtons at this point in their shared lives: "I liked working with Richard and Liz very much, but Richard seemed utterly bored by the whole thing, which didn't surprise me because it was a huge bore whenever the Burtons had to make love for the camera." As for Taylor, he found her bizarre German funny, while adding, "There is nothing tepid about her, either as a woman or as an actress."

The Burtons saw little to no gain artistically from their participation in *The Comedians*, but they did meet young photographer Gianni Bozzacchi, who would capture their images into the early 1970s. He became their official photographer, and his feelings for Taylor combined friendship and reverence. "The world sees ... the beauty, the dress, the makeup—but without makeup she glows! With makeup she doesn't. I photographed her without makeup— my God! There's a sensuality always present," adding, "If Botticelli were living today, he would be inspired by Elizabeth."

When *The Comedians* was released in October, reviews were negative and business was low. Taylor was badly presented in an unflattering Alexandre de Paris bouffant. Her dresses are ill fitting and stiff, like they need frequent adjustments lest they ride up where they ought not. The accounts of her gorgeousness by Burton and Bozzacchi don't come across the screen, at least not as strongly as they had so many times prior. Worse still was the Burtons' onscreen affair, looking rather silly and inconsequential amidst government-sponsored terrorism.

Taylor is soft here, whispering her lines, the shrew in retreat. But she doesn't replace her with anything compelling. This is by any measure one of her weaker performances. And with *Becket*, *Night of the Iguana*, and *The Sandpiper*, Burton had patented men of tested faith on screen. Approaching that character type again here, with additions of cynicism and jealousy, reaches self-parody.

David Robinson of *The London Times* outlined the problem. Notoriety had overwhelmed any claim to artistic legitimacy: "The Burtons are quite the most extraordinary phenomenon in pictures today. A stocky couple, courting premature middle age, they are nobody's ideal of young romance, despite Elizabeth Taylor's extraordinarily beautiful features, and their acting hardly seems to matter ... the whole reason for their attraction remains obscure: but a partial, likely explanation is the publicized turbulence of their off-screen lives, the disdain for convention and disregard for opinion

that, even in an age of discarded conventions, has a grandeur and glamour and uniqueness."

Boom! (1968, Universal, directed by Joseph Losey)

Boom! is a film to unsettle the meaning of bad. Its banquet of creative missteps doomed it to everything but ridicule, camp, and latter-day reassessments. And therein lies its covert charm.

This was Taylor's welcome reunion with the words of Tennessee Williams, who had written Cat on a Hot Tin Roof and Suddenly, Last Summer, works featuring two of her most celebrated performances. The director would be the esteemed Joseph Losey, whose films The Servant (1963) and Accident (1967) were uncompromising realizations of Harold Pinter on screen. Production would be shot on a rocky island in the turquoise Mediterranean, while the Burtons would live in seafaring splendor aboard their newly purchased luxury yacht the Kalizma.

That's all fine, but there were serious problems with the source. Boom! is based on The Milk Train Doesn't Stop Here Anymore, a Williams play that failed not once but twice on Broadway. The script was hardly sacred, so he cranked out numerous rewrites. This was Williams at his loopiest. Flora "Sissy" Goforth (Taylor) is the world's richest woman dictating her memoirs while dying of an unnamed illness. Chris Flanders (Burton), a man of unknown origin and purpose, arrives on shore by diving off a nearby boat. We learn he is the Angel of Death (l'angelo della morte). And the meaning of "boom"? Chris tells us, more than once so we don't forget, it is "the shock of each moment of still being alive."

Sissy grows more irritable as she tries to deny and deflect the inevitable. She is forever barking displeasures to her staff from her isolated villa atop the limestone crags of Capo Caccia, Sardinia. As

she is on the precipice of life and death, her home is aptly located. Be warned this is not a movie for acrophobes.

Casting was all over the place. Once again, Taylor was the first to sign, and she insisted Burton be attached to the project. Simone Signoret and Sean Connery had been discussed. So had Ingrid Bergman and Dirk Bogarde. None of them fit Williams's original conception, but Taylor and Burton contributed hugely to the eventual disaster of *Boom!* Whereas counterintuitive casting of *Who's Afraid of Virginia Woolf?* worked to everyone's advantage, no such good fortune visited *Boom!* Williams initially saw an older actress for Sissy, and a beautiful young blonde Adonis for Chris. Hermione Baddeley and Tallulah Bankhead played Sissy before Taylor, while Paul Roebling and Tab Hunter were the first to play Chris. They could hardly resemble Taylor and Burton less.

The Burtons came with money, and the budget swelled to $4.5 million. This was Losey's first big price-tag film, and he sought to make commercially successful Art with a capital A. Tiziani, the Texas-born opera singer turned couturier of Rome, designed Taylor's costumes for *Reflections in a Golden Eye* and *The Comedians* but made his greatest impression on her here. She appears for dinner in a luminous silvery white caftan weighing forty-two pounds and decorated with 21,000 hand-stitched beads. But the showstopper is the multi-spiked crystalline headdress attached to her scalp.

Sissy's huge villa is a feat of whitewashed walls, muslin curtains, and travertine marble evoking a cross between Le Corbusier, Frank Gehry, and the rounded corners and earthen buildings of Cappadocia. A balustrade cuts a sharp line between island and sky, with geometry and engineering interrupting the voluptuous shapes of nature. The film plays with color in an uneasy game of vague symbolism. Flanders wears a pink robe and sleeps in a pink room with a Marc Chagall mural on the wall. Blackie, the secretary who receives dictation and contempt from Sissy, is in a room done up in blue, contrasting gender. The incidental nonspeaking role of houseboy is in fire engine red, while everyone else is in black,

white, or earth tones. Sissy's final backlit white transparent lingerie is something out of softcore porn.

Taylor and the director did not mesh, at least initially. "Joseph Losey was a strange guy," wrote production photographer Gianni Bozzacchi. "No one managed to communicate with him much, on or off the set. He wasn't friendly, was very focused on himself. Elizabeth respected him and did what he said, but I don't think she appreciated his directing much. More than once, at the end of a scene, I heard Losey call, 'Cut! Good.' But Elizabeth would then say that she could have done better, and an argument would follow. Richard never intervened. But Elizabeth always won anyway."

Bloody marys were served every morning, and much of the production was shot while cast and crew were hammered. I envision a film set as extended bacchanal, with the Burtons at their most entitled and indulgent. But they were also having a good time. They were living very big and less inclined to concentrate on the tiresome minutia of good filmmaking. Global celebrity meant life came with a growing entourage of tag-along journalists, police, and security. Noël Coward, cast as Sissy's occasional visitor the Witch of Capri, was flattering to the Burtons. "My God you have such fantastic authority," he told Taylor. Burton reported he said "that Elizabeth and I were so packed with dynamic personality that he expected us any minute to burst at the seams and flow like volcanic lava." Losey soon grew irritated at the Burtons, who were fighting regularly. He claimed she was argumentative and puzzled by his directorial intents. She complained of one thing or another, then delayed production, and had to shoot her first scene thirteen times. It's possible she was in a panic at realizing *Boom!* was turning into something quite ludicrous.

Casting Taylor with a Tennessee Williams script is like handing her a flamethrower. She scorches everyone in her proximity. Hard to imagine they weren't having a degree of fun on the set chortling at the dialogue and situations as they downed those bloody marys under the glaring bright sun. Oddities abound. Taylor and Burton

don't exchange dialogue until nearly an hour in. I wonder what Williams and Losey were thinking. The most famous couple in the world, and you deny them shared screen time for fifty minutes? And odd allusions are found throughout. Sissy calls Chris "Mr. Trojan House Guest." She sets her "black devil dogs," demonic canines in Western folklore, on him. She knows who he is and is frightened and resigned, even intrigued. Does she view her seduction of him as a man, not an angel, as her only hope?

With *Boom!*, audiences were fair in wondering if the joke was on them. For some it confirmed the Burtons were as monstrous as their worst publicity, capable of destroying movies with their egos and gross pretentions. For others, the charm of *Boom!* is its ability to be simultaneously misbegotten and entertaining. It's rather like encountering a nasty waiter who doesn't care if you like the food or not. Just shut up and eat it.

The piling of the bizarre and silly can be distasteful. There's exploitation of the dwarf who barely speaks but lurks about for mood and decoration. Taylor seems to forget Sissy is dying until it's time to cough, which she does with conviction. Her phlebotomist has a fondness for drink, while *Boom!* gives us perhaps the phoniest looking blood in cinema history. Sissy barks orders to her beleaguered and uncomprehending staff of secretary, doctor, servants, and musicians. If she's so rich, why doesn't she hire a staff that speaks her language?

Taylor is a comic termagant, so unrelentingly churlish she forces laughter out of me. But the strange delight doesn't end there. *Boom!* also features one of Taylor's first self-referential performances. Sissy had six husbands, hordes jewelry, and suffers great back pain. Her hair is teased to tumbleweed volume. She hisses, snarls, and shows no presence of tenderness. She barely smiles, and we never hear that infectious laugh of hers. Can't a woman dictate her memoirs and drink in peace? Must she be hounded and inconvenienced by a bush-league staff and the Angel of Death?

For most of the film she's got as much fire as Kate of *The Taming of the Shrew*. And like Kate, she's prone to throwing things. When

Sissy sends Chris's book of poems into the air, Taylor flinches and breaks character at its faulty landing. But my favorite scenes feature Taylor with the effete Coward, who arrives on a brawny man's shoulders. They greet each other with a loud exchange of hoots. I see no point in asking why. Such moments are most in tune with *Boom!* as a demented comedy.

While *Boom!* is routinely mocked for Taylor's strangely realized character, it has earned genuine respect elsewhere. Thanks to cinematographer Douglas Slocombe, it looks great. It takes in long sunny afternoons, with a rich blue sea below set against the ragged cliffs of the island. Slocombe's camera peers through porthole windows of the villa, creating a shipboard effect, as Sissy will soon float to the undiscovered country.

Once *Boom!* was established as a major flop, Losey sought blame elsewhere, on the critics, audiences, and distributors. (The title credit reads B O O M, but during early marketing, the geniuses at Universal added a "!") It was panned hither and yon, and tanked at the box office. Taylor, who thought she was terrible in *Boom!*, aims Sissy between the distraught hysteria of *Suddenly, Last Summer* and the spasmodic anger of *Who's Afraid of Virginia Woolf?*, landing at some wretched place in between.

I don't pretend to understand the artistic intent or finished effects of *Boom!*, but I'll hand it to Taylor. This is her ultimate so-bad-she's-good performance. She's every inch the movie star, and once again I can't take my eyes off her. And apparently neither could Tennessee Williams, who reportedly called *Boom!* the favorite among his film adaptations.

Secret Ceremony (1968, Universal, directed by Joseph Losey)

Taylor didn't hold a grudge. She and Losey argued on *Boom!* but created no lasting ill will. She liked him enough to team again for *Secret Ceremony*. This is a late 1960s artsy movie, the kind that

began as cinema-going for grownups, then played revival houses in big cities for another fifteen years, then dropped off the radar. Its likely companion on a double bill would be *Boom!* featuring the same director and star.

Taylor is Leonora, a prostitute who makes a chance connection with Cenci, a waifish girl-woman (Mia Farrow in a Morticia Addams wig). Cenci reminds Leonora of her dead daughter, while Leonora reminds Cenci of her dead mother. Walled up in a grand art nouveau residential masterpiece in London, Leonora's and Cenci's mysteries and passions deepen. Robert Mitchum appears as Albert, Cenci's incestuous stepfather, with Pamela Brown (the High Priestess in *Cleopatra*) and Peggy Ashcroft signing in as a pair of eccentric aunts.

Based on a novella by Argentine Marco Denevi, *Secret Ceremony* had been filmed before for South American television. Losey's version was subject to an abundance of rewrites and uncertainties about relationships and motivations. In the novella, Cenci is blonde and chubby, and there is no Albert. Leonora isn't a prostitute, but instead is a fifty-eight years old devout Catholic. Losey was exploring the human need for ritual and our readiness to abandon each other. I think *Secret Ceremony* is also about the ceaselessness of mourning. In whatever interpretation, the result is a dense, difficult, and moody film.

Production accounts convey a mixed experience on set. The two women, one a studio system creation and the other representative of New Hollywood, got along well. Farrow was impressed at Taylor's professionalism and expertise, knowing how to match her movements and expressions shot to shot. But Mitchum reportedly got along with no one. Richard Burton was nearby making *Where Eagles Dare* (1968), while Taylor suffered through acute back pain. She also had a hysterectomy during filming, further warping the film's already twisted themes of motherhood.

Once again, Taylor is an asset in a film bereft of many. She's bawdy, regal, entitled, and sensual. Losey gives her extended

speechless scenes wandering the house, absorbing it into her cells. She eventually wears clothes belonging to Cenci's mother, blending the dead woman's identity with her own. She offers another all-over-the-place performance, not so much creating a coherent person in Leonora as a series of compelling if emotionally disconnected scenes.

Taylor's playing of a breakfast scene is out of order with the rest of the film, which is precisely what makes it amusing and memorable. Dressed in a glam hooded black satin mourning outfit, she inhales her plate of food, relishing every bite as if she were dining on orgasms. She chews luxuriously between sips of tea and dabbing her mouth, all the while being stared at by the extraterrestrial-like Cenci. She finishes with a loud belch. As a lonely and hungry prostitute, her empty stomach represents her empty life. Food fills her.

Reviews for *Secret Ceremony* were kinder in Europe than the United States and better overall than anything said about *Boom!* But the general reception was hardly favorable, and *Secret Ceremony* became another money loser for Taylor. The frequently mean-spirited critic Rex Reed sharpened his knives: "The disintegration of Elizabeth Taylor has been a very sad thing to stand by helplessly and watch. Something ghastly has happened over the course of her last four films. She has become a hideous parody of herself—a fat, sloppy, yelling, screeching banshee."

I include this review excerpt to illustrate Taylor's dilemma. Such disfavor was now typical among film arbiters, creating a downward vortex. Kind words on Taylor's work at the end of the 1960s are hard to find. Group-think established her "disintegration," and few bothered to look closer, much less write against prevailing beliefs. When Reed describes a nude Taylor as resembling "an enormous boiled turnip," he sacrifices legitimate criticism for insolence. He and others largely bullied and belittled her on the way down, leaving her later performances as regrettable afterthoughts. She was punished for being different more than being bad. It's now

clearer she was exploring the baroque and bizarre, something never allowed of her in the studio days of plastic glamour.

That is not to say I'm a fan of *Secret Ceremony*. It has its latter-day admirers, but I find *Boom!* a more entertaining calamity. *Secret Ceremony* was made and released at a pivotal time for Taylor and the film industry. It opened less than one month before the new Motion Picture Association film-rating system commenced on November 1, 1968, and was eventually rated R for restricted—persons under sixteen not admitted unless accompanied by parent or adult guardian. The Production Code that had so compromised *Cat on a Hot Tin Roof* and others was dead. Now, films were freer to tackle mature themes and be targeted to select audiences accordingly. *Secret Ceremony* didn't find a large following, but at least its murky preoccupations with mental illness, suicide, incest, rape, and murder could be fairly explored and honestly marketed.

At the time of production, *Reflections in a Golden Eye*, *Doctor Faustus*, and *The Comedians* had all opened and bombed. Universal committed over $3 million to *Secret Ceremony* before *Boom!* was released. The studio was displeased with both, and Taylor's status as bankable movie star was in real jeopardy. When *Secret Ceremony* appeared on NBC television, it was chopped up so badly as to be nearly unintelligible. It moldered in obscurity and disregard for years. *Secret Ceremony* was remastered in 2020 and is available for fair appraisal once again.

Anne of the Thousand Days (1969, Universal, directed by Charles Jarrott)

At minute sixty-one of this costume drama, Queen Katherine of Aragon, played by Greek actress Irene Papas, is praying in a chapel. She hears party commotion from the nearby hall. The door bursts open and two revelers enter. One of them is Taylor, who quickly hides behind a feathered mask. Burton starring as King Henry

VIII is the obvious explanation for Taylor's unbilled cameo. So is her wifely oversight as he screen romances young French Canadian actress Geneviève Bujold as Anne Boleyn. Taylor's appearance is a pointless moment that pulls us out of the action, with Papas's deadpan reaction needing the thought bubble, "Did I just see Elizabeth Taylor?"

The Only Game in Town (1970, Twentieth Century-Fox, directed by George Stevens)

Taylor's career, health, and marriage were in trouble when she made *The Only Game in Town*. The effects are unfortunate. Her brittle performance may be as much from personal anxieties as character interpretation.

Frank D. Gilroy wrote the screenplay based on his play, and that was the first misstep in getting this on film. He enjoyed a Pulitzer Prize–winning triumph with the intense family drama *The Subject Was Roses*, which became an Oscar winning 1968 film. But *The Only Game in Town* was no *The Subject Was Roses*. It ran for a pitiful sixteen performances on Broadway. Gilroy's script failed to supply the reimagining the play needed to make the transition.

Taylor likely believed the project had promise because of the people attached. *The Only Game in Town* is a chamber drama, with chorus girl Fran and lounge pianist Joe lurching their way to love under the neon nights of Las Vegas. No less than George Stevens, the man who guided Taylor so effectively in *A Place in the Sun* and *Giant*, was on board to direct.

Frank Sinatra was to be Taylor's costar, but he backed out. Warren Beatty, who had tremendous respect for Stevens, replaced Sinatra. Taylor and Beatty formed a problematic duo. He was relatively new to films, scored a massive breakthrough as producer-star of *Bonnie and Clyde* (1967), and represented the vanguard replacing aging studio stars epitomized by Taylor. In fact, *Secret Ceremony*'s

Mia Farrow and Beatty's girlfriend Julie Christie were discussed for Fran. Both had "New Generation" stamped on them and were a decade younger than Taylor.

Production began in September of 1968, while Taylor was distracted with being the world's most famous celebrity movie star. She was also laboring under intense back pain, and shot *The Only Game in Town* in a brace. Why did she and Burton live and work at such a frantic pace, and why were they so quick to accept offers? "Elizabeth and Richard didn't have much of a choice," noted Taylor's official photographer Gianni Bozzacchi. "They were trapped inside their own fame. A helicopter, a plane, a luxury car, an entourage, a yacht, homes in various countries, lawyers all over the place, not to mention children. . . . All this had to be paid for, which meant work. Lots of it."

The Only Game in Town was shot at the Fox lot in LA, various locales around Las Vegas, and in Paris. The overseas location accommodated Taylor's demands to be near Burton while he filmed the homosexual love story *Staircase* (1969) with Rex Harrison, *Cleopatra*'s Caesar. During shooting, the Burtons partied with the German Rothschilds and Marie Helene and Alexis Redé. Taylor was reportedly indulging heavily in booze and narcotics. Delays and costs compounded, and the film didn't wrap until March 1969.

The Paris shooting, the delays, and Taylor's $1.25 million paycheck resulted in the cheapest looking super-expensive film you may ever see. Stevens commits repeated lapses in judgment. The opening takes a cue from *BUtterfield 8*, with Fran's alarm clock rousting her at 3:15 PM. Soon she is on the darkening streets of Vegas as the opening credits play like some low-cost TV movie of the same era. Taylor is badly rendered visually, her miniskirts and flipped hairstyle achieving a mod-retro effect. The close-up inserts of Fran in a production number are risible.

Taylor and Beatty make anti-chemistry. Neither appears happy in the other's company. That's a bit surprising, considering both can be so crackling good with opposite-sexed screen

partners—Montgomery Clift, Paul Newman, and Burton for her, and Christie, Diane Keaton, and Annette Bening for him.

Fran is a rare withdrawn character for Taylor, who infuses her with an uncharacteristic timidity. She's content to nest with old movies on *The Late Show* in her small apartment, while incessant blinking Vegas lights spell *S-a-h-a-r-a* from her terrace. She's is one of those people whose terror of being hurt and alone guarantees she will be hurt and alone. She alternatively stutters, looks away, rebuffs, whines, and pleads, while an unfinished dress hangs on her living room dummy to symbolize a half-lived life.

The Taylor-Beatty scenes, which comprise the bulk of the film, appear scrappy and hastily assembled. There's much chitchat going nowhere, as though Taylor, Beatty, and Stevens are grasping to define these characters. At their best moments, both stars achieve a certain essence of loneliness, while Beatty does some committed acting when he's deep in high-stakes gambling. But *The Only Game in Town* is predominantly a bloodless affair, void of interest or even a reason to exist. It's a sad coda attached to the star and director who did such remarkable work together in the 1950s. Stevens had lost his touch, and he never made another film. *The Only Game in Town* lost millions of dollars. So did *Staircase*. The days of seven-figure paychecks for the Burtons were over.

X Y & Zee (also released as *Zee and Co*) (1972, Columbia, directed by Brian G. Hutton)

Brian G. Hutton met Taylor when he directed Richard Burton in *Where Eagles Dare*. He liked her immensely and found her most helpful in keeping Burton happy and (mostly) sober. They signed on to work together on a script by novelist Edna O'Brien about a warring married couple in London. *Zee and Co*, as it was originally titled, lacked the theatrical artifice and poetic dialogue of Tennessee

Williams and Edward Albee. It was more like spying on loud sleazy neighbors who leave their curtains open.

X Y & Zee, as it was titled in the United States, was in production fourteen weeks at Shepperton Studios in Surrey, England, where Taylor filmed *Suddenly, Last Summer* more than a decade earlier. Michael Caine and Susannah York completed the star lineup. Margaret Leighton, current wife of Taylor's second husband Michael Wilding, took a supporting role as Gladys, the boozy hostess of a turned-on party of London's most eccentric creative types.

Caine relished working with Taylor. "I very quickly got a sense of the awe with which she was regarded," he wrote. "Unlike the rest of us, who were expected to be on set at 8:30 in the morning, her contract stipulated that she didn't have to show up until 10:00—and we were given a running commentary on her journey: 'She's just left the hotel . . . the car's pulling up outside . . . she's in makeup . . . she's in hair . . . *she's on her way!'*" Adding, "She was delightful, utterly professional, and the only actor I've ever been on set with never to mess up a line." Hutton had an easygoing relationship with Taylor and could make her laugh, so the filming of *X Y & Zee* was largely positive. Taylor even got a prize for it, Italy's David di Donatello Award for Best Foreign Actress.

The set-up is simple. Zee (Taylor) and Robert (Caine) are a childless married couple hanging on by acrimony and sadomasochism. She throws away their money; he rubs her face in his affairs. He's possessive; she's vindictive. He wants out, or says he does, but she perseveres. He romances fragile dress designer and boutique owner Stella (York). Zee does everything to disrupt them, including her own seduction of Stella.

The opening slow-motion ping-pong game offers symbolism on the give and take of marriage, or maybe it's to illustrate Zee and Robert can have fun together. Or maybe it's just a ping-pong game. Soon they are flashing their talons. It's very *Who's Afraid of Virginia Woolf?* without the verbal word play and underlying recreational sport.

As a screen partner to Taylor, Caine is no Burton. He's rather too intimidated to give anything but a standard performance of a rotter. He and York are deprived of good lines and are repeatedly immobilized and silenced by Taylor's High Harridan command performance. During production, Burton could see that *X Y & Zee* belonged to Taylor: "There are always little subtleties in Elizabeth's performance to be discovered anew, whereas Caine and [York] are always carefully studied but obvious."

Something about this story, this director, and these actors combined fortuitously for Taylor. She hadn't been this engaged since *The Taming of the Shrew*. In *X Y & Zee* she becomes the raucous bawdy comedienne we knew she could be. There *is* some virago redundancy going on, with lines spoken with the near exact inflections found in *Virginia Woolf*. But taken by herself, Zee is a barnstorming trickster, and Taylor is clearly having a ball. Her delivery of one word—"piranha"—is a delight of timing and innuendo. Maybe a creeping insouciance lightened her late career attitude. "I'm so bloody lazy," she said at the time. "I think I should retire. I should quit and raise cats."

Zee strives to be utterly insufferable. One reviewer called her immoral, but is that fair? She's trying to save her marriage, however obnoxiously. Her methods are more on the order of harassment than assault. As a spurned wife, she yells into the lovers' bedroom from the street below, topples a garbage can, and throws luggage out the window. A cuckold might do far worse to his wife and her lover. Zee is hardly spiking Stella's tea with hemlock or planting a bomb under her car.

Zee begins as Martha in clown face. The standard descriptors for Martha—loud, vulgar, sloppy—apply 100 percent to Zee. But Zee is both more and less than *Virginia Woolf*'s damaged heroine. She finishes what Martha couldn't because of censorship's last gasp. It's a bracing delight to hear Taylor deliver "shit" and "son of a bitch" loud and clear with all the conviction she has, the censors now vanquished.

Zee is a brazen and taunting broad, and as dedicated to saving her marriage as Taylor is to pleasing her dwindling film audience. She abandons the pretense that *X Y & Zee* is a drama and floats above a film that otherwise takes itself too seriously. (And the multiple critical references to Taylor's weight gain at the time read like misogynistic fat-shaming today.)

X Y & Zee is all Taylor—if you're not amused by her performance, then there's little else to recommend. Certainly not a vapid York in an underwritten role or a piggish Caine devoted to conquest. Hutton's direction is journeyman level, and the script disserves the actors. When Zee gets tender and loving near the end, it's too little too late. She has been making life a ceaseless hell for her husband and his mistress, so a display of her softness and vulnerability late in the show reads as insincere.

When the time comes for Zee to make her move on Stella, she trades her gaudy '70s muumuus and ponchos for a sensible black and white suit. Zee approaches her as an enabler approaches a drunk, preying on vulnerabilities without a genuine emotional bond. Taylor has never looked more heterosexual than during a hug of comfort that initiates their off-screen lovemaking.

This is lesbianism as plot device. There was shock value to same-sex coupling in films of the era, but Hutton runs so far from exploitation that *X Y & Zee* becomes tepid when it ought to scorch. It's far less sensational than the lesbian psychodrama *The Killing of Sister George* (1968), also with York. It's light years away from *The Vampire Lovers* (1970), *Countess Dracula* (1971), or others of the brief but fabulous lesbian vampire horror subgenre coming from Hammer Film Productions. *X Y & Zee* trades a bit of tawdry for such restrained homophobia. After Zee has finished the job of making love to Stella, she quietly reassembles. Stella lies in a stupor of misery, blanket up to her chin, hair flat, and face streaked with tears. Could making love to Elizabeth Taylor be *that* dreadful?

Under Milk Wood (1972, The Rank Organization, directed by Andrew Sinclair)

Burton took his great affection for writer and fellow Welshman Dylan Thomas (1914–1953) and devised a movie around him as artistically elevated and commercially limited as *Doctor Faustus.* Thomas's poetic prose had been a 1954 radio drama and was given staged readings, but it was altogether nervier to put *Under Milk Wood* on film. Sacrifices would be made. Burton and Peter O'Toole, as the two key players, would work for free. So would Taylor as Rosie Probert, the sailor's whore.

Other fine players, including Glynis Johns, Vivien Merchant, and Siân Phillips, signed on, but this was Burton's show. He knew Thomas, loved his writing, and maintained a lifelong connection to his Welsh homeland. With his dulcet voice speaking Thomas's evocative words, Burton seemed almost preordained to make *Under Milk Wood.* Free of all commercial aspirations, it "was a brave thing, a wonderful thing, a beautiful thing to do," said Burton immodestly.

Taylor was moved by the language, the setting, and Thomas's significance to her husband emotionally and artistically. *Under Milk Wood* was filmed at Fishguard, a coastal village in Pembrokeshire, in January 1971. Taylor's role was tiny, while Burton and O'Toole, reunited for the first time since *Becket*, had the major acting responsibilities. Taylor was on the job for just two days. Her scenes were filmed in London by doctor's orders to accommodate her chronic back pain.

Under Milk Wood is a lovely film requiring surrender to its purpose as a rare Thomas cinematic showcase. Poetry and lyricism meet and comingle with realism. It doesn't always work. Visual literalism against Thomas's poetry can have an unfortunate show-and-tell effect. And I'm sorry to report Taylor's involvement leaves me vexed. Her *Cleopatra* eyeliner and careful lighting are offenses to the film. She appears unwilling to detach movie star from actress

in service to the role. While everyone else reeks of cod, Taylor looks ready to present the Academy Award for Best Picture. It's a real shame, as her vanity becomes an obstacle to her performance and the success of the film. Her voiceover is stunning, however, simple and unforced, with Burton judging her Welsh accent as magnificent. "I am going into the darkness of the darkness forever," says Rosie at her death. "I have forgotten that I was ever born." It's as purely fine a line reading as Taylor ever gave.

Hammersmith Is Out (1972, Cinerama, directed by Peter Ustinov)

In the spring of 1971, the Burtons arrived in Cuernavaca, Mexico, to film this flea market *Doctor Faustus*. Peter Ustinov, who appeared with the Burtons in *The Comedians*, would direct. Financing came from J. Cornelius Crean, founder of Fleetwood Enterprises mobile homes.

Narrated by Ustinov, *Hammersmith Is Out* traces the quick rise and even quicker fall of nose-picking Texan Billy Breedlove. Hammersmith, a straitjacketed psychiatric hospital inmate, promises Breedlove wealth and fame in exchange for his freedom. Breedlove gets Hammersmith sprung, and sure enough he comes to own a pharmaceutical company and strip club, advancing on to oil tycoon and political kingmaker.

Taylor is Jimmie Jean Jackson, a blonde-wigged Helen of Troy who slings hash in a southern roadside greasy spoon. "Hey—I could go for you" she coos Marilyn Monroe-like to Billy (Beau Bridges). She joins him on his upward trajectory. Once Billy is rich, Jimmie becomes someone more resembling Elizabeth Taylor. She loses her southern twang and shows up in shimmering jewels, bright stylish caftans, and her signature black hair. (Legendary costumer Edith Head's credit on this film now makes sense.) Billy and Jimmie come to despise each other, while Hammersmith grants Jimmie's wish of

motherhood. Billy commits suicide and Hammersmith returns to incarceration.

Hammersmith's attempts at being . . . what exactly? . . . fail absolutely. Ustinov packs it with quick edits reminiscent of a Richard Lester Beatles movie, with free-floating voices whispering, "Hammersmith is out" to convey madness. But *Hammersmith* torpedoes its own effort to be an offbeat darkly funny crime caper film. The humor is strictly lowbrow. Nightclub owner Guido Scartucci, played by movie tough guy George Raft, runs a nightclub with an all-woman's topless band called The Tits. Ustinov, who cast himself as a doctor, is seen reading "Studies in Anal Retention." As Hammersmith, Burton is at his worst. He's got the opportunity to play lunacy in fifth gear, and he blows it. Though he expressed some enthusiasm for Hammersmith in his diary, his robotic delivery conveys the effects of hardcore alcoholism and his contempt for the venture. This might be fun only if watched with friends supplying *Mystery Science Theater*–style commentary over wine and/or edibles.

Taylor goes hammy as she did with *Boom!*, but her performance there was at least consistently misdirected. In *Hammersmith Is Out*, she's flailing. As the dim Jimmie, she first throws her voice into an upper octave to simulate youth. She's generally a harridan but has a moment of warmth at describing her desire for motherhood. When Billy suffers a waterskiing "accident," Taylor's suppression of delight is wickedly satisfying. Then she goes on an emasculating rampage, tossing insults like "monkey dick, peanut balls" to the newly invalided Billy. She pouts, grimaces, smirks, chortles, and purrs in a kind of sideshow for her fans. She doesn't provide a character as much as a series of entertaining moments.

Ustinov paid Taylor a high compliment during the making of *Hammersmith* by way of voicing his artistic shortcomings. He said Taylor's "instinct of what a woman would do under various circumstances is devastating and unnerving and absolutely invaluable to a clumsy writer or director who is struggling to put his great

flat feet into a woman's shoes." But Taylor's gift to Ustinov isn't obvious in the film, leaving me to believe he was more desperate and she was less inspirational.

Hammersmith Is Out sat on the shelf for about a year, but it was eventually released in 1972. It disappeared quickly in the United States but performed better in Europe. Taylor even won the Silver Bear for Best Actress at the Berlin Film Festival. Even so, I feel something akin to sadness watching *Hammersmith Is Out*. It provides a strange time warp with the inclusion of Leon Ames in the cast, an actor found in *A Date with Judy*, *Little Women*, and *The Big Hangover* from Taylor's long-ago years at MGM.

But more sadly, *Hammersmith* confirmed Taylor was reduced as an artist. The early 1970s was a period of great ferment in American cinema, with new directors shaking up established practices and making brilliantly idiosyncratic films. Robert Altman, Francis Ford Coppola, Hal Ashby, Peter Bogdanovich, Steven Spielberg, and Martin Scorsese were all ascending, and Taylor would never work with any of them.

Night Watch (1973, Avco Embassy-Brut Productions, directed by Brian G. Hutton)

The plot shell of *Night Watch* has Taylor as Ellen Wheeler, living unhappily with her businessman husband in an art-packed flat in London. She's an insomniac, and on a dark and stormy night, she sees a murder in a tall derelict house that abuts her backyard. Or does she? Nobody believes her, and her demeanor veering toward a nervous breakdown further damages her credibility. Since everyone thinks she's crazy, we the audience *don't* think she's crazy. She just needs to prove herself.

Night Watch is a film to recall other films. It was Taylor's second and final outing with Laurence Harvey (*BUtterfield 8*). As an entry in the wife-driven-to-madness suspense-mystery subgenre, it

borrows from *Midnight Lace* (1960), maybe even a little *Rosemary's Baby* (1968), and topped off with a touch of *Rear Window* (1954) voyeurism. It originated as a play by Lucille Fletcher, author of the great radio suspenser *Sorry, Wrong Number*, which became a nail-biting 1948 film starring Barbara Stanwyck. I imagine it worked well on stage, where claustrophobia, hysteria, and tension could be well controlled.

The early 1970s produced some impressively sophisticated suspense-horror films, from *Don't Look Now* (1973) and *Sleuth* (1971) to the box-office juggernaut *The Exorcist* (1973). *Night Watch* does not qualitatively belong in their company. Made on a modest budget by a production company spawned from Fabergé cosmetics, it looks only slightly more posh than a Hammer horror film of the same era. Director Brian G. Hutton, back with Taylor after *X Y & Zee*, employs a wide selection of haunted house clichés. Filmed in a flat in Bayswater, there's heavy rain, thunder and lightning, clapping window shutters, and a creaky floorboard. (He spares us a hissing black cat.) His post-production flourishes are equally redundant, from shrieking violins to shock edits and mysterious flashbacks.

Burton called it one of his wife's "sadly deteriorating" movies. This was the closest she came to the matron in distress–Grand Guignol horror game of her screen predecessors Bette Davis (*Whatever Happened to Baby Jane?*, 1962), Joan Crawford (*Strait-Jacket,* 1964), and Olivia de Havilland (*Lady in a Cage,* 1964). But she was only forty-one and negotiated far more flattering terms than the others, with costumes by Valentino and soft lighting by director of photography Billy Williams, another alumnus of *X Y & Zee*.

Night Watch gives Taylor opportunity to do some of her best cinematic screaming since Catherine in *Suddenly, Last Summer*. Those paralyzing eyes are unsurprisingly well suited for horror, enlarging on cue. Her voice turns raspy and tired, well expressing the exhaustion of prolonged anxiety and neurological stress. But the film needs modulation. As soon as Taylor spots a murder, she

goes full out hysterical. That's understandable, but she never loses confidence in her vision. With every one around her saying she's nuts, she ought to have moments of "I guess you're right. I guess it was all in my head." She never does, leaving her with a performance alternating between shaky and commanding, accusatory and withdrawn.

Taylor has more fun in the last half hour, as she assembles a literal and metaphoric jigsaw puzzle. The in-for-the-kill revelation and resolution somewhat redeem the film's more cautious earlier scenes. Startling acts of violence appear late in the film. Taylor has appeared verbally assaultive plenty of times, it became something of a trademark after *Who's Afraid of Virginia Woolf?*, but physically assaultive is something else. And, true to form, she goes all in.

The strength of the ending serves to highlight the weakness of what came before. The film is humorless, not once does Taylor break out with a full smile or deliver that fantastic cackle of hers. I get a feeling of missed opportunities with *Night Watch*. It's a shame she didn't do more horror. Too bad she never worked with Stephen King. She's got the right intensity, rage, and nervous energy.

Night Watch had a premiere engagement at the Radio City Music Hall, a showy venue entirely ill suited to such a humble film. It bombed. Still, she enjoyed working with Hutton and was delighted to reunite with friend Laurence Harvey. She was bereft when he died of stomach cancer soon after production wrapped. He had nothing but effusive praise. "I adore her," he said. "She's one of the few people I've ever worked with who really gives me something in return. One of the very few. With a lot of actresses I just have to imagine them being what I can read into the parts they play. . . . With Elizabeth it's different. When she speaks and behaves like Ellen in *Night Watch*, I know that *is* Ellen. There's no question about it being anybody else. It's because of her absolute concentration on what she is doing."

Ash Wednesday (1973, Paramount, directed by Larry Peerce)

Barbara Sawyer is a wealthy fifty-five-year-old woman stuck in a marriage dying of ennui. To repossess her straying husband and wobbly self-esteem, she undergoes a grueling series of full-body surgeries. In a voiceover, the doctor explains to her and us what will happen. There's no reassurance when he tells Barbara it won't hurt a bit, as he inspects Taylor's makeup of sags, bags, and wrinkles. He scrawls lines all over her face with a thick pencil, then pinches her body double's fleshy midriff. There's a bit of science fiction thrown in, with injections given to revivify her internal organs.

Barbara is one of the supreme do-nothings in the Taylor canon. Beauty is all she has—or had. She's presented with terrible options: don't get the surgery, lose your man, and be miserable. Or get the surgery to keep your man and confront the shallowness of a husband who loves you only for your looks. Such are the choices of those who live exclusively for others.

Ash Wednesday begins like a horror film, complete with the gruesome realities of cosmetic surgery. An actual facelift is performed on screen long before the TV series Nip/Tuck debuted in 2003. Apparently no one involved thought to lighten this film with intentional humor, which it sorely needs to balance the knives and blood, and long wanderings of Barbara in recovery. It's slow and grim to start, with a quietly pained Taylor doing what she can under immobilizing tight bandages.

Ash Wednesday stirs my interest as a barometer of attitudes on plastic surgery. The film is more severely judgmental than any of us are likely to be. Director Larry Peerce treats facelifts, tummy tucks, and chemical peels as physical and psychological terror. Those who submit to the knife are vain and shallow, transferring a dread of aging into something addictive and immoral.

Barbara has joined a vampiric underworld. The swaddled patients who stroll zombie-like through the posh recovery resort in

the Dolomites have spilt their own blood in a strange tribal initiation. David (Ketih Baxter), her spirit guide for the falsely youthful, warns her. Don't go in the sun, drink only mineral water, not wine. Lose the dowdy wardrobe. Another man expects her to reject her adult daughter, since she now looks more like a kid sister.

Ash Wednesday doesn't stick with its ghoulishness. It transitions into something like a funhouse mirror version of a Lana Turner weepy; William Castle meets Ross Hunter. This becomes one of Taylor's dress-up movies. She wore her own jewelry here; the pearl pendant earrings are from her collection. Barbara loves her new beauteous self and gazes into mirrors and reflections like Narcissus of Cortina d'Ampezzo. But her stares transmit aimlessness and alienation as well. This is a woman who doesn't know herself. Peerce includes extended scenes of her solo, while everyone around her is coupled or in reveling gangs. Taylor is exploring loneliness on screen, which is rare for her.

Barbara calls herself the "last of the sex in the dark generation." There's not much to her besides being the wife of a successful Detroit lawyer. She's Kay from *Father of the Bride*, grown up, middle-aged, and disillusioned. "I don't enjoy doing things without you," she says to her husband. When he considers plastic surgery, she rather pitifully says, "Don't you dare" in mock outrage. She's exposing the tired double standard that old men are distinguished, but old women are hags. Taylor herself claimed to have few hang-ups about aging. "My efforts to make myself look good are not attempts to make myself look young," she said.

Taylor rose above *Ash Wednesday*'s problematic script and direction to deliver a performance of sporadic poignancy. She had to warm to the film. "I didn't really like the script the first time I read it," she said. "It sort of gave me a yucky feeling. Two months after reading it, I could remember every scene and every emotion this woman went through. Now that's very unusual with a script." The subject agreed with her. The film's technical advisor, Dr. Rodolphe Troques, said, "She never had to be coached and yet, in the picture, she behaved exactly like the average patient I operated on." Taylor's

Barbara was good enough to earn a Golden Globe nomination, one of the few post–*Who's Afraid of Virginia Woolf?* performances to be cited for any laurel.

Henry Fonda shows up in the small but dreary role of Mark, Taylor's cold husband. They enact the familiarity of a long-lasting couple, but we know little of what's at stake if the marriage dies. Mark is involved with a younger woman, proving that youth *does* matter and surgery won't change the fact that Barbara is fifty-five. We see her trying so hard, but privately knowing it won't work. She places her fingertips at her temples, and speaks haltingly, "Look, Mark . . . Look at this face. Isn't it almost the face you married? Look, Mark. Look at these breasts. Aren't they beautiful?" She's soft and vulnerable, but Mark remains unmoved.

The film's cruelties were enlarged as Richard Burton was a frequent guest on the set, drunk on port and openly mean. Their marriage was taking its last breath. "Elizabeth was at the height of her domestic crisis," reported actress Margaret Blye, who played Barbara's daughter. Taylor "was hell bent on self-punishment. She would comfort eat so she couldn't fit into her costumes, then explode in anger—mostly at herself."

Turns out *Ash Wednesday*'s best moments are between the two actresses, where Taylor *finally* has a chance to reveal some human emotions. But *Ash Wednesday* is not explicit in its condemnation of women's limited choices. Barbara cannot or will not break free of her narrow self-image and confront her conditioned response to marriage and men. Or does she? We're left wondering. Her gait after Mark's train leaves the station has a new confidence. *Ash Wednesday* ends with the flickering promise of Barbara's self-discovery.

The Driver's Seat (a.k.a. *Identikit*) (1974, Avco Embassy, directed by Giuseppe Patroni Griffi)

I usually bristle when a performance is labeled courageous. Firefighting is courageous. Acting not so much. That said, Taylor in

The Dirver's Seat tempts me to grant an exception. This is a coura-
geous performance. Her first marriage to Richard Burton was over,
her career was moribund, and her future uncertain. *The Driver's
Seat* was a step outside and beyond anything she'd attempted be-
fore. This is her first film that doesn't have American or English
money behind it. It's all Italian, shot in Rome, produced by Franco
Rossellini, and directed by Giuseppe Patroni Griffi. Perhaps fa-
talism had set in. The critics were going to kick her anyway, so why
not do something dark and outrageous?

At first glance, *The Driver's Seat* refuses to be coherent. It's a
maligned film, breaking many of the rules believed sacred, or
at least recommended, to storytelling. It unfolds in jagged non-
linear progression, with everyday business disturbed by scenes
of police interrogations. (*Identikit*, a picture made from witness
descriptions in a criminal investigation, is a superior title.) The di-
alogue is insane. What would *you* do with the line, "When I diet,
I diet, and when I orgasm, I orgasm. I don't believe in mixing the
two cultures."?

Repeat viewings don't reveal all connections in the film's many
troubling incidences and encounters, but they do reveal its di-
abolical intent. When I lowered my defenses, the ones believing
The Driver's Seat was merely an inept psychological drama, it be-
came far more unsettling. For years, *The Driver's Seat* was avail-
able only on degraded videotape. When I finally saw it on a finely
remastered print, I was startled into a reassessment. Taylor gives
a performance of raw nerves and mental instability that can't be
dismissed with nervous laughter and broad swipes at the film's
many eccentricities.

Taylor is Lise, a mysterious woman traveling alone from London
to Rome. She encounters various people, but she's distracted and
perturbed, and her behavior is intermittently hostile. She meets
the sexually aggressive Bill (a leering Ian Bannen), who promotes
daily orgasms and a macrobiotic diet. Later she shares a taxi with
friendly Mrs. Fiedke (Mona Washbourne), who goes shopping with

Lise in a segment of the film that seems almost normal. But even then Lise assumes a gaze with no light behind it. Eventually we realize she is in search of a man who will murder her according to her exact instructions and so end an empty life.

The Driver's Seat derives from a short novel of spare and terrifying prose by Muriel Spark (*The Prime of Miss Jean Brodie*). Though two writers are credited with the screenplay, Taylor told reporters the film was made without a formal shooting script. Not surprisingly, scenes have a loose improvisational quality. And despite the free-formed dialogue, the film adheres closely to the book. It captures what Spark called an "indecent exposure to fear and pity, pity and fear."

Exact dialogue wasn't forthcoming during production, but instructions and purpose were. The script called for Lise to be "garish and vulgar." She's sporting tortured rat's nest hair and carrying a tacky plastic shopping bag. She wears a Valentino dress that is one degree shy of a circus tent—pink, green, yellow, orange, and blue.

A reporter for *Vogue* was on the set and offered a rare impression of Taylor in production:

> Liz saunters in around four, followed by her private secretary, her private hairdresser, and her private wardrobe mistress. Her face is incredibly beautiful, especially those famous purple eyes, and her body is surprisingly trim. She kisses Franco, Giuseppe Patroni Griffi (the director), the other actors, a favored assistant or two, and begins work at once, having been made up, coiffed, and dressed at the hotel. The crew is ready for her because they have rehearsed the scene with her private stand-in, an Italian girl who has stood in for Liz in eight movies. On the first take, Liz executes the scene perfectly; she walks through the terminal with 200 extras; she screams as an Arab Terrorist cuts through the crowd; she faints away as he stabs a man at her feet. The scene happens so fast and looks so real, Andy [Warhol, in a cameo appearance]

thinks it *is* real and panics. "My god," he flashes; "Liz is still Jewish isn't she?"

The Driver's Seat had troubles with marketing and distribution, and it was snubbed for the Cannes Film Festival. Rossellini and Griffi were enraged and planned their own splashy premiere as competition. They took it to Monte Carlo for a glittering party at the Hôtel de Paris hosted by His Majesty Prince Rainer and Her Highness Princess Grace, the former actress Grace Kelly who was almost *Giant*'s Leslie Benedict. The invitations were gold-encrusted and engraved with the official seal of Monaco's Royal Palace. Monte Carlo became the place to be, not Cannes. The event attracted Salvador Dali, Franco Zefferelli, Vittorio de Sica, Christina Ford, Aristotle Onassis, and Taylor. "There were so many diamonds and emeralds they were bouncing light from the chandeliers," reported the *New York Daily News*.

How very strange, then, that such a starry event circled around a film as sick and twisted as *The Driver's Seat*. We know Lise is disturbed early on, when she goes berserk in a dress shop and at being touched by airport security. "What's that coming out of your trousers?" she asks deadpan to Bill, as one of his pocketed food bags springs a leak, sending meal down his pants and onto the floor. Taylor repeatedly chills me with her languid matter-of-fact readings of appalling lines:

"Do you carry a revolver?" she asks a man in uniform.
"No," he says.
"Because if you did, you could shoot me," she says with a smile.

The absence of background on Lise contributes to the uneasy sum of the film. She is mentally ill. Why? In more typical storytelling, that would be a fair question. Here, it's irrelevant. Minus a formal script, Taylor reportedly invented many of the scenes herself as an autobiography with shock value. But Taylor's familiarity works against her here. That's Velvet Brown and Cleopatra on the screen, not some pathetic everywoman looking for an avenue to death.

Fortunately, the intervening years have reduced the blinding effects of fame and allowed Taylor's performance to stand apart. She's transfixing, free of the usual concerns for her relationship to the camera. She nails Lise's peculiar rhythms and surrenders to the unflattering demands and peculiarities of the role in ways not seen since *Who's Afraid of Virginia Woolf?* She's more vulnerable and exposed than ever, permitting us to catch her descent not with grand gestures, but with a succession of disturbing small moments. She's given multiple tight close-ups, the imperfections and blemishes of her skin in ready view. She is unguarded and stripped down. She applies thick raccoon eyeliner as though she were at home making up for Halloween.

The uncertainty of this woman's sickness and potential for violence keep me on edge. Lise is capable of something awful, and to endure *The Driver's Seat* is to confront the yawning emptiness of her existence. Taylor is controlled, deliberate, and purposeful in the final scene. Lise's calculated orchestrations of her murder could be the creepiest moments Taylor ever put on screen.

Even intrepid film watchers might very well abandon *The Driver's Seat* after twenty minutes. I'm forgiving of it primarily because of Taylor's audacious and judiciously wry attack on the material. I love Taylor when she's quiet and understated, at least for her. But stripped down and *crazy* is a first. She's distantly removed from the amplified explorations of insanity in *Raintree County*. Her low-key, soft-spoken manner here exposes rather than hides the troublesomeness of her words and actions. She plays Lise just a bit east of normal—not enough to raise serious alarm, but enough to hope she won't be a seat neighbor on a flight from London to Rome.

That's Entertainment! (1974, MGM, directed by Jack Haley Jr.)

In 1974, an ailing MGM released a documentary celebrating its fantastic musical legacy. Packed with clips of Fred Astaire, Gene Kelly,

Judy Garland, and a horde of other musical stars of yesteryear, *That's Entertainment!* cost almost nothing to make and reaped millions. Taylor was one of ten former MGM stars to narrate a portion of the film on camera. Her segment was filmed in Rome at the time she was making the psychological thriller *The Driver's Seat*—and what a contrast these two films provide. Taylor is given the gauzy old-fashioned treatment here, regally descending a movie staircase in a shimmering blue gown. She comments on her modest musical skills as we see a clip from *Cynthia*. "I was ten years old when I first came to MGM, and I spent most of the next eighteen years of my life behind the walls of that studio," she begins. "As a young girl growing up in that strange place, it's hard to recall what was real and what wasn't." Innocuous enough, though it might summarize the condition of Taylor's life as perpetrated by MGM at least through her studio-produced marriage to Nicky Hilton.

The Blue Bird (1976, Twentieth Century-Fox, directed by George Cukor)

Here's another one that came with anticipation and excitement: an adaptation of the 1908 French play *L'Oiseau blue* by Maurice Maeterlinck. The allegory of two children in search of happiness was to be directed by the great George Cukor (*The Philadelphia Story* [1940], *My Fair Lady* [1964]) and costar Ava Gardner, Jane Fonda, and Cicely Tyson. But the plum casting belongs to Taylor. She would take not one but *four* roles—as Mother, Witch, Queen of Light, and Maternal Love. Though surrounded by other actresses, Taylor was certain to dominate.

Touted as the first Russo-American co-production, *The Blue Bird* had strange financing. The money came from Twentieth Century-Fox, Mosfilm, and mobile home tycoon J. Cornelius Crean, who had also been executive producer on *Hammersmith Is Out*. The budget was set at a hefty $15 million, but gone were the perks

Taylor had come to expect. She had $3,000 a week for expenses, which didn't cover housing for her, her boyfriend Henry Wynberg, her secretary/assistant, and various traveling pets. Another pot of money went to remaking Taylor's costumes to her liking. Cukor wrote to a producer: "renegotiated my agreement with the Soviets" so that Taylor's costumes would be built by Americans.

Taylor started January 27, 1975, in Leningrad, and by February 19, she was diagnosed with "grippe" as reported by an attending doctor. She suffered from swollen glands and was exiled to her suite with a mixture of antibiotics and cough suppressants. A rare bright spot had her talking to Edith Head long distance about costumes. Then in April, with the production still grinding, Taylor got amoebic dysentery, sending her to a hospital in London for treatment.

Conditions on the set completed the misery. Infectious diseases were shared among cast and crew. Rather like Monday morning quarterbacking of *Cleopatra*'s England shoot, the problems plaguing *The Blue Bird* seem so obvious now. A Russian co-production added costs, delays, and translation problems aplenty. Worst case scenarios weren't covered. Producers came and went. Angry memos flew regarding payment and who does what. And at seventy-six, Cukor, a forty-five-year veteran of the film business, lacked the fortitude to negotiate so much miscommunication or properly wrangle a multilingual crew.

Production was horribly protracted, and bankrupt, but blessedly completed in August. Taylor could only hope the months of deprivation and illness would pay off in a financially successful film. That didn't happen. *The Blue Bird* was a critical and box-office failure of the highest level. Critics hissed and moviegoers stayed home.

The widespread rejection of *The Blue Bird* is largely merited. Cukor's desperation is discernable in every scene. Actors are awkwardly blocked, like they were playing to a live audience rather than a camera. The film has alternating visual styles resulting in jarring discontinuity. An extended dance sequence looks like it was filmed

off a theatrical stage for public television. Second-rate special effects cheapen the live action. Exterior shots look like strolls in a large city park. In the plus column, the Castle of Darkness, the Oak Forest, and the Queendom of Night are terrific set pieces made from paint and lumber in the tradition of pre-CGI studio craftsmanship.

There's effort and failure to inject magic and fun. Tyson slinks about in a ruffled unitard, and Fonda poses through a one-note delivery. Taylor loyalists take heart. Given the acute stresses of the production, she pulls it together for the camera, keeps her head up high, and manages some good work while the film around her immolates. Her Mother role is stern, toiling in a granny shawl and mopcap. She loves her kids as Mother, but her Maternal Love is ideal, unsoiled by the drudgery of household chores. As the Witch, Taylor is unrecognizable under a hooked nose, pointed chin, wire-rimmed glasses, and humped back. Even that Taylor cackle has an unfamiliar rasp to it.

The Blue Bird keeps changing its stripes. As the children's grandparents, Will Geer and Mona Washburn (*The Driver's Seat*) sing thirty minutes into the film, turning it into a temporary musical. Then is becomes ersatz Fellini. The Queendom of Luxury segment with Ava Gardner is a cavalcade of noisy indulgent grotesque revelry. "Eat when you're not hungry, drink when you're not thirsty" advises Gardner as Luxury. Red is her dominant color, and she's even more eye-catching than Taylor as the radiant Queen of Light.

There's something almost resembling sweetness near the end, when the film presents an orgy of personifications. Dog, milk, bread, water, sugar, fire, an oak tree, and cat all take human form, and they deliver harsh words on how they've been treated by us. It arrives at *The Blue Bird*'s "there's no place like home" summary message, with vastly less artistic beauty and emotional involvement than *The Wizard of Oz*.

The Blue Bird is now obscure and likely to remain so. Its theatrical run was brief, and its availability on the home market limited.

Taylor had hoped to recoup with a percentage of the profits, but there were none. She was encumbered with *The Blue Bird* while between marriages to Richard Burton. They had been in close touch while she was stranded in Russia. He had sworn off drinking, and that was enough to pull her back to him. As if to keep the public enthralled at their extravagant relationship, they were remarried at the Chobe Game Reserve in Botswana in October. Rather like the unlikely menagerie in *The Blue Bird*, witnesses were a rhino, cheetah, several bird species, and two hippos.

A Little Night Music (1977, New World Pictures, directed by Harold Prince)

It should have been much better. Certainly it had the highest potential for wide success of anything Taylor took on since *The Taming of the Shrew*. Harold (Hal) Prince, the genius stage director of *Cabaret*, *Company*, *Follies*, and *Pacific Overtures*, would helm the film version of his 1973 all-waltzing Broadway musical romance *A Little Night Music*. Taylor had reasons to be optimistic. It would be set and filmed in Austria on a sprawling country estate and opulently costumed. Prince had scant movie experience, but stage-trained Mike Nichols (*Who's Afraid of Virginia Woolf?*) and Franco Zeffirelli (*Shrew*) had even less. Prince announced his intention to hold close to the popular stage version in the adaptation. *Night Music*'s ever-shifting geometry of recombining spouses and lovers, based on Ingmar Bergman's sublime film *Smiles of a Summer Night* (1955), appeared to suit Taylor and the baggage that arrived with her name.

Alas, this gorgeous puff pastry collapsed on the road to filmdom. It needed Norman Jewison (*Fiddler on the Roof*, 1971) or Bob Fosse (*Cabaret*, 1972), two directors who knew how to turn a stage musical into *cinema*. Prince seems not the slightest bit comfortable with a camera, much less one that moves. *Night Music* is nearer an

operetta than a musical, and his longing for theater is so great he puts the opening and closing number ("Night Waltz") on a proscenium stage and has his actors take bows during the credit crawl. The witty book by Hugh Wheeler acts as filler bridging the inventive Stephen Sondheim tunes, rather than anything consistently pertinent to the story. The editing wavers between clumsy and brutal, and the result gives the film an unredeemable artifice.

All blame does not rest with Prince and his stage-to-film miscalculations. Taylor hesitated playing the perennially romantic actress Desiree Armfeldt, but she had a contractual responsibility to fulfill. She was replacing Tony-winner Glynis Johns and would share scenes with stage holdovers Len Cariou and Hermione Gingold. On tap, too, was estimable Diana Rigg, who supplies the film's best performance. Taylor had to sing "Send In the Clowns," Desiree's angry and sad contemplation on love's bad timing. She was petrified. "Every great singer has done it—and now, here comes Chunko," she said with typical self-deprecation. In the context of *A Little Night Music*, it's more acted than sung, and Taylor's thin voice serves Desiree's emotional vulnerability well. It's the truest few minutes she delivers.

The cast and crew liked Taylor, delighting in her humor and filmmaking expertise, but that did not translate into a satisfying performance. She is not served well here, either by Prince or costume designer Florence Klotz. She's in so many low necklines her breasts become two more cast members. Desiree is ravenous after a performance, and Taylor could have had some fun with that, but the comic opportunity is lost. Her reactions to her lover entering her bedroom have an odd tempo. Did somebody miss a cue? Why no retake? She's disengaged. Now when she flashes those eyes, it looks like a well-worn trick in her playbook.

Still, Prince found reasons to rave. "Taylor has the unique willingness to try anything and not worry, like so many other stars, about her public image," he said. "She's the least vain person I've ever met." She was also distracted. To predictable media scrutiny,

she had been courting former US Secretary of the Navy John Warner. Wealthy and socially adroit, he had high connections in Washington. She loved what he *wasn't*—a jetsetter, alcoholic, or someone anywhere near the film business. He was far more emotionally stable and staid than Burton, and long days at his 2,000-acre estate in Middleburg, Virginia, brought back happy memories of her bucolic childhood in England.

A Little Night Music was a critical and commercial failure that left Taylor's big screen viability in doubt. She wouldn't have another film role of any consequence for three years. While she considered semi-retirement, Warner considered a run for the US Senate.

Winter Kills (1979, Embassy Pictures, directed by William Richert)

This is a densely plotted political assassination thriller with a dark sense of humor. Taylor has a cameo as Lola Comante, once a multiple-married film queen, now a madam to the stars. She looks great, thanks to top-flight cinematographer Vilmos Zsigmond. Lola supplies women to the president of the United States. Taylor has no dialogue, but we can read her lips as she says "son of a bitch" in reference to the president.

The Mirror Crack'd (1980, EMI Films, directed by Guy Hamilton)

The Mirror Crack'd first appears as a standard issue adaptation of an Agatha Christie novel. Miss Marple, along with various professional and amateur sleuths, go about solving a murder among suspects in Christie's make-believe English village St. Mary Mead. But *The Mirror Crack'd* turns into something else. A film-within-a-film takes place, complete with Hollywood clichés: the harried

director, fast-talking producer, and a pair of indulged narcissistic movie stars.

The screenplay source is Christie's 1962 novel *The Mirror Crack'd from Side to Side*. Taylor's character, an aging American actress named Marina Rudd, is playing the title role in *Mary, Queen of Scots*. The meta-references to Taylor's life are rampant and unflattering. Marina is emotionally fragile, prone to "nervous storms," and has a history of many husbands and just as many breakdowns. Movie magazines report on drugs, drinking, and sexual high jinks.

While Christie melded the floral countryside with Hollywood razzle-dazzle in her book, director Guy Hamilton and screenwriters Jonathan Hales and Barry Sandler go further. Their *Mary, Queen of Scots* is closer to a bodice ripper than historical drama. And *The Mirror Crack'd* is stolen and repurposed by the Hollywood contingent played by aging 1950s favorites Taylor, Rock Hudson, Kim Novak, and Tony Curtis. They clearly relish vulgarizing Christie with stops-out cartoon performances delivered at about 125 percent. "I could eat a can of Kodak and puke a better movie," snorts Novak as rival star Lola Brewster in full Queen Elizabeth costuming. Taylor and Novak go at each other like a pair of drag queens in heat. They trade withering put-downs about age, weight, promiscuity, and canine resemblances. Air dropped in from another movie universe, their zingers only last a few moments, but briefly turn *The Mirror Crack'd* into something almost as loopy as early John Waters.

Meanwhile, there is a murder to solve, and Edward Fox, Geraldine Chaplin, and Angela Lansbury go about their duties closer to the spirit of classic Christie. It's disconcerting to see Lansbury, Taylor's big sister in *National Velvet*, don a gray wig to do Miss Marple. It's like watching some dowdy crook-mouthed audition for Jessica Fletcher, Lansbury's far more chic crime solver in her later TV show *Murder, She Wrote*. The reunion of Taylor and Hudson is a chief pleasure of *The Mirror Crack'd*. By 1980, they both had aged enough to be ready for the third act of *Giant* without

makeup or padding. He's cast as Marina's director-husband, and their long-term offscreen friendship is palpable. As actors, they bring the well-worn appeasements, humor, and reassurances of long-term spouses.

The Mirror Crack'd was made at a perilous time in Taylor's life. Her role as senator's wife to John Warner was proving unsustainable. The specter of another failed marriage, as well as a career veering toward obsolescence, sent her into a depression. She medicated with pills and bloody marys, and the pounds went up. Private miseries gone public was nothing new, but now was the season to be cruel to Elizabeth Taylor. John Belushi, the coked-out madman of *Saturday Night Live*, reenacted Taylor at Big Stone Gap, Virginia, chocking on a chicken bone. Cartoonist Garry Trudeau lampooned "Senator and Mrs. Taylor" in his urbane comic strip *Doonesbury*. And Elizabeth Taylor fat jokes, all 850 of them, became comedienne Joan Rivers's trademark.

Through all the pain, Taylor delivers the most accomplished performance in a film that's not much more than a cash-in of *Murder on the Orient Express* (1974) and *Death on the Nile* (1978), two successful all-star book-to-movie Christie adaptations. While her costars are delivering performances that run broad and shallow, Taylor actually lends depth and complexity to Marina. Novak charges at Taylor like a hungry lioness, ("I'm going to wipe that cow right off the screen!"), while Taylor doesn't meet her with equivalent fangs and bloodlust, as might be expected in simple one-upmanship. Instead, Marina becomes someone more hurt and forlorn. Now they were throwing fat jokes at her to her face, and on film no less. Her eyes are heavy and their sparkle flickers. She's bloated and relies on caftans and muumuus for most of her costuming. Where sympathy's involved, the line between character and woman was narrow.

Taylor has a terrific scene with Fox that nearly redeems the entire film. He interrogates her, and her response is a bit large. But it seems consistent with Taylor playing a movie star who is well

accustomed to being "on" for her fans. Then he recognizes the scene she's playing from one of her movies, and she lets out a laugh at his discovery. Taylor then becomes more sincere, and we realize she has played *us*. It's quite a show of an actress playing an actress who's acting. She's been underestimated yet again.

Genocide (1981, A Simon Wiesenthal Center Release, directed by Arnold Schwartzman)

With *Genocide*, filmmaker Arnold Schwartzman attempts to impart a magnitude of the Holocaust in eighty-three minutes. That is quite impossible, of course, but *Genocide* uses film to make a thundering impact. It does that and more, winning the Best Documentary Academy Award.

In the fall of 1980, Taylor received the first Simon Wiesenthal Humanitarian Award. Wiesenthal honored her for converting to Judaism, "a courageous decision, for even in the best of times it has never been easy to live as a Jew." With her offer to exchange herself for hostages at the Entebbe Airport in Uganda in 1976, a role in the TV movie *Victory at Entebbe,* and now *Genocide*, Taylor used her fame to expose modern atrocities against Jews. At the dinner held in her honor, she delivered a prophetic speech: "Today, a whole generation is growing up that does not know [the Holocaust], that has no memory of these events, that has no terms of reference to know how close we all came to the final curtain. Worse, around this new generation can be heard new ominous voices seeking to pollute their minds, to corrupt their values, to impair their future. In Europe and in the United States, anti-Semitism is on the rise. Haters are running for public office, pitting white versus black, Christian versus Jew."

The award dinner was a fundraiser for the proposed Los Angeles Museum of the Holocaust, now Holocaust Museum LA. Rabbi Marvin Hier, founder of the Wiesenthal Center and producer of *Genocide*, sought Taylor as co-narrator. When she read the script, she "cried all night" and accepted. The resulting documentary

standardized a presentation of the Holocaust in intimate stories
that would be echoed in other centers of culture and history in
Washington and New York.

Genocide will burn through your eyes and heart. It's eloquent,
direct, and infused with a magisterial score by Elmer Bernstein.
Schwartzman has his narrators, Orson Welles in addition to Taylor,
heard but not seen. That keeps the subject immediate as the film
traces post–World War I Jewish hopes dashed with economic
reversals. The prelude to the Holocaust is traced quickly, with
neighbors against neighbors, growing suspicion, and scapegoating
as part of the cyclical history of anti-Semitism in Europe.

Welles narrates the big history, while Taylor concentrates on the
individuals' lives and deaths. With tremendous depth of feeling,
she reads testimony of the torture and killing of Hassidic Jews in
Poland. She continues with readings from letters of the condemned.
She sounds barely able to continue, but she does. Witnesses speak of
naked women shot with children in their arms. Of people still alive
lying in a growing pile of corpses. She reads simple words enlarged
to meet the horror: "I cannot convey my suffering" and "I wanted
to close my eyes, but I *could not!*" She reads "The Butterfly," a poem
written by Pavel Friedmann at Theresienstadt concentration camp
two years before his death at Auschwitz.

Taylor's voice remains calm and even soothing. She speaks of a
soldier imploring prisoners to "sing us a Yiddish ditty" before he
executes them. Again, she halts, as if the words summon hell it-
self. This is Elizabeth Taylor, not a character, not Maggie the Cat
or Cleopatra or Martha, speaking to us. She is using her voice for
enlightenment and remembrance.

Young Toscanini (Il Giovane Toscanini) (1988, Carthago Films, directed by Franco Zeffirelli)

During the happy 1966 production of *The Taming of the Shrew*,
Taylor mentioned to director Franco Zeffirelli that she'd welcome

the opportunity to work together again. That came more than twenty years later with *Young Toscanini*. Alas, as with George Stevens and *The Only Game in Town*, Taylor made one film too many with Franco Zeffirelli.

When nineteen-year-old Italian cellist Arturo Toscanini (C. Thomas Howell) toured South America in 1886, he was asked to conduct a performance of Giuseppe Verdi's *Aida* in Rio de Janeiro. The occasion had a mighty impact on Toscanini's career, and Zeffirelli and screenwriter William Stadiem concocted a fiction around his life leading to that momentous evening.

They invented the Russian soprano Nadina Bulichoff (Taylor), who has been musically idle as the mistress of Emperor Dom Pedro II (Philippe Noiret) of Brazil. When Toscanini is sent to her mansion to retrain her voice for a comeback, she throws a diva fit. How dare the opera company dispatch this featherweight! Bulichoff had been coddled for years, keeps slaves, and is well accustomed to opulence. She squeals in glee when presented with a giant diamond ring from the emperor. (That moment was certainly no stretch for Taylor the jewelry lover.)

A parallel relationship develops between Toscanini and beautiful young Margherita (Sophie Ward). Her work at an impoverished hospital for the children of slaves awakens his moral conscience. Eventually Bulichoff is moved as well. Following *Aida*'s Grand March, she stops the show. She reminds us that Aida is a slave, and slavery is ongoing just outside the opera house. To address that sin, she will donate her ring from Dom Pedro to the Organization for the Abolition of Slavery, and free her slaves effective immediately. She beseeches her fellow elite Brazilians to open their hearts and do likewise. The crowd cheers and rises to its feet, apparently waiting for the right diva to incite voluntary emancipation. In Taylor's entire career, no scene was ever more absurd.

Young Toscanini is a maddening film. The weaving of fiction and history is compelling, but for every plus there's at least one minus. Zeffirelli creates a smothering antique shop of costumes and décor. The musical passages are glorious and recall the very successful

reimagining of Mozart in 1984's *Amadeus*. But setting aside historic accuracy, Taylor in Nubian blackface creates a troubling vision. Her vocals are dubbed by the celebrated American soprano Aprile Millo, layering the film with still greater artifice.

Zeffirelli directed opera and film throughout his career, and he seems to have forgotten he's directing the latter. Plot holes, wild implausibility, and sketchy character development might be more tolerable in the theatrical fantasy of classic opera than in cinematic close-up. While the story has terrific potential, the dialogue is cursed with nonsense about doors to the soul and life beyond music. Characters don't breathe, and there's inadequate tightening of dramatic tension.

Young Toscanini previewed at the 1988 Venice Film Festival, screened briefly in Europe, but was never distributed in the United States. It was to be Taylor's last starring role in a feature film, yet it is perhaps the least seen performance she ever gave.

While the film's problems are epidemic, it does not merit such neglect. Here is Elizabeth Taylor in a *real* movie again, however botched it may be. *Young Toscanini* is a reminder of what might have been. More historical dramas. Dowagers, empresses, society matrons. Perhaps another *Who's Afraid of Virginia Woolf?*–style tour-de-force. But I suspect the sorrow of unfulfillment was felt more keenly among fans than Taylor herself. The climax of *Young Toscanini* explains both why she accepted the part and why her career was essentially over. Bulichoff's reckoning against slave owners and slavery easily translates into Taylor's fight against AIDS and public indifference. On the theater-within-a-film stage of *Young Toscanini*, Taylor the actress and Taylor the humanitarian were united.

The Flintstones (1994, Hanna-Barbera/Amblin/Universal, directed by Brian Levant)

A strange movie trend arose when baby boomers reached middle age. TV shows of their youth started appearing as feature films,

shamelessly capitalizing on a generation's huge capacity for nostalgia: *Batman* (1989), *The Jetsons* (1990), *The Addams Family* (1991), *The Beverly Hillbillies* (1993), *The Fugitive* (1993), *The Brady Bunch* (1995), *Mission: Impossible* (1996), *McHale's Navy* (1997), *Leave it to Beaver* (1997), *Mr. Magoo* (1997), *Lost in Space* (1998), *The Avengers* (1998), *The Mod Squad* (1999), and many more. They all wallowed in sentiment and pop references. Some became movie franchise industries, but most of them slipped into the bog of dated throwaway entertainment.

The Flintstones, based on a popular Hanna-Barbera sitcom that ran from 1960 to 1966, was slightly off the trend. It took a nighttime animated sitcom and turned it into a live action feature film. Set in early human prehistory, there's hapless Fred, crane operator at the Slate Rock and Gravel Company, and his loving wife Wilma. Best pal and next door neighbor Barney Rubble is married to Betty, best friend to Wilma.

From the looks of it, *The Flintstones'* $45 million budget went largely to impressive CGI from Industrial Light & Magic and puppetry from Jim Henson's Creature Shop. But the visuals have no place to go. The jokes are on all things prehistoric, and they don't stop—from stone tools to the invention of the wheel to décor and furniture of animal pelts and leg bones. Chases, heavy falling objects, and dinosaur encounters mistimed by more than 60 million years are unrelenting. *The Flintstones* is, as expected, cute but brainless entertainment that alternatively amuses and benumbs.

Taylor is Pearl Slaghoople, mother to Wilma and eternal antagonist to Fred. This isn't a performance as much as a display of muggings and put-downs. Pearl could have been played by anyone with name and camp value. She slips in and out of the movie without disrupting the plot, perhaps so Pearl could be excised if Taylor's health prevented her from completing the assignment. She got through it, was kept in the film, and earned a Golden Raspberry Award nomination as Worst Supporting Actress for her efforts.

The Flintstones was a lark. Taylor wasn't taking acting seriously anymore. She'd already received honorary awards from the American Film Institute, Hollywood Foreign Press Association (bestowers of the Golden Globes), and Academy of Motion Picture Arts and Sciences, so another bubble gum movie wasn't going to soil her legacy. I imagine she wanted to enjoy the camaraderie, laughs, community, and adoration on a film set one more time. Her participation guaranteed *The Flintstones'* premiere was an AIDS fundraiser, and that's what mattered. Poor health prevented her from attending, but her priorities were clear. "Acting is, to me now, artificial," she said. "Seeing people suffer is real."

3

Television, Theater, and
Special Appearances

Elizabeth Taylor's career off the big screen is a hodgepodge of TV movies, theater, TV series guest spots, interviews, radio broadcasts, and award show appearances. There's not much coherence. Her serious acting gave way to playing herself in grand meta-splendor, with situation comedy cameos and "Oh my God, you're Elizabeth Taylor!!" style humor.

There are far too many appearances to list. Included here are television and stage credits that required acting and the creation of characters. What generally *isn't* here are "making of" mini-documentaries, innumerable talk show appearances, news footage of film premieres or health crises alerts, award show presentations, and Taylor's appearances on tributes to other people.

Television listings include program title, followed by original North American broadcast date, episode name, season and episode numbers if applicable, and network. Movies made for television include director's name. (Note some of these films may have had theatrical distribution in the UK and elsewhere.) Theater credits include title, date of opening night (not including out-of-town previews), venue, and city.

For Taylor devotees, I recommend YouTube for a sampling of her abundant charm and humor. You will find her inaugurating the Best Costumes Academy Awards category (March 24, 1949), disguising her voice amusingly on *What's My Line?* (November 14, 1954), accepting the Oscar for *BUtterfield 8* (April 17, 1961), and sitting down for interviews with Barbara Walters, David

Frost, Oprah Winfrey, Larry King, and Johnny Carson. Also pre-
served and available are a few notorious moments of Taylor on the
small screen. Among them is the infamous Oscar night when she
attempted composure in presenting Best Picture after a streaker
ran across the stage (April 2, 1974). In 2001, she botched her tele-
prompter reading at the Golden Globes so thoroughly as to prompt
speculation about heavy medication. And she's downright hyster-
ical making hash out of producer James M. Nederlander's name (it
became "Neidelheimer") at the 1981 Tony Awards.

Taylor in London (October 6, 1963, CBS, directed by Sid Smith)

In 1962, the television special *A Tour of the White House with Mrs.
John F. Kennedy* drew huge audiences and defined a new form of
documentary produced largely for women. *Elizabeth Taylor in
London* followed the essential format. Taylor is dressed in Yves
Saint Laurent gowns while visiting cultural landmarks and dis-
parate neighborhoods of London. Scripted commentary mixes
with quotes by Shakespeare, Queen Victoria, and Elizabeth
Barrett Browning. She visits the Billingsgate Fish Market, "bohe-
mian" Chelsea, the Westminster Bridge, the Tower of London, the
Limehouse district, and her childhood home in Hampstead.

 Elizabeth Taylor in London had a giant budget for television,
and it came with a soaring John Barry score. Taylor, at the height
of her movie star celebrity, was paid a record-breaking $250,000.
The format was unfamiliar to her; she had to unlearn not to look at
the camera in order to narrate the one-hour color special. She's very
much the glamour queen while appearing at ease in body and voice.
Her readings are compelling. She even imitates a gravelly Winston
Churchill giving his VE Day speech: "London—like a great rhi-
noceros, a great hippopotamus, saying 'Let them do their worst—
London could take anything.'"

World Enough and Time (June 22, 1964, Lunt-Fontanne Theatre, New York City)

Taylor and Burton held a night of poetry and prose reading as a $100 a ticket fundraiser for the American Musical and Dramatic Academy of New York, headed by Richard's acting mentor and adoptive father Philip Burton.

World Enough and Time (titled from "To His Coy Mistress" by Andrew Marvell) was important to Taylor's self-worth as an actress. Despite the lavish admiration of stage-trained costars Montgomery Clift, Paul Newman, and Burton, she bought into the notion that a studio bred screen star doesn't possess the high skill of a veteran stage actor versed in the classics. In adapting to a live audience, she trained with Philip Burton for two weeks to project her voice to the back of the theater. She made progress but relied on a microphone.

Without the accustomed safety net of multiple takes, Taylor was a mass of nerves going live. The Lunt-Fontanne Theatre, then housing a sold-out production of Richard Burton in *Hamlet*, was packed with major names from show business and politics, from Alan Jay Lerner and Lauren Bacall to Eunice Kennedy Shriver, New York congressman and future mayor John Lindsay, and *Cleopatra* survivors actor Hume Cronyn and producer Walter Wanger.

Taylor's recitations included "The Ruined Maid" by Thomas Hardy, "Three Bushes" by William Butler Yeats, "My True Love Hath My Heart and I Have His" by Philip Sydney, and "How Do I Love Thee? Let Me Count the Ways" by Elizabeth Barrett Browning, which Taylor also read effectively in the 1963 TV special *Elizabeth Taylor in London*.

Witnesses reported something glorious happened that night. Taylor was good, really good. After the introductory fright, "I became terribly daring, audacious, and I lifted my eyes from the page," she recalled. "There was no snapping of memory. My eyeballs didn't fall out of my head, and I looked at the audience and I said whole

stanzas, and I didn't mess them up." The audience took notice. Beatrice Lillie quipped, "If she doesn't get bad pretty soon people are going to start leaving." Not only did they not leave, but they rewarded the Burtons with a standing ovation.

Taylor felt *World Enough and Time* was her triumph as much as it was anyone's. When an interviewer alluded to Richard's influence, she tore into him. "What you're trying to say is that most people thought I was the village idiot before he got me in tow," she said. "Well, he hasn't been my Svengali, but he has widened my scope."

Sammy Davis Jr. Show (January 7, 1966, season 1, episode 1, NBC)

Taylor sits down with Davis and Burton for what they play as ad-lib. The Burtons perform "Ar lan y môr" ("Beside the Sea"), a Welsh folk song. They do a quiet lovely job of it considering Taylor's limited range. In their rendering, it becomes a love duet, and one of the few times we see them uncomplicatedly tender with each other on screen. Unfortunately there was more time to fill, so they sang, "What Do the Simple Folk Do?" from *Camelot*. Taylor's weak vocals are particularly evident in the second song.

Doctor Faustus (February 14, 1966, Oxford University Dramatic Society)

The Burtons appeared in a one-week school mounting of Christopher Marlowe's late sixteenth-century *Doctor Faustus*. The production was a benefit for the Oxford University Theatre Appeal Fund. They appeared without pay and to honor professor Nevill Coghill, who inspired Burton to go into the theater.

Taylor played Helen of Troy and didn't utter a word. As she put it, "I have never acted on stage before, so I'm starting the easy way.

It's a marvelous opportunity." Eyewitnesses recalled a hushed and spellbound audience when Taylor made her entrance. She did nothing more than walk across the stage.

This nostalgia trip attracted considerable press to a student production that would otherwise have been ignored. Reviews were not positive, while the Burtons were given appreciation for lending their time and talent to a worthy fundraiser.

Around the World of Mike Todd (September 8, 1968, ABC, directed by Saul Swimmer)

This is a one-hour remembrance of master showman and Taylor's third husband, Mike Todd. Big dreamer, high-stakes gambler, salesman, and promoter, Todd is affectionately remembered here by Orson Welles, Gypsy Rose Lee, Ethel Merman, and Art Buckwald. Taylor shares memories of his aggressive courting and his loving qualities as a husband and father to their daughter, Liza. "Living with Mike Todd was like living with a circus," she said. "He never walked into a room. He erupted."

Here's Lucy (September 14, 1970, "Lucy Meets the Burtons," season 3, episode 1, CBS)

Amidst a grand publicity effort, the Burtons appeared on Lucille Ball's sitcom *Here's Lucy* as themselves. Burton despised Ball, calling her "a monster of staggering charmlessness." Trouble started when Ball directed Burton in how to read his lines. "I warned the director to warn Jingle-Balls that if she tried any of that stuff on Elizabeth she would see, in person, what a thousand megaton hydrogen bomb does when the warhead is attached and exploded." Apparently Ball backed off, and Taylor managed the appearance more agreeably than Burton.

Taped with a live audience in May 1970, the broader than broad comedy has Taylor's world-famous ring caught on Lucy's finger. At a press party where everybody wants to see the ring on Taylor, Lucy hides behind a curtain while her ringed hand appears to belong to Taylor. Taylor reacts to her free-willed left arm and hand with sublime timing and good humor. The results are funny enough to suppose Taylor could have starred in her own sitcom. The ratings were stratospheric.

Divorce His/Divorce Hers (February 6–7, 1973, ABC, directed by Waris Hussein)

Divorce His/Divorce Hers was some kind of tacit recognition that the Burtons were no longer bankable movie stars. Their last effort, *Hammersmith Is Out*, opened in the spring of 1972 and died a quick death. If they no longer sold tickets, perhaps they could earn high ratings.

Divorce His/Divorce Hers is fueled by the simple idiom, "There are two sides to every story." A marriage breaks up, and we see its decomposition from his perspective, then hers. It was filmed in Munich for Harlech Television and broadcast on American television over two nights following a huge marketing campaign. Great care would be taken, even by Taylor standards and within a limited budget, on costumes, hair, jewels, and makeup. This was, after all, her first TV movie, and she wanted to look her best for this transition from movie theaters to dens and living rooms.

The set-up for marital breakdown was utterly familiar. He's Martin, a harried business executive. She's Jane, a neglected stay-at-home wife. He's aloof; she's possessive. The interpersonal pathology becomes noxious. "Beat me black and blue, but don't leave me," Jane says. This comes *after* he struck her and she feared for her life.

While that doesn't exactly describe the Burtons, the films carry the unsavory scent of private lives made public. Tabloids reported

the Burton marriage was in trouble for years, and these films captured their exhaustion and alienation. Previous films teased the public that *maybe* they were seeing tidbits from the Burton's marriage. *Divorce His/Divorce Hers* looked more like spying on them at their worst. Taylor dropped character and started tearing. "For a moment it seemed as if we were really quarreling," she said to director Waris Hussein. "We can't just go on playing ourselves," said Burton. "Oh, where are the writers to rescue us?"

Hussein offered little to elevate the material or to the Burtons' enervated performances. He was not aggressive in a way that benefited either of them, and he lost their confidence. Compounding the problem was the Burtons lack of communication with each other, both choosing to retreat to their respective entourages between scenes.

Sheer curiosity brought in viewers over two nights in February of 1973. What they got, however, was unrewarding. *Divorce His/Divorce Hers* tried for a certain *La Dolce Vita* Euro chic, playing with nonlinear time while spouses and lovers treat each other like clothes to buy, wear, and discard. Considering the dissolution of a real marriage within a fictitious one, many of the scenes play as surprisingly phony. I don't care about these people or their plight because I'm unconvinced this family, including the kids, enjoyed one moment of shared happiness. Divorce in this case is a blessing.

Due to the structure of *Divorce His/Divorce Hers*, we get some turgid moments repeated. Maybe Elizabeth and Richard are bad because the misery of Jane and Martin is too close to reality. Taylor *does* generate real emotions when she says goodbye, perhaps foreseeing another divorce in her life. And she manages one cheaply memorable line, thanks to good timing. Jane hears about her husband's mistress from the woman herself, inciting Jane to say, "Straight from the horse's *[pause]* . . . mouth, if you want to be kind about it."

On July 3, less than five months after the premiere airing of *Divorce His/Divorce Hers*, the Burtons announced their separation.

Victory at Entebbe (December 13, 1976, ABC, directed by Marvin J. Chomsky)

On June 27, 1976, Air France flight #139 left Athens for Paris. Once in the air, German and Palestinian terrorists hijacked the plane and rerouted it to Entebbe Airport in Uganda, where strongman Idi Amin directed operations. Hijackers sought to free Palestinians imprisoned in Israel through an exchange. Of the 256 passengers on board, nearly half were Jewish.

Victory at Entebbe's executive producer David L. Wolper was an extraordinary filmmaker. He directed and/or produced documentaries with guts and power, such as *The Race for Space* (1959), *The Making of the President* (1960), *The Rise and Fall of the Third Reich* (1968), and Oscar winner *The Hellstrom Chronicle* (1971). Wolper's track record enabled the hiring of major if over-ripe headliners Burt Lancaster, Kirk Douglas, and Taylor, as well as Helmut Berger (*Ash Wednesday*), Richard Dreyfuss, Helen Hayes, and Linda Blair.

Because of its topicality and political urgency, *Victory at Entebbe* was a rush job. A screenplay was slapped together combining the headline main event with personal dramas of the hostages. And for Taylor, *Victory at Entebbe* was a second choice effort to act on behalf of others. She offered to trade herself for the hostages but was rejected. "Giving was her heart," said husband John Warner.

The production values of *Victory at Entebbe* are appalling. Sets are shoddy, lighting is blotchy, and the whole thing looks like it was taped in someone's basement. The actors fare no better. The terrorists are Aryan caricatures, while Lancaster and Hayes essentially reprise their hammy roles in the disaster film blockbuster *Airport* (1970). *Victory at Entebbe* reaches self-parody when sweet young Blair offers chocolates to the passengers *after* they've all been hijacked. This film treats her budding sex life and Hayes's Valium intake on a dramatic par with international terrorism.

Taylor's role is tiny, and, blessedly, she stays on the ground. She and Douglas play Blair's distraught parents who beseech Israel Prime Minister Yitzhak Rabin (an acutely miscast Anthony Hopkins) to negotiate with terrorists. Anything to free their daughter! Somehow they missed the ad nauseam sledgehammer message of this most reductive of message movies: We will *not* negotiate with terrorists!

Victory at Entebbe is so badly rendered as to insult not just the audience but also the victims and survivors of the hijacking. Somewhere during the film's slapdash creation, Wolper and company wandered too far from the real story of heroism and sacrifice that was their original inspiration.

Return Engagement (November 17, 1978, NBC, directed by Joseph Hardy)

Plump and forlorn Emily Loomis has a history. She was once half of a married song-and-dance team. Then her husband dumped her. Following the sting of rejection, she abandoned show business, went back to school, and eventually became a professor of ancient history at a sun-soaked college in California. She is an effective teacher, giving recitations on Abydos with great feeling.

One of her students, Stewart Anderman (Joseph Bottoms), rents a room in her house. He charges into her staid life with the insistent energy of an untrained puppy. He discovers her show business past, and she swears him to secrecy. This film's definition of "scandalous" is wacky. Seems her old song-and-dance routine was so good it landed her two gigs on *The Ed Sullivan Show*. But nobody among her current colleagues must know. Eventually these two damaged lonely hearts guide each other to fulfill their lives.

Return Engagement comes with a glaringly tight budget. But paltry sets and perfunctory lights are more tolerable than a Swiss cheese script. Emily is written without agency or conviction,

repeatedly saying, "Yes" after initially saying "No." She and Stewart get drunk and kiss. They get cozy and watch *Casablanca* on *The Late Show*. She chills champagne on his birthday. For *Return Engagement* to work, we must believe the college would object to her appearing on *The Ed Sullivan Show* but not to her cohabitating with a current student.

Emily and Stewart break through their self-imposed barriers and perform a musical routine to a roaring standing ovation. This, too, requires a leap of faith, as neither Taylor nor Bottoms are accomplished in musical theater. But somewhere beyond this sorry script is a quiet and lovely Taylor performance. She's vulnerable here, with darting eyes and trembling voice. She's moving in her "I've Grown Accustomed to His Face"–style confession scene with a workmate. She struggles to articulate her feelings for Stewart, and Emily's words sound invented on the spot. *Return Engagement* is as pleasingly unpretentious as it is flawed. I like this film beyond its limited merits, perhaps because Taylor brings real emotional pain to the part. She makes me care for Emily; I want her to be happy.

The Little Foxes (May 7, 1981, Martin Beck Theatre, New York City)

A childhood ballet recital for British royalty, a high-profile night of poetry reading, and a non-speaking role in an amateur production of *Doctor Faustus* do not count. *This* was Taylor's real stage debut.

When the 1980s arrived, Taylor was an alcoholic and miserable. Through willpower, she climbed out of despair by giving herself a great challenge. A conversation with theater producer Zev Bufman began her serious thoughts of going onstage. They assembled a group of actors to read the considered plays: *Sweet Bird of Youth*, *The Lion in Winter*, *Hay Fever*, and *The Little Foxes*. Lillian Hellman's *The Little Foxes*, a trenchant, evergreen study of greed's ability to destroy souls, won. Taylor sought Mike Nichols (*Who's*

Afraid of Virginia Woolf?) or Joseph Hardy (*Return Engagement*) to direct, but both were committed elsewhere. Austin Pendleton, who starred in a 1967 Broadway revival of *Foxes* directed by Nichols, got the job.

Most of 1981 became theatrical boot camp. Taylor went on a diet and regimen of physical conditioning. As rehearsals commenced in January, she memorized great chunks of dialogue. She quickly fell in love with her role. "Regina is not just a total icicle and avaricious bitch, as she is usually portrayed," said Taylor, throwing shade on Bette Davis's sardonic playing of her in the 1941 film. "I want to give her a new dimension. She's a woman who's been pushed in a corner. She's a killer—but she's saying, 'Sorry, fellas, you put me in this position.'" Hellman was pleased with Taylor's approach. "Elizabeth is the right person at the right age at the right time," she said.

Taylor had plenty of training to do. Nichols visited rehearsals and was concerned her voice wouldn't reach the back of the theater. "Let's face it, I'm no Judith Anderson," Taylor said. Just as she trained it to go lower for *Virginia Woolf*'s Martha, so, too, did she train her voice to travel in *The Little Foxes*. She once again refused lessons, yet she delivered.

The first performances were held in February at the Parker Playhouse in Fort Lauderdale. Taylor's debut on the legitimate stage was national news, and the house was packed. From Fort Lauderdale, the company moved to the Eisenhower Theater in Washington, DC, for forty-seven performances. Reports of the production and Taylor's performance were strong. Pendleton observed she grew into the role and her place in the ensemble as she adjusted to the absence of close-ups and multiple takes. Vocal projection, audience interaction, and long-term development of a character all followed.

In April, Taylor and company moved into the Martin Beck Theatre on West 45th Street in the heart of Broadway. The marketing was effectively simple: a close-up of Taylor's vulpine eyes above the words *The Little Foxes*. Ticket sales reached $1 million

in one week. Taylor had been greeted warmly so far, but she could be forgiven a case of the collywobbles on opening night. She was facing the poison pens of the New York critics, ready to declare this Hollywood princess in way over her pretty head. Most important, she was facing her own professional and artistic reckoning. She had gambled, and if *The Little Foxes* collapsed in a stew of stinking reviews and cruel jokes, she was looking at despair or worse.

May 7 was opening night at the Martin Beck, and not since *Who's Afraid of Virginia Woolf?* in 1966 had Taylor drawn so much attention for a professional appearance. It turns out Regina was a terrific fit. The role gave her a level of challenge she could sustain over the months *The Little Foxes* played New York, London, and on tour. She brought a girlish-flirty affectation to the role, making it easier to underestimate Regina's moxie. She smiles and cajoles then does that patented Taylor shift of tone, pitch, and expression to land a bomb. She sent her voice up to sound simple, innocent, and flighty, all the while plotting such wickedness. The effect was comic or chilling, or both.

Comfortable with a southern accent, Taylor elongated her vowels to suit a particular aim. She is especially good conveying Regina's insincerity and duplicity. When husband Horace returns, she rushes to him gleeful, her arms outstretched. But she's glad to see him for malevolent reasons. The scathing contempt she brought to the men around her recalls the attitude she assumed in *X Y & Zee*. And when Regina's dream of vast wealth is threatened, Taylor speaks with a resolve and intensity that recalls her best work of the late 1950s.

Taylor was surrounded by an ensemble of strong stage actors, and once the "That's Elizabeth Taylor" moment passes, she meshes with them. There was, however, one key difference on the undated live performance disc I saw. While the other actors stuck to the script with precision, Taylor modified many of her lines while keeping their inherent meaning. "Quite a convention so early in the morning, aren't you all?" becomes "You all are quite a convention

this morning, aren't you?" Whether she habitually played with word order, returned to Hellman's exact dialogue, or kept her changes I cannot say.

Taylor found professional renewal with *The Little Foxes*. It was another high-risk venture that brought her heightened confidence, as did *A Place in the Sun, Cat on a Hot Tin Roof, Who's Afraid of Virginia Woolf?*, and *The Taming of the Shrew*. She loved the energy loop created when live theater is clicking. "Being in a for-real situation rather than appearing in a scene photographed for later viewing sent the adrenaline coursing through my body," she wrote. The rewards continued on tour to New Orleans, finishing in Los Angeles in December.

The theater world was genuinely impressed. *The Little Foxes* was honored with five Tony Award nominations: Best Revival, Best Director of a Play, Best Actress in a Play (Taylor), Best Featured Actor in a Play (Tom Aldredge), and Best Featured Actress in a Play (Maureen Stapleton). It won none, but how gratifying it must have been for Taylor to see her name among fellow nominees and theater giants Jean Lapotaire (the winner), Glenda Jackson, and Eva Le Gallienne.

Perhaps unsurprisingly, Taylor's professional invigoration brought the end to her marriage to John Warner. She bought a spacious home in the wooded hills of Bel Air at about the time she announced their separation. At the commencement of 1982, she was flying to London for a sixteen-week West End production of *The Little Foxes* at the Victoria Palace Theatre.

Pendleton believed Taylor's best works were inventions of theater. I imagine he was invoking *Cat on a Hot Tin Roof, Suddenly, Last Summer, Who's Afraid of Virginia Woolf?*, and *The Taming of the Shrew*, not *Cynthia, Life with Father, Boom!*, and *A Little Night Music*. Still, the point is well taken. Though she was the ultimate movie star, Taylor often thrived when her characters possessed a grandeur that fills big live theaters. *The Little Foxes* validates that idea. A breathing audience replaced the camera, and Taylor the actress was reborn.

General Hospital (November 10, 12, 16, 17, and 19, 1981, ABC)

Taylor joked that since she spent so much time in hospitals, why not appear in one on television? She was a fan of the long-running daytime soap *General Hospital*, prompting the writers to invent the imposing clotheshorse Helena Cassadine for her. She's a revenge-hungry widow who curses the wedding of the popular couple Luke (Anthony Geary) and Laura (Genie Francis). The wedding episode aired November 16 with a record-smashing audience of 30 million, while Taylor was amused by a foray into daytime television. Helena lived on; she was played by Dimitra Arliss in 1996 and Constance Towers from 1997 to 2022. Her durability owes something to Taylor's original take on the scenery-chewing role. And Taylor kept the Geary connection going with an appearance with him on a Bob Hope TV special in 1982, playing a frisky nurse in a comedy sketch. Films, stage, and daytime and nighttime TV were more segregated then, so Taylor's shifting from one to another was unorthodox and perhaps evidence she was beyond any career damage brought on by such playful mixings of mediums.

Between Friends (*Nobody Makes Me Cry*) (September 11, 1983, CBS, directed by Lou Antonio)

I find certain banal old TV movies comforting. You know what you're getting. Costumes are from private wardrobes, offering a snapshot of fashions du jour. The camerawork is dull, and scenes are long to save on editing. Timed fades to black for commercials are as predictable as reel changes. They're awkward and under-rehearsed, with plot holes, strange pacing, and generic music played on pre-dictable schedule. The influence of recent hits seep into one or another department. A tinkling piano cued to the tender moments in

Between Friends sounds like music leftovers from *On Golden Pond* (1981).

Between Friends, shot in early 1983 in Toronto, is such a TV movie. Its great draw was the pairing of Taylor with Carol Burnett as two women who fall into friendship almost by accident. The film uses many of the story devices used in tired romantic comedies. They meet-cute with a fender bender, as Deborah (Taylor) arrives to consult with her realtor Mary (Burnett). A snowstorm leaves them stranded and gets our heroines quickly bonded. Trapped at Deborah's house while a blizzard rages, they drink copious amounts of champagne and swap stories of childhood, romances, husbands, and menopause.

Between Friends upends expectations in casting. Taylor is a one-man woman, and Burnett sleeps around. It's a pleasure to see them together, and the film is a reminder that Taylor rarely had the chance to act opposite another strong actress of her generation. But, alas, Burnett doesn't make me forget she's foremost a comedienne. I'm not prepared to accept her as either humorless or wanton. Her thighs, velvety skin, and rapacious sexual appetite are topics of discussion here. When she declares everything but her heart is available to men, I scanned the horizon for Harvey Korman.

Taylor has a better time with this dubious material. Deborah longs to be married and monogamous. While that might elicit chortles given Taylor's history, she finds her own soft center that begins every marriage with that dream. And we get two rarities for Taylor here—sharing the screen with a woman, and working in retail. She's inept at the cash register to begin, then eventually gets the hang of it. She's later fired for a drunken outburst at a bookstore customer, followed by—of all things—a dreadful reading of Walt Whitman's "Oh Captain! My Captain!"

Taylor is a different kind of drunk here than she was in *Who's Afraid of Virginia Wool?* The script calls for her to get ugly and disgrace herself, while Burnett is her foil. Deborah's big drunk scene is an orgy of self-pity and truths unleashed, with onlookers

jolted into grimacing silence. Mary doesn't expose Deborah in any dramatically forceful way. Instead, she sends her to Alcoholics Anonymous. But for all the script shortcomings, Taylor effectively hides the extent of Deborah's emotional instability until an opportune moment.

The film gains some acceleration of power and psychological insight. Both women sting from divorce and talk men-men-men. Mary's response is to get slutty and spar with her daughter. Deborah's is to withdraw, pursue romance with one man who's wrong for her, and drink a lot. Their only hope is in each other as they shine a light on their respective blind spots. While avoiding all Sapphic undertones, it turns out Deborah and Mary are better for each other than any man has ever been.

Between Friends is warmed by the affection between Burnett and Taylor. After production wrapped, Burnett said, "I don't know what there was, but I spent six weeks laughing. I felt like I was eleven years old. Elizabeth is a very funny person." This was filmed before the family intervention that took Taylor to the Betty Ford Center. One can only suppose what was going on in Taylor's mind. Did she detach from the character and deny any resemblance? Or did she admit, privately at least, that she, too, was gripped with addiction?

All My Children (April 19, 1983, ABC)

While Taylor was in rehearsals for *Private Lives* on stage in New York, she taped an uncredited cameo on the long-running soap opera *All My Children*. She appears in a scene with Carol Burnett, who had a recurring role. As a not-so-inside joke, Taylor is costumed as the charwoman Burnett immortalized on her TV variety show. She interrupts Burnett and her companion in a restaurant, spouting nonsense. After Taylor exits, Burnett deadpans, "That woman's pilot light is out."

Private Lives (May 8, 1983, Lunt-Fontanne Theatre, New York City)

Taylor had a history of skirting Noël Coward's comedy of manners *Private Lives* (1930). Mike Todd suggested it as a vehicle for her and then husband Michael Wilding back in the 1950s. Coward himself suggested it when he costarred with Taylor and Burton in *Boom!* He readily envisioned them as Amanda and Elyot, the divorced sophisticates who wind up in adjoining suites on the Riviera, both with new spouses in tow. With so much distance between their fiery passion and today, Amanda and Elyot are nevertheless still attached. Coward's play sounded like a premonition of the Burtons.

The production went awry at the onset of rehearsals in March. Burton isolated the problem as stemming from Taylor's increased addictions and unprofessionalism. She "stinks of garlic—who has garlic for breakfast?" he wrote in his diary. "She is also on something or other because there are lines here and there which she can't say at all. Very worrying. It's appalling, but I'd not mind if she found she couldn't do it and we had to get someone else. She is also terribly low in energy. Tells me twice an hour how lonely she is."

John Cullum, cast as Amanda's new husband, offered a rare criticism of Taylor the actress. It seems the stagecraft she honed in *The Little Foxes* was being ignored. "Elizabeth was a natural," he said. "She was one of the most skillful film actresses you'd ever met. She just didn't have very much stage experience. For instance, when I first met with her, I suggested we run through the lines; she didn't want to do that, because I think her attitude was, it would take the edge off the performance. That's okay for film, but if you have to get jacked up for every performance, it's gonna kill you."

While camped at the Shubert Theatre in Boston, Taylor and Burton refused interviews, diligently shuttling between rehearsals and their hotel suites. Conditions improved by the end of the month, and the production was sold out for the Boston run beginning in April. Reviews were scathing, but ticket sales were robust

from curiosity, not expectations of great, or even good, theater. Taylor sounds "like Minnie Mouse," while Burton was "nearly as dour as Titus Andronicus," reported the *Boston Globe*. Both had "a clumsy hesitation."

The company moved on to New York for residency at the Lunt-Fontanne Theatre on West 46th Street. With the anticipated big box office, *Private Lives* opened on Broadway two years and one day after the opening of *The Little Foxes*. And, in keeping with the Boston reception, New York critics were unkind. *The New York Times*' Walter Kerr recognized stage and film acting had distinct techniques. While he acknowledged Taylor's skill on camera, he had some harsh words for her work on stage: "Miss Taylor is still being scolded, here and there, for acting badly in *Private Lives*. But this is not the case. She is not acting badly. She's not acting at all. She simply doesn't know how."

The charmed conditions of *The Little Foxes* were not duplicated with *Private Lives*. Taylor and Burton together again was first gimmicky, then debasing. His health was delicate as he tried to keep sober, while she was drinking. The Liz and Dick Show had worn itself out, with that painful reminder coming at them eight times a week.

From New York, *Private Lives* toured to Philadelphia, the Kennedy Center in Washington, Chicago, and Los Angeles. Unprofessionalism crept in. Taylor's arrival at the stage door became an event in itself, often causing delays in curtain rising. Taylor incorporated Alvin, her companion parrot, into the play. Another onlooker reported the Burtons pitched biscuits into the audience. An emotionally fragile Taylor hoped she and Burton might reunite. She was therefore demolished when he jetted to Las Vegas during the run of the play to marry author and theater producer Sally Hay.

The sorry *Private Lives* folded at the Wilshire Theatre in Los Angeles in November. Taylor and Bufman dissolved the Elizabeth Taylor Group, and Home Box Office dropped its $3 million plan to tape the production for television and theatrical release in Europe.

"The project was doomed from the start," assessed Taylor when it was all over. "I was not in good shape and neither was Richard. Worse yet, we were both miscast. We should have done a drama, not an English drawing room comedy. The experience was devastating, certainly for me, and I'm sure for Richard. . . . I began to crack. My worst habits surfaced. I began overeating, drinking, and taking pills." Taylor hit bottom with *Private Lives*. After the show closed, and her family staged an intervention, she checked into the Betty Ford Center for substance dependence as its first celebrity patient.

Hotel (September 26, 1984, "Intimate Strangers," season 2, episode 1, ABC)

Taylor's first post–Betty Ford acting gig was this guest spot on the TV series *Hotel*. She made sure this assignment would be amusing. She's Katherine Cole, veteran movie star worried "the clock on my career is ticking." She flirts with handsome James Brolin, wears her famous diamond ring, and has no less than ten costume changes for less than twenty minutes screen time.

She's paired with lifelong friend Roddy McDowell as her effete advance man, boy Friday, dietician, masseur, and confidante. When Katherine goes down a hallway with series regular Shea Farrell, she said to him, "My God, this looks like we're walking down the aisle together. In which case, I'm very well rehearsed!"

Malice in Wonderland (a.k.a. *The Rumor Mill*, May 12, 1985, CBS, directed by Gus Trikonis)

In 1973, author George Eells published *Hedda and Louella: The Dual Biography of Hedda Hopper and Louella Parsons*. As a literary showdown of the two most fearsome gossip columnists in Golden Age Hollywood, the book was a juicy read.

For the TV movie based on Eells's book, some kind of divine justice had Taylor playing Parsons, with Jane Alexander as Hopper, chief competitor in the rumor racket. There were very few people Taylor publicly despised, and "Lolly" Parsons was one of them. Taylor described her as "dumpy, dowdy, and dedicated to nastiness. Forget anybody that stood in her way. And her voice . . . so irritating. You just wanted to smack her." She made her name and power off salacious, and not necessarily accurate, dish on movie stars. So did Hopper, and Taylor wanted to settle the score with her and her reporting of Taylor's affair with Eddie Fisher.

Malice in Wonderland pushes all the expected buttons. Nolan Miller's outfits are campy Halloween costumes. The script tries to squeeze humor out of actors playing mighty executives, including Louis B. Mayer, Jack Warner, and Samuel Goldwyn. According to *Malice*, they all quiver at the sight of either one of them. Those two were drunk on other people's fear as well as the power it supposedly brought them to save or ruin films and careers.

Taylor plays Parsons as nervy and determined to rule Hollywood. She went unchallenged until Hopper came along and forced her to battle for scoops and exclusives. She visually flatters Parsons, who was not a pretty woman. But she gives her a slow dull voice. She's sweet and flattering one minute, then she's a hard-boiled newspaperwoman the next. And Taylor must have enjoyed the scene where Parsons stands up to MGM boss Mayer, who Taylor loathed on equal levels.

Malice in Wonderland doesn't much explore Hopper's challenge to Parsons's supremacy. Instead, it's devoted to Hopper selling her soul, which makes her more interesting and fully written. Hopper begins as a struggling minor actress on her way down, then a lackluster radio host, then, with goading, the vicious hat-wearing gossipmonger of legend. Parsons, in contrast, starts as the unchallenged queen of Tinsel Town dish and spends most of the film hanging on by her claws. Taylor does an admirable job, but Alexander has the showier role that brought her an Emmy nomination.

The film ends with a kind of truce and begrudging mutual respect, as both realize they should *pretend* to be enemies in order to play on the weaknesses of others. It's a shallow resolution, fitting for a film that renders them as a couple of show business parasites.

North & South: Book 1, North & South (November 9, 1985, book 1, episode 5, ABC, directed by Richard Heffron)

Taylor appears in one episode of this lengthy and very popular ABC miniseries. Looking trim and gorgeous as a New Orleans Civil War era madam, she makes a queenly entrance down a curved staircase, followed by four of her "girls." She has a scene with actor Philip Casnoff before disappearing. Taylor was part of a ratings-booster list of "Guest Stars" including Gene Kelly, Jean Simmons, and Johnny Cash, and '80s names like Genie Francis (*General Hospital*) and Morgan Fairchild.

There Must Be a Pony (October 5, 1986, ABC, directed by Joseph Sargent)

Taylor knows what people say and how they talk, and she's clearly invested in looking great for this minor TV project. She appears in a succession of fashionable outfits, quite possibly plucked from her wardrobe closet. They don't suit her character, a destitute actress recently discharged from a mental hospital. But they definitely suit Elizabeth Taylor.

Vanity and image maintenance are at work in *There Must Be a Pony*. No other woman gets close-ups or extended screen time. Taylor's jewels, hair, and makeup are immaculate; she is not committed to looking frowzy if the moment calls for it. She moves through this film in heavy rouge and a cotton candy coif with back

fringe, making her already large head appear larger, even atop regulation 1980s shoulder pads. She's trim and gorgeous, looking better than she did in *The Mirror Crack'd*, her most recent feature film. In a particular beachside scene, she looks closer to Laura in *The Sandpiper* of twenty years earlier.

Like *The Mirror Crack'd*, this one plays on star egos and a raft of not-so-inside jokes. She's Margarite, not Rita—just as she's Elizabeth, not Liz. It's 1986, and *Dynasty* was all the rage. A fan mistakes her for *Dynasty's* Joan Collins, once dubbed the poor man's Elizabeth Taylor. Margarite has been married and divorced multiple times. Her mother took Margarite from Ohio to LA and got her in the movies as a child. She loves the film business, but she hates the film business. Again and again this movie winks at its audience. Even *National Velvet* costar Mickey Rooney shows up as himself at the horse races.

Pony is based on a novel by James (*A Chorus Line*) Kirkwood with a screenplay by Mart (*The Boys in the Band*) Crowley, but that doesn't mean it's good. Taylor strikes a movie star attitude throughout and attempts to make something of the dialogue that doesn't rise to second-rate Neil Simon. "For a strong person, I have an amazing lack of will power," she coos to Robert Wagner before admitting him to her bedroom. She stares out the patio door and is approached by her son, played by Chad Lowe. She says, "I'm looking at the sky. Such a beautiful violet." And the trouble with life? There's "no score and bad lighting."

She and the film veer from mood to mood, undecided what to be—a mystery, Hollywood exposé, romantic comedy, or family reconciliation drama. She delivers in any case, but *Pony* is ultimately not much beyond a diverting Elizabeth Taylor vehicle. And just when the film threatens to be utterly forgettable, she delivers two astounding scenes. Margarite suffers a breakdown and is incapacitated with spasms and stuttering. Taylor is playing out the description she gave of her reaction to Mike Todd's death. In another, Margarite shrieks and rolls in the bedcovers, mummifying herself

in grief when learning of a suicide. Taylor assured director Joseph Sargent she knew exactly what to do in that scene, that she was reliving the moment she learned of Richard Burton's death. Sargent recalled Taylor "shook the rafters."

The movie's curious title is in reference to a punch line concerning equine manure. Taylor deserves better than this, but I'm not sure she much cared about acting anymore. Soon after the HIV-related death of her friend Rock Hudson in 1985, she co-founded the American Foundation for AIDS Research (amfAR), and that came to occupy her heart and mind.

Poker Alice (May 22, 1987, CBS, directed by Arthur Allan Seidelman)

Soon after Taylor christened her hugely successful perfume empire in early 1987, she reported to the Sonoran desert set of her latest TV movie. *Poker Alice* has a delightfully atypical setting for Taylor, as she queens it up in nineteenth-century fancy lady dresses amidst the saguaro of Arizona. She's a career woman this time, though her business is created only because she wins a bordello in a card game. *Poker Alice* is based on an actual woman, Alice Ivers from Devonshire, England, though the screenplay fictionalizes much of her life.

Alice is given an interesting background, but the script doesn't fulfill on its promise. She comes from a well-to-do Boston family but was disowned for the unladylike pastime of gambling. If she's not playing poker, she's thumping her Bible. She's never been married, while she and her cousin John (George Hamilton) are oddly devoted to each other. He's a failed writer, and his insecurities play out in being possessive of Alice. We root for her as she assumes management of the bordello and proves to be a clever businesswoman.

I like where *Poker Alice* begins. It has a jaunty comic Western vibe enlivened by a harmonica on the soundtrack. Taylor looks fantastic, far improved from her dissipated appearance of the early

1980s. Rather like Taylor's absurdly voluminous wardrobe in the remote locale of *Elephant Walk*, Alice would need a separate stagecoach for all the Nolan Miller (*Dynasty* TV series, 1981–1989) gowns she hauls into the desert. Then, for no good reason, *Poker Alice* switches mood from gentle comedy to corny melodrama. Taylor and Tom Skeritt as bounty hunter Jeremy fall unconvincingly in love. Soon Alice wants to unload the bordello so she can be Mrs. Bounty Hunter instead.

Poker Alice ends with a freeze frame on Alice's face. As her wagon leaves King City, she looks back at John. They wave, and there's fondness and feeling in her expression. Is she remembering their life together, or is she having doubts about riding off with near stranger Jeremy? I suspect the former. This film isn't sophisticated enough to pull off the latter and offer anything other than a happy ending.

Apart from a body-doubled catfight, Taylor plays Alice as refined, and I wish she had juiced it up a bit. She wasn't in the mood to take risks, instead gliding through the film with a movie star's regality. Perhaps she felt a newly created perfume magnate ought to keep her dignity and upright bearing, even in a mediocre TV movie. *Newsday* was smitten, recognizing the eternal magnitude of Taylor even as her films got smaller: "Liz is marvelous in her new TV movie. The New, Improved, Better-Tasting Liz looks positively radiant. . . . She is a star. More than that, she is a symbol, a fixture, of American culture. She is a legend. There aren't many stars left from the pre-TV days. She has a glow that not even an appearance on *Hotel* can dim."

Sweet Bird of Youth (October 1, 1989, NBC, directed by Nicolas Roeg)

Sweet Bird of Youth's Alexandra Del Lago is one of Tennessee Williams's grand self-pitying women. Maggie the Cat was steady in

her goal to win back her husband, and Catherine (*Suddenly, Last Summer*) is fierce in her quest for truth and justice. *Boom!*'s Sissy devotes her last hours to hiding her vulnerabilities. In contrast, Alexandra, Williams's fictitious movie star, is all flights of delusion and egomania in her ambition to stage a comeback.

In making comparisons with the 1962 big screen version starring Geraldine Page and Paul Newman, this one is inadequate. As hustler Chance Wayne, Mark Harmon lacks the necessary menace. Taylor, also, is off track. She plays Alexandra as boozy and overtly depressed, teetering and bleary in her heels, furs, and dark glasses. *Youth* opens with Alexandra running horrified from a theater screening her comeback film. The audience-within-the-film is laughing at her close-ups. Then director Nicolas Roeg gives us close-ups of Taylor, and she looks great. Page infused her performance with strong waves of desperation and narcissism, but Taylor as Alexandra doesn't seem to give a damn whether she makes a comeback. Taylor is shorter and more corporeal than Page but more fragile, too. When she calls for oxygen, it may be in genuine need. When Page calls for it, it's in psychosomatic agitation.

Chance and Alexandra are two people occupying the same space, but otherwise disconnected. She treats him like an employee. The dysfunctional relationship between her and Roddy McDowell in their 1984 *Hotel* guest spot was more interesting and promised more psychological fascination. Through a combination of writing and acting, Taylor again gives a performance that lurches from one primary emotion to another. Alexandra is predatory and controlling one moment, warm and caring the next. If she is conceived as manic, then Taylor and Roeg achieved their aim. But this Alexandra doesn't have a consistency to make her real. She's all filigree and no foundation.

Taylor's performance is depressed and depressing, with little of the vivacity and acting satisfaction she expressed in previous outings with Williams. Some of the problem emanates from Gavin Lambert's teleplay, which dilutes the original beyond any tinkering

found in the earlier film. It was also the last time Taylor had anything resembling a real acting chore. You'd think between Williams and director Nicolas Roeg, the man behind *Walkabout* (1971), *Don't Look Now*, and *The Man Who Fell to Earth* (1976), three of the most distinctive films of the 1970s, something meritorious would emerge. But this *Sweet Bird of Youth* just doesn't work.

Captain Planet and the Planeteers (November 21, 1992, season 3, episode 11, Turner Broadcasting System, TBS)

Taylor lent her voice to the superhero animated series. She plays Mrs. Andrews, the mother of a high school basketball player who is HIV-positive. The episode, titled "A Formula for Hate," becomes a lesson in the evils of scapegoating and the virtues of compassion.

The Simpsons (December 3, 1992, "Lisa's First Word," season 4, episode 10, Fox)

In a clever bit of stunt casting, Taylor guest voiced the popular animated series. She had one word to speak, "Daddy," and she recorded it nearly two dozen times to get the perfect babyish inflection. This became the highest rated episode of the season.

The Simpsons (May 13, 1993, "Krusty Gets Kancelled," season 4, episode 22, Fox)

This is the last episode of the season, and it's a doozy.

The Simpsons was such a huge pop culture phenomenon that the very famous were clamoring for guest slots. Taylor is not the only one here. Also heard in "Krusty Gets Kancelled" are Johnny Carson,

Bette Midler, Barry White, Hugh Hefner, Red Hot Chili Peppers, and Luke Perry. Taylor plays herself, polishing an Oscar and scrubbing her Krupp diamond, her violet eyes reflected on its many surfaces.

How to Be Absolutely Fabulous (January 6, 1995, BBC)

How to Be Absolutely Fabulous is a fluffy half hour behind-the-scenes documentary on the BBC series *Absolutely Fabulous*. Writer and star Jennifer Saunders offer fans a bevy of clips, outtakes, and new footage. Taylor as herself leaves a voice message. She brainstorms Saunders creating an *AbFab* perfume called Hangover.

"Liz Night" (February 26, 1998, CBS)

Taylor appeared as herself in four consecutive sitcoms as a marketing campaign for Black Pearls, her new perfume. CBS received criticism for what some considered a crass stunt. Taylor quite agreed and reminded the world she is a businesswoman. And this was hardly the first or last time that products appeared outside strict commercial time on television.

The Nanny ("Where's the Pearls?" season 3, episode 21)
Taylor is in New York to film a perfume commercial, but the nanny (Fran Drescher) loses Taylor's black pearls in a cab. Taylor spends most of her screen time unmoved while everyone around her goes ga-ga.

Can't Hurry Love ("The Elizabeth Taylor Episode," a.k.a. "The Liz Taylor Show," season 1, episode 19)
Actresses Nancy McKeon and Mariska Hargitay are so over energized as to come off as idiotic. Taylor floats over them in comic repose. This was the final episode of the series.

Murphy Brown ("Trick or Retreat," season 8, episode 18)
Taylor cancels an interview with Murphy Brown (Candice Bergen).

High Society ("The Family Jewels," season 1, episode 13)
Taylor does a voiceover only. As with *Can't Hurry Love*, this series was cancelled soon after Taylor's guest spot.

God, The Devil and Bob (March 19, 2011, "God's Girlfriend," season 1, episode 12, NBC)

This unusual animated series has God and the Devil engaged with human concerns large and small. Bob, a beer guzzling auto-plant worker in Detroit, is their test case for the survival or destruction of humanity. If Bob makes the world better for his existence, then we are saved.

Taylor plays Sarah, God's ex-girlfriend. (It's explained that God can have a girlfriend, since we're created in his image. But he's not very good at relationships.) When she goes out with Bob, Sarah gets drunk and has a few bitter things to say about dating God. Several episodes of *God, The Devil and Bob* were first aired in 2000, but several others, including "God's Girlfriend," weren't seen until airing on the Cartoon Network in 2011. "God's Girlfriend" aired on March 19, just four days before Taylor's death.

These Old Broads (February 12, 2001, ABC, directed by Matthew Diamond)

This was a work of pure opportunistic packaging. Collect four old broads, Taylor, Shirley MacLaine, Debbie Reynolds, and Joan Collins (because Lauren Bacall was unavailable), and put them in a show business teleplay written by actress-author Carrie Fisher. Not

only was she Reynolds's daughter, she was Taylor's stepdaughter by way of the ill-fated marriage to Eddie Fisher.

Taylor didn't want to do *Broads*, but reportedly accepted as a favor to Reynolds, who had financial woes. Fisher's script has three movie goddesses of yesteryear finding public interest surging by the reissue of their 1960s camp musical *Boy Crazy*. A television executive wants to reunite them in a special, but that's not easy. First he has to face their shared agent, who is one tough cookie. Then he has to convince the stars to rise above their rampant animosities for each other and do it. It's one long catfight of old grudges and new putdowns. Think *The Sunshine Boys* meets *Grumpy Old Men* topped with drag queen one-liners.

Our heroines play according to type. MacLaine made an industry out of lampooning her commercial metaphysics—this time with chanting, candles, incense, and a turban. Reynolds made an industry out of being the wronged party in the Taylor-Fisher affair, and she continues that ignoble tradition here. Collins made an industry out of being somebody's idea of a legendary seductress. And to democratize their participation, they take turns wearing bright red while the others wear something more subdued.

Broads includes a maudlin subplot with MacLaine's closeted gay son, played by Jonathan Silverman. He thinks he's adopted but learns that she birthed him. He goes on and on about this revelation. Adoptees everywhere might feel a jabbing pain at that clumsily written scene. Collins provides *Broads* its liveliest performance. She's ready to engage in a sex farce that's forever preempted by one side story or another. She even gets away with saying Taylor's great line from *A Place in the Sun*, "Tell mama. Tell mama all," to bedroom prey Peter Graves. Reynolds is always three beats behind everyone else, the dim bulb of the group. She's less adept at spewing zingers, even those written by her daughter. And she's not as virtuous as she lets on.

That leaves Taylor as tough-talking veteran agent Beryl Mason, based loosely on legendary superagent Sue Mengers. Director Matthew Diamond, whose mostly television credits include

Desperate Housewives, That's So Raven, The Golden Girls, and *Designing Women,* has a solid history of wrangling strong actresses. But Taylor at the turn of the century was something else. I get the impression she was more accommodated than directed. She has significantly less screen time than the others, and she shows up in whatever gaudy loungewear suits her mood. She wasn't well enough to meet the demands of singing and dancing and pratfalling as did the others. Most of her scenes have her holding court at home on her collection of plush throw pillows.

We find her watching footage of D-Day and sipping Slim Down. She's wearing the Elizabeth Taylor diamond ring, which we see in close-up, just in case *These Old Broads* is mistaken for subtle filmmaking. Beryl is reported dead, but turns up very much alive, just as Taylor was pronounced dead on multiple occasions. And she does some crazy vocals here that I guess were her own invention, landing her delivery somewhere between Yente the Matchmaker and Edith Bunker.

There's a constant drip-drip of body parts and sex "jokes"—menopause, humping like rabbits, vasectomies, a freckled penis, face lifts, sagging breasts, sagging asses, and so on. But it gets worse, winding up as a "comedy" of how to dispose of a dead man with a big penis. There's an exchange about Taylor stealing husband Freddie Hunter (get it?) from Reynolds. They put on smiles and claim no hard feelings. Why should anyone care more than forty years later? And is anyone laughing as Taylor and Reynolds describe Hunter's anatomy like a pair of twelve-year-old girls trying to gross each other out at a sleepover? Its star lineup and history guarantee *These Old Broads* will always be a curio. But you've been warned.

Elton John: Original Sin music video (2002, directed by David LaChapelle)

The setting of this Elton John music video is all shiny surfaces and romper room colors out of a Jeffrey Koons nightmare. A frail Taylor

sits in a Pepto-Bismol pink robe with matching turban, with her beloved Maltese terrier Sugar on her lap. *Original Sin* opens with a headshot of Taylor, delivering her lines tentatively. She's on for a few seconds, then never to be seen again, like a celebrity acting as product placement. Mandy Moore, all pimply and awkward in dirty blonde pigtails, is transformed as "Original Sin" plays on the soundtrack. She becomes a stunning young woman at a 1970s Elton John concert. There she hob-knobs with lookalikes of Sonny and Cher, Bette Midler, and Liza Minnelli.

Love Letters (December 1, 2007, Paramount Studio, Hollywood)

Taylor's last professional acting assignment was on stage at the Paramount Studios in Hollywood, where she had made *A Place in the Sun* near the beginning of her career. She and James Earl Jones, a costar in 1968's *The Comedians* and fellow 2002 Kennedy Center Honors recipient, read A. R. Gurney's *Love Letters*. The two-character play has been performed in dozens of productions since its premiere in 1988 and is a favorite among actors. Lines are read from letters and cards spanning decades, revealing the joys and sorrows in the business of living.

This *Love Letters* was steeped in meaning and virtue. Staged for one performance on World AIDS Day, it was produced as a fund-raiser for the Elizabeth Taylor Endowment Fund for the UCLA HIV/AIDS CARE Center, to provide mobile medical units in sub-Saharan Africa. Tickets were priced at $2,500, with larger donations received from Elton John, Hugh Hefner, David Geffen, and Paul Newman.

Taylor was dressed in an orange Michael Kors gown, fur, and coral, amethyst, and diamond Van Cleef & Arpels earrings, gifts from Richard Burton from long ago. She was now in a wheelchair and weakened by prolonged ill health. But in her drive to support

the cause of her lifetime, she appeared on stage again after twenty-three years.

The evening was a triumph. Taylor held the adoration of the crowd for just being there, but even at the end of her career and life, she was underestimated. Onlookers reported her performance was stunning. Said Gurney: "I feel an extra shiver of hubris over tonight's cast. I've already had the special pleasure of seeing Mr. Jones nail his part, but to see Elizabeth Taylor bring her beauty and talent to a role I've often dreamed of her playing is a consummation devoutly to be celebrated." Taylor grew in depth and delivery through the evening. As columnist Liz Smith reported, Taylor's entrance garnered an ovation for her chutzpah and dedication to the suffering of others. At the end of the evening, the audience jumped to its feet to honor Elizabeth Taylor the performing artist.

Dissonance outside the theater added more substance to the performance. The Writers Guild of America was on strike but agreed to suspend picketing at Paramount that evening. Guild President Patric Verrone delivered a statement proclaiming: "This worthy event is happening solely through the efforts and underwriting of Dame Elizabeth Taylor, who is not only a longtime member of the Screen Actors Guild, but an outspoken supporter of the Writers Guild."

Not all sentiments were gracious that night. Members of the Westboro Baptist Church Religious Ministry assembled outside Paramount, damning AIDS patients to hell. "Our traditions of free speech are to be revered and protected, and that extends even when a group uses this freedom to monger hatred of innocent people," responded Taylor. "This reminder that such ignorance and hatred of our fellow human beings forces us to redouble our efforts to address HIV/AIDS. Please pray for hearts that are filled with hatred . . . when the greatest need is God's love."

Conclusion

Before writing this book, I loved Elizabeth Taylor for her embrace of life, her fearlessness in love and acting, and her commitment to the well-being of people in extreme need. I finish *On Elizabeth Taylor* with each of those points of admiration enhanced.

I loved taking in her long wild ride of a career, pausing to contemplate where she was artistically, personally, and professionally with each film. The eras and styles she traversed were spectacular. From child star who loved animals and the great outdoors (*National Velvet*), to newly minted bombshell (*A Date with Judy, Conspirator*), to haughty yet soulful young adult star (*A Place in the Sun*) all before she was eighteen. MGM insisted she grow up very quickly, at least in front of the camera. But at reaching maturity, she was greeted with a succession of films demonstrating the studio didn't know what to do with her and/or believed she had little potential as an actress (*Love Is Better Than Ever, Rhapsody*). She was among the last of the studio-manufactured stars, with her every film, costume, public appearance, interview, and photograph under the microscope of publicists, stylists, production executives, and parents. Her rebellions, including matrimony, drinking and drugs, and outspoken defiance against studio heads and directors, were in response to a gilded life created for her by others.

Giant reminded the world of her great possibilities on screen. Thus began her zenith, with *Raintree County, Cat on a Hot Tin Roof, Suddenly, Last Summer,* and *BUtterfield 8*—four films in four years with four Oscar nominations, the last one netting her the statuette. When she was free of MGM, she embarked on a series of varyingly fine, odd, and insane films in the 1960s, her range and power as

an actress now fully ripened. There should be another descriptor besides "motion picture" for *Cleopatra*. "Once-in-a-century event," perhaps? Even so, and for all the sensationalism accompanying that film, it does not dominate Taylor's legacy.

I came to a greater appreciation of her earlier work, where Taylor was fully committed to stardom *and* acting. Five of her films, *Lassie Come Home*, *National Velvet*, *A Place in the Sun*, *Giant*, and *Who's Afraid of Virginia Woolf?*, are in the ever-expanding National Film Registry, selected by the Library of Congress for their cultural, historic, or artistic significance. With those criteria, where are *Cat on a Hot Tin Roof*, *Suddenly, Last Summer*, and in particular *Cleopatra*?

A reader moving through *On Elizabeth Taylor* chronologically will perceive a long and sad career decline following *Who's Afraid of Virginia Woolf?* By the late 1960s, her films and performances were reduced in number, frequency, financial success, and praise. Film tastes were changing, and younger actresses unassociated with old-style studio glamour were asserting themselves, but part of the problem came from Taylor herself. Unmoored from a long-term contract, she alternated between films of bold if flawed distinction that failed at the box office (*Reflections in a Golden Eye*, *The Driver's Seat*) to tedium unrelieved by her lackluster presence (*The Only Game in Town*, *The Blue Bird*), to films that appear to have been made *inebriato* (*Boom!*, *Hammersmith Is Out*). The stresses of an ostentatious public life overwhelmed her great talent, while her performances revealed a creeping indifference to the art of acting. Yet for all the problematic later films, Taylor forever possessed the ephemeral, mercurial qualities of light. I always want to see what she'll do next, how she'll change and proceed.

From there her feature films appeared only every few years, while she turned to television (*Divorce His/Divorce Hers*, *Poker Alice*, *Sweet Bird of Youth*) with mixed results. In the 1980s, her perfume business and commitment to people with AIDS became stated priorities. By the 1990s, her output was but a trickle, with the occasional guest appearance on series television, usually as herself

or in voiceover. Taylor made it official in 2003. "I've retired from acting; it doesn't really interest me that much anymore," she said. "It seems kind of superficial because now my life is AIDS, not acting."

Fame grabbed on to her at an early age, and it never let go. But while the highest reaches of twentieth-century celebrity brought seclusion and retreat (Greta Garbo, Jackie Kennedy) or forced commitment to a public life (Queen Elizabeth II), it had quite a different effect on Taylor. For all of her life vagaries intensified by the public's ceaseless gaze, she was never defeated. She came back with a new movie, husband, medical alert, business, or worthy cause. I am staggered at how Taylor kept the public enthralled decades after her career as a working movie actress ended. For another quarter century, she was always there, like the Lincoln Memorial or Grand Canyon. Until she wasn't. Taylor died of congestive heart failure at seventy-nine in 2011, and it seemed like the last of old Hollywood went with her.

She was a fascinating mix of actress, star, and celebrity since age twelve, but the ratios shifted over time. *Boom!*, I think, was a key tipping point. The cheap jokes and media preoccupation with the excesses of her life impeded a true appreciation of her gifts as an actress. Celebrity and star dominated over artist from then on, exacerbated by two marriages to Richard Burton fueled by millionaire nomadism, diamonds, embarrassingly bad movies, and alcohol. When the onset of AIDS coincided with her fading movie career, the great cause of her life began. Actress receded further, while star and celebrity found a magnificent new guise. "I resented my fame," she said, "until I realized I could use it."

The cruelty surrounding AIDS was fierce. The stricken were shunned as latter-day lepers. Nobody, but nobody, of any broad influence was saying anything. Washington was inert. Early on AIDS primarily struck homosexual men, inciting various evangelicals, right-wing politicians, and the closed hearted to brand it "The Gay Plague." Victims were left to die alone or in the trembling isolated care of friends and lovers. President Reagan didn't address the crisis

in a major speech for six years. By then, nearly 40,000 Americans had died.

Taylor was seething. She had many gay friends, so society's willful ignorance and hostility unsettled her. But her eventual embrace of people with AIDS was not merely personal. She was morally outraged not just as a friend but also as a greatly compassionate human being. As with other crossroads in her life, she had a frank talk with her conscience: "*Bitch, do something yourself. Instead of sitting there getting angry. Do something.*" She founded the American Foundation for AIDS Research (amfAR) in September 1985, then wept when her dear friend Rock Hudson died of AIDS-related illness in October.

A standard reading of Taylor's life has her retiring from acting to devote her energies to a wildly successful perfume empire, all the while raising hundreds of millions of dollars for AIDS research and care. I'd like to nuance that to suggest she never fully retired from acting. From films certainly, but not acting. In her public speaking, testimonials before Congress, and hand holding of the sick, dying, and bereaved, she performed the role of Elizabeth the Beneficent. She understood the essential link between **act**ing and **act**ivism, but that does not diminish her vast accomplishments or the sincerity of her efforts. She spoke of her financial and emotional dedication to people with AIDS as the culmination of her life's work, and it's easy to see why. I see it not as a break from her past, but as an extension of it. She brought to it the compassion of Leslie Benedict, the anger of Catherine Holly and Martha, and the fervor and determination of Velvet Brown and Maggie the Cat, all mixed with Cleopatra's shrewd awareness of her own charisma and power.

On March 29, 1993, the Academy of Motion Picture Arts and Sciences gave Taylor the Jean Hersholt Humanitarian Award for her support of AIDS research. She was luminous that night, as though she had found the truth so often sought in the roles she played. Clutching her shiny new Oscar and looking serene and self-assured, she spoke to a worldwide audience of many millions:

[This is] something I just have to do, that my passion must do. I am filled with pride and humility. I accept this award in honor of all the men, women, and children with AIDS who are waging incredibly valiant battles for their lives, those to whom I have given my commitment, the real heroes of the pandemic of AIDS. . . . I will remain here, as rowdy an activist as I have to be and, God willing, for as long as I have to be. Tonight I am asking for your help. I call upon you to draw from the depths of your being to prove that we are a human race. To prove that our love outweighs our need to hate, that our compassion is more compelling than our need to blame. That our sensitivity to those in need is stronger than our greed. That our ability to reason overcomes our fear. And that at the end of each of our lives, we can look back and be proud that we have treated others with the kindness, dignity, and respect that every human being deserves. Thank you, and God bless.

It was another great Elizabeth Taylor performance. But this time, it was also what she lived and who she was.

Notes

AMPAS – Margaret Herrick Library, Academy of Motion Picture Arts and Sciences, Beverly Hills, California.
ET – *Elizabeth Taylor: An Informal Memoir.*
NYPL/PA – Elizabeth Taylor clipping files, New York Public Library for the Performing Arts, Lincoln Center.

Epigraps and Introduction

vi "Beauty is rarely": Donna Tartt, *The Secret History*, p. 37.
vi "Everything makes me": warbletocouncil.org/frases-elizabeth-taylor-7413.
 2 "idiosyncratic acting": "The Improbable Elizabeth Taylor" by Hilton Als, *The New Yorker*, March 24, 2011.
 2 "heart like a cathedral": American Film Institute Elizabeth Taylor Life Achievement Award Tribute Book, 1993, p. 9.
 2 "The quality that shines": *Newark Evening News*, January 8, 1967.
 3 "What can you say?": youtube.com/watch?y=GmZuPwuA9do.
 4 "I think she's one": youtube.com/watch?y=AcSuQf4RZWs.
 4 "I'd rather work": Bosworth, p. 228.
 4 "The maximum emotional": *The New York Times*, April 12, 1964.
 4 "At her best": Paglia, p. 16.
 4 "I think film acting": *ET*, p. 195.
 6 "The public takes": *Life*, December 18, 1964, p. 81.
 8 "There have been": Munn, p. 91.
 8 "Planes, trains": *The New York Times*, March 24, 2011.
 8 "If I'm pounced on": NYPL/PA, unattributed clip, 1975.
11 "Elizabeth Taylor charmed": Graham, p. 219.

Films

30 "a ballerina": "National Velveeta" by Aaron Latham, *Esquire*, November 1977, p. 172.

31 "Little Elizabeth Taylor": *Elizabeth Taylor: An Intimate Portrait* TV documentary, April 30, 1975.

31 "It felt like": *Elizabeth the First* podcast, episode 1, 2022.

31 "The lot was so huge": *ET*, pp. 23-24.

32 "You were perfect": *ET*, p. 51.

33 "I had a great imagination": Taylor, *My Love Affair with Jewelry*, p. 15.

36 "It was like Chekov": *ET*, pp. 192-193.

36 "Act of God": Young, p. 264.

41 "an elaborate series": Spoto, pp. 40-41.

43 "You can't see it": youtube.com/watch?v=PfF7TeYAiJM&t=240s.

43 "Elizabeth was a lovely person": Rode, p. 395.

45 "well-mannered English girl": Astor, p. 192.

45 "high – like a bird": *Photoplay*, May 1945.

45 "Don't you dare": *ET*, p. 56.

46 "I knew that with lipstick": Taylor, *Elizabeth Takes Off*, p. 56.

49 "I will go far": Cashmore, p. 2.

50 "My taste buds": *Look*, July 24, 1956, p. 48.

51 "the first person": Mann, pp. 87-88.

52 "No one ever suggested": Taylor, *Elizabeth Takes Off*, p. 59.

53 "LB Mayer and MGM": *ET*, p. 21.

53 "She is a bland": *Life,* February 21, 1949.

53 "Usually it isn't": NYPL/PA, unattributed clip by Frances Levison, 1949.

54 "She's a natural": Moseley, p. 176.

55 "Miss Taylor is beautiful": *The New Yorker*, June 3, 1950.

57 "I was so in awe": interview, *A Place in the Sun* DVD extras, 2001.

58 "had enormous beauty": Spoto, p. 63.

58 "was a great believer": Bosworth, p. 134.

58 "I trusted him absolutely": interview, *A Place in the Sun* DVD extras, 2001.

59 "For the first time": *George Stevens and His Place in the Sun* documentary, 2001.

60 "I wanted the words": Bosworth, pp. 184-185.

62 "She has been associating": Transcript of an unpublished interview with Stevens by Ruth Waterbury, George Stevens Collection, AMPAS, September 7, 1962.

62 "Clift and Taylor": Bosworth, p. 213.

63 "I don't presume": Transcript of an unpublished interview with Stevens by Ruth Waterbury, George Stevens Collection, AMPAS, September 7, 1962.

64 "I could have killed": Curtis, p. 594.

71 "is a very shapely lady": *The New York Times*, March 4, 1952.

72 "a piece of cachou": *ET*, p. 45.

75 "Whenever I was in trouble": Taylor, *My Love Affair with Jewelry*, p. 212.

77 "*Forget* it!": *Interview*, November 1976, p. 12.

78 "All I did": *ET*, p. 61.

78 "The films I did": *ET*, pp. 60-61.

80 "What's the use": De La Hoz, p. 123.

82 "A rather curiously": *The New York Times,* April 12, 1964.

84 "We gave her a very difficult part": American Film Institute Elizabeth Taylor Life Achievement Award Tribute Book, 1993, p. 46.

84 "The ugliest landscape": McCambridge, p. 206.

85 "George shoots extensive footage": *ET*, p. 70.

85 "Damn it, George": Hinkle, p. 57.

86 "shrinking violet": Graham, p. 141.

86 "George was a tyrant": Walker, p. 162.

87 "I was very connected": Graham, p. 184.

87 "What's going on?": youtube.com/watch?v=AcSuQf4RZWs.

91 "Given her powerful position": Moss, p. 224.

93 "Liz was a hard worker": Dmytryk, p. 211.

93 "talked a lot": Bosworth, p. 228.

94 "all restored itself": *ET*, p. 73.

98 "Action!": *Elizabeth Takes Off,* pp. 90-91.

99 "It was noisy": Bosworth, p. 325.

99 "By the time": Daniel, p. 129.

99 "I put myself": *The New York Times*, April 12, 1964.

103 "I'm pleased with *Cat*": *Newsweek*, September 1, 1958.

103 "Here's a girl on the big screen": *Elizabeth Taylor: An Intimate Portrait* TV documentary, April 30, 1975.

106 "Dear Elizabeth": Mankiewicz and Crane, p. 46.

107 "It tore Elizabeth's gut out": Walker, p. 213.

107 "broken up completely": *Look*, April 12, 1960.

107 "Okay, everyone": Walker, pp. 214-215.

107 "one of the finest": *Look*, April 12, 1960.

107 "An aria from a tragic opera": Casillo, p. 256.

108 "more irritating than damaging": Mankiewicz Papers, *Suddenly, Last Summer*, AMPAS Special Collections, November 19, 1959.

108 "*Suddenly, Last Summer* was the most difficult": Casillo, p. 253.

110 "the most pornographic": Wiley and Bona, p. 320.

110 "She was very sweet": "An Oral History with Ralph Winters," interview by Jennifer Peterson, AMPAS, 2003, p. 188.

110 "She is wildly professional": Sinai, pp. 251-252.

111 "Finds men her source": Daniel Mann Collection, AMPAS.

114 "All I can do": youtube.com/watch?v=nSaSkMp7-X8.

114 "Liz Taylor Great": *Chicago Sun-Times*, November 7, 1960.

114 "Liz Superb": *New York Journal-America*, November 17, 1960.

114 "Elizabeth Taylor in a strong dramatic role": *Hollywood Reporter*, October 26, 1960.

114 "The finest performance": *Cue*, November 19, 1960.

114 "well nigh perfect": *New York Mirror*, November 17, 1960.

114 "I still say it stinks": tcm.com/tcmdb/title/2648/butterfield-8#articles-reviews?articleId=31292.

115 "She is the only woman": Wanger and Hyams, p. 2.

115 "If somebody's dumb enough": Casillo, p. 262.

116 "The picture was conceived": Brodsky and Weiss, p. xiii.

116 "the hardest three pictures": Geist, p. 327.

116 "She knows exactly": Harrison, p. 182.

117 "I fell in love": Taylor, *My Love Affair with Jewelry*, p. 50.

117 "It's no rumor": Brodsky and Weiss, p. 35.

117 "a game which they start": *The New York Times*, April 5, 1962.

118 "Once you start saying": Davis, p. 283.

118 "Any effort to saddle blame": Geist, p. 333.

118 "Waited for Miss Taylor": Mankiewicz Papers, *Cleopatra*, AMPAS Special Collections.

119 "They were terrific": C.O. Erickson interview by Douglas Bell, AMPAS, 2006, p. 255.

119 "Miss Taylor completed": Mankiewicz Papers, *Cleopatra*, AMPAS Special Collections.

119 "Cleopatra. In scarlet letters": *Time*, June 21, 1963.

120 "*Cleopatra* is not only": *Variety*, June 19, 1963.

121 "brings to it all": *Cleopatra: The Film That Changed Hollywood* documentary, 2001.

122 "overweight, over bosomed": Brower, p. 212.

123 "Surely that film": *ET*, p. 123.

123 "I bared my soul": Munn, p. 125.

124 "There will always": Brodsky and Weiss, p. 168.

126 "The Elizabeth Taylor who's famous": *Life*, December 18, 1964, p. 74.

127 "After we did *The V.I.P.s*": *ET*, p. 181.

128 "hits pretty close": *Time*, June 16, 1965.

128 "ludicrous and dated": Minnelli, p. 356.

131 "salacious and profound": Haskell Wexler, *Who's Afraid of Virginia Woolf?* DVD commentary, 2006.

131 "savage, humorous": Warner Bros. inter-office memo Lehman to Warner, October 16, 1964.

132 "It was the most difficult": *ET*, p. 184.

132 "People know how": Harris, *Mike Nichols*, p. 153.

132 "I would have done it": Munn, pp. 157-158.

132 "They didn't want me": Munn, p. 157.

133 "Mike is a hinting director": *ET*, p. 189.

133 "It's like asking": Harris, *Mike Nichols*, p. 176.

134 "Here were four stage people": Nichols, *Virginia Woolf* DVD commentary, 2006.

135 "Don't fire him": Mike Nichols, *Who's Afraid of Virginia Woolf?* DVD commentary, 2006.

135 "I am just constantly surprised": *Saturday Evening Post*, October 9, 1965, p. 85.

136 "I've never been so happy": *ET*, p. 188.

136 "It was stepping": *ET*, p. 186.

137 "forces us to confront": Mike Nichols, *Who's Afraid of Virginia Woolf?* DVD commentary, 2006.

137 "had that thrilling thing": Harris, *Pictures at a Revolution*, p. 275.

138 "held on to a sliver": Brower, p. 229.

140 "and the fact that": *ET*, p. 125.

141 "Muggins from Hollywood": *Elizabeth the First* podcast, episode 4, 2022.

141 "Elizabeth and I": Cottrell and Cashin, p. 302.

142 "On my first day": Taraborrelli, p. 262.

142 "skinny lens": "An Oral History with Takuo Miyagishima," interview by Duane Dell'Amico, AMPAS, 2009.

143 "It would have been very difficult": Cottrell and Cashin, p. 302.

148 "Must we *always*": Bragg, p. 208.

149 "Elizabeth comes to the set": Grobel, pp. 581-582.

149 "acute animal sensitivity": Brower, p. 234.

151 "Liz Taylor was becoming": "An Oral History with C. O. Erickson," interview by Douglas Bell, AMPAS, 2006, p. 338.

152 "Elizabeth is looking": Bragg, p. 234.

153 "I liked working": Munn, p. 166.

153 "There is nothing": American Film Institute Elizabeth Taylor Life Achievement Award Tribute Book, 1993, p. 15.

154 "The world sees": Kashner and Schoenberger, p. 198.

154 "The Burtons are quite": Morley, pp. 153-154.

157 "Joseph Losey was a strange guy": Bozzacchi, p. 69.

157 "My God you have": Burton and Williams, p. 179.

161 "The disintegration of Elizabeth": Reed, p. 199.

164 "Elizabeth and Richard didn't have": Bozzacchi, p. 86.

166 "I very quickly got": Caine, pp. 140-141.

167 "There are always": Burton and Williams, p. 563.

167 "I'm so bloody lazy": *Time*, January 11, 1971.

171 "instinct of what a woman": unattributed clip, NYPL/PA, October 24, 1971.

173 "sadly deteriorating": Sinai, p. 345.

176 "My efforts to make": Taylor, *Elizabeth Takes Off*, p. 26.

176 "I didn't really like": NYPL/PA, undated.

176 "She never had": Vermilye and Ricci, pp. 235-236.

177 "Elizabeth was at the height": *The Telegraph*, May 19, 2016.

179 "Liz saunters in": "The Liz and Andy Show" by Robert Colacello, *Vogue*, January 1974, p. 102.

180 "There were so many diamonds": *New York Daily News*, June 2, 1974.

183 "renegotiated my agreement": Cukor Special Collection, AMPAS, September 30, 1974.

186 "Every great singer": *Los Angeles Times*, February 20, 1978.

186 "Taylor has the unique willingness": American Film Institute Elizabeth Taylor Life Achievement Award Tribute Book, 1993, p. 75.

190 "Today, a whole generation": *Variety*, November 19, 1980, p. 2.

190 "cried all night": Brower, p. 308.

195 "Acting is, to me": *Wall Street Journal*, March 24, 2011.

Television, Theater, and Special Appearances

198 "I became terribly": *ET*, p. 197.

199 "If she doesn't get bad": *Washington Post*, June 23, 1964.

199 "What you're trying to say": Brower, p. 222.

199 "I have never acted": Kashner and Schoenberger, p. 188.

200 "A monster of staggering": Burton and Williams, p. 352.

200 "I warned the director": Burton and Williams, p 354.

202 "For a moment": *The New York Times*, March 25, 1973.

203 "Giving was her heart": Brower, p. 298.

206 "Regina is not": dameelizabethtaylor.com/little_foxes.html.

206 "Let's face it": Taylor, *Elizabeth Takes Off*, pp. 93-94.

211 "I don't know what there was": American Film Institute Elizabeth Taylor Life Achievement Award Tribute Book, 1993, p. 80.

212 "stinks of garlic": Burton and Williams, p. 649.

212 "Elizabeth was a natural": Kashner and Schoenberger, p. 416.

213 "like Minnie Mouse": Kevin Kelly, *Boston Globe*, NYPL/PA, 1983.

213 "Miss Taylor is still": *The New York Times*, May 8, 1983.

214 "The project was doomed": Taylor, *Elizabeth Takes Off*, pp. 97-98.

214 "My God, this looks": *People*, October 29, 1984.

215 "dumpy, dowdy, and dedicated": Barbas, p. 345.

218 "shook the rafters": youtube.com/watch?v=4z0280aCxlU.

219 "Liz is marvelous": De La Hoz, p. 281.

227 "this worthy event": dameelizabethtaylor.com/love_letters.html.

227 "This reminder that such": "Liz Taylor performs 'Love Letters,'" *Variety*, December 3, 2007.

Conclusion

230 "I've retired from acting": *Entertainment Weekly*, March 21, 2003.

230 "I resented my fame": *Vanity Fair*, February 2023, p. 76.

231 "*Bitch do something*": *Vanity Fair*, February 2023, p. 78.

232 ". . . [This is] something": aaspeechesdb.oscars.org/link/065-25.

Bibliography

Anonymous. *American Film Institute Elizabeth Taylor Life Achievement Award Tribute Book*. Los Angeles: Project Marketing, 1993.

Astor, Mary. *A Life on Film*. New York: Delacorte Press, 1967.

Barbas, Samantha. *The First Lady of Hollywood*. Berkeley and Los Angeles: University of California Press, 2005.

Bosworth, Patricia. *Montgomery Clift*. New York: Harcourt Brace Jovanovich, 1978.

Bozzacchi, Gianni. *My Life in Focus: A Photographer's Journey with Elizabeth Taylor and the Hollywood Jet Set*. Lexington: University Press of Kentucky, 2017.

Bragg, Melvyn. *Richard Burton: A Life*. Boston: Little, Brown, 1988.

Brodsky, Jack, and Nathan Weiss. *The Cleopatra Papers: A Private Correspondence*. New York: Simon & Schuster, 1963.

Brower, Kate Andersen. *Elizabeth Taylor: The Grit & Glamour of an Icon*. New York: HarperCollins, 2022.

Burton, Richard, and Chris Williams, editor. *The Richard Burton Diaries*. New Haven: Yale University Press, 2012.

Caine, Michael. *The Elephant to Hollywood*. New York: Henry Holt, 2010.

Cashmore, Ellis. *Elizabeth Taylor: A Private Life for Public Consumption*. New York: Bloomsbury Academic, 2016.

Casillo, Charles. *Elizabeth and Monty: The Untold Story of Their Intimate Friendship*. New York: Kensington, 2021.

Cottrell, John, and Fergus Cashin. *Richard Burton, Very Close Up*. Englewood Cliffs, NJ: Prentice-Hall, 1971.

Curtis, James. *Spencer Tracy: A Biography*. New York: Knopf, 2011.

Daniel, Douglass K. *Tough as Nails: The Life and Films of Richard Brooks*. Madison: University of Wisconsin Press, 2011.

Davis, Nick. *Competing with Idiots: Herman and Joe Mankiewicz*. New York: Knopf, 2021.

De La Hoz, Cindy. *Elizabeth Taylor: A Shining Legacy on Film*. Philadelphia: Running Press, 2012.

Dmytryk, Edward. *It's a Hell of a Living but Not a Bad Living*. New York: Times Books, 1978.

Fontaine, Joan. *No Bed of Roses*. New York: William Morrow, 1978.

Geist, Kenneth L. *Pictures Will Talk: The Life and Films of Joseph L. Mankiewicz*. New York: Da Capo Press, 1978.

Graham, Don. *Giant: Elizabeth Taylor, Rock Hudson, James Dean, Edna Ferber and the Making of a Legendary American Film*. New York: St. Martin's, 2018.

Grobel, Lawrence. *The Hustons*. New York: Scribner, 1989.

Harris, Mark. *Mike Nichols: A Life*. New York: Penguin Press, 2021.

Harris, Mark. *Pictures at a Revolution*. New York: Penguin Press, 2008.

Harrison, Rex. *A Damned Serious Business*. New York: Bantam, 1991.

Heymann, C. David. *Liz: An Intimate Biography of Elizabeth Taylor*. New York: Birch Lane, 1995.

Hinkle, Robert. *Call Me Lucky: A Texan in Hollywood*. Norman: University of Oklahoma Press, 2009.

Hirsch, Foster. *Elizabeth Taylor*. New York: Pyramid Books, 1973.

Kashner, Sam, and Nancy Schoenberger. *Furious Love: Elizabeth Taylor, Richard Burton and the Marriage of the Century*. New York: HarperCollins, 2010.

Lord, M. G. *The Accidental Feminist*. New York: Walker, 2012.

Maddox, Brenda. *Who's Afraid of Elizabeth Taylor?* New York: M. Evans, 1977.

Mankiewicz, Tom, and Robert Crane. *My Life as a Mankiewicz*. Lexington: University Press of Kentucky, 2012.

Mann, William J. *How to Be a Movie Star*. New York: Houghton Mifflin, 2009.

McLeland, Susan. "Elizabeth Taylor: Hollywood's Last Glamour Girl." In Radner, Hilary and Luckett, Moya (eds.) *Swinging Single: Representing Sexuality in the 1960s*. Minneapolis: University of Minnesota Press, 1999, pp. 226–251.

Minnelli, Vincente. *I Remember It Well*. New York: Samuel French, 1990.

Morley, Sheridan. *Elizabeth Taylor: A Celebration*. London: Pavilion Books, 1988.

Moseley, Roy. *Evergreen: Victor Saville in His Own Words*. Carbondale: Southern Illinois University Press, 2000.

Moss, Marilyn Ann. *Giant: George Stevens, a Life on Film*. Madison: University of Wisconsin Press, 2004.

Munn, Michael. *Richard Burton: Prince of Players*. New York: Skyhorse Publishing, 2008.

Nickens, Christopher. *Elizabeth Taylor: A Biography in Photographs*. New York: Arrow, 1984.

Paglia, Camille. "Elizabeth Taylor: Hollywood's Pagan Queen." In *Sex, Art, and American Culture*. New York: Vintage, 1992, pp. 14–18.

Reed, Rex. *Big Screen, Little Screen*. New York: Macmillan, 1971.

Rode, Alan K. *Michael Curtiz: A Life in Film*. Lexington: University Press of Kentucky, 2017.

Sinai, Anne. *Reach for the Top: The Turbulent Life of Lawrence Harvey*. Lanham, MD: Scarecrow Press, 2003.

Smith, Susan. *Elizabeth Taylor*. London: British Film Institute, 2019.

Spoto, Donald. *A Passion for Life: The Biography of Elizabeth Taylor*. New York: HarperCollins, 1995.

Stevens, George, Jr. *Conversations with the Great Moviemakers of Hollywood's Golden Age*. New York: Knopf, 2006.

Taraborrelli, J. Randy. *Elizabeth*. New York: Warner Books, 2006.

Taylor, Elizabeth. *Elizabeth Takes Off*. New York: G.P. Putnam's Sons, 1987.

Taylor, Elizabeth. *Elizabeth Taylor*. New York: Harper & Row, 1964, Avon reprint 1967.

Taylor, Elizabeth. *Elizabeth Taylor: My Love Affair with Jewelry*. New York: Simon & Schuster, 2002.

Taylor, Elizabeth. *Nibbles and Me*. New York: Duell, Sloan and Pearce, 1946.

Vermilye, Jerry, and Mark Ricci. *The Films of Elizabeth Taylor*. New York: Citadel Press, 1976.

Walker, Alexander. *Elizabeth: The Life of Elizabeth Taylor*. New York: Grove Weidenfeld, 1990.

Wanger, Walter, and Joe Hyams. *My Life with Cleopatra*. New York: Vintage Books, 1963.

Wiley, Mason, and Damien Bona. *Inside Oscar*. New York: Ballantine Books, 1996.

Willoughby, Bob. *Liz: An Intimate Collection: Photographs of Elizabeth Taylor*. London: Merrell Publishers, 2004.

Young, Gwenda. *Clarence Brown: Hollywood's Forgotten Master*. Lexington: University Press of Kentucky, 2018.

Index

For the benefit of digital users, indexed terms that span two pages (e.g., 52–53) may, on occasion, appear on only one of those pages.

254 INDEX